Galway
History on a Postcard

GALWAY

History on a Postcard

Paul Duffy

CURRACH PRESS

First published in 2013 by
CURRACH PRESS
55A Spruce Avenue, Stillorgan Industrial Park,
Blackrock, Co. Dublin

www.currach.ie

Front cover and layout design by Bill Bolger
Back cover design by Shaun Gallagher
Origination by Currach Press
Printed by Nicholson & Bass Ltd

ISBN 978 1 85607 803 0

Contents

Introduction

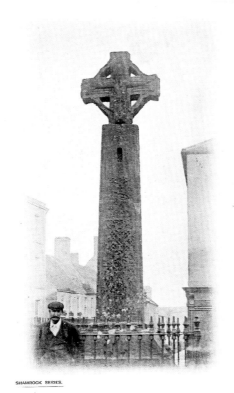

SHAMROCK SERIES.

The Tuam Cross.

The Austro-Hungarian postal authorities introduced a plain postcard for public use on October 1st 1869. The success of this new medium of correspondence was immediate. Other countries quickly followed the Austrian example and the United Kingdom issued its own postcards on October 1st 1870. The cards carried the Royal coat of arms at the top of the front, or address side, the back being reserved for the message. Businesses could buy prepaid cards with the stamp printed as part of the card. With a postage rate of one halfpenny as opposed to the standard letter rate of one penny, postcards were cheap, useful and convenient, particularly when there was same-day delivery. Soon companies began to use cards with a vignette of their logo or product to acknowledge orders or confirm consignment of goods to customers. Stationers also began selling cards with decorative borders or vignettes on the back, or message side, but the production of picture postcards was delayed for a number of years because of the British postal authority's insistence that privately produced cards be liable for the full postage rate of one penny. This restriction was finally lifted in 1894. By then the use of pictorial cards was well established on the continent and the cards were fast growing in popularity as collectables. The vogue for collecting pictorial cards would seem to have begun in Paris in 1853. In that year a draper named Aristide Boucicaut produced collector cards to publicise his business. Soon a wide variety of shops, chocolate makers, starch manufactures, and, even, undertakers followed suit. By the 1880s European cigarette makers were promoting sales with sets of cigarette cards. Fashionable members of society had pictorial cartes de visite or visitor cards which they left on visiting a household. These too became collectable so when pictorial postcards were first produced there was an established collectors market for them. There was a large readily available supply of photographs from the stock held by such firms as Eason, Valentine's and Lawrence's – to name just a few photographic

firms. These companies had built up a large stock as a result of commissions from railway companies and book publishers for suitable photographs to promote destinations or illustrate books. The cards also provided a useful souvenir for holidaymakers who couldn't afford a camera; they had a ready-made set of photographs of their destination to take home with them. The pictorial card became the poor man's photograph – this latter would explain why so many early postcards were never sent through the postal system.

It would appear that the earliest Irish picture postcards were produced by Valentine and Sons, a Scottish firm. Their business prospered and in 1905 they opened a branch office in Dublin. Lawrence, the celebrated Dublin photographic firm, was also involved in the view card business from the early days but, initially, seemed to have concentrated on supplying copies of their stock photographs to other firms for the production of cards; however, by 1900 Lawrence was firmly established as a postcard publisher. Other firms soon entered the business: Easons (The Signal Series); Fergal O'Connor of Cork and Dublin (The Erin go Bragh Series); Healy and Mason, both of Dublin; Bairds of Belfast; Guy and Co., Limerick; Duffner Brothers, Dundalk; Cuthbert Harrison, Sligo – to mention just a few. Soon many local photographers and stationary shops began producing cards showing views of their own area. Some of the Galway producers were: Clifden, R. Joyce; Bernard Ludden; M. Ward's Stores and Coen's Stationers, Oughterard; Madden, Monaghan and Clegget, Gort; Stephenson, Kinvara; Mrs Margaret O'Donnell, Athenry; Higgins, Loughrea; M. J. Kelly and Wynnes, Ballinasloe; J. H. Greene, Portumna; Kathleen Molloy and M. H. Lavan, Tuam; Patrick Lyons and M. S. Walsh, Dunmore; M. Charles, Glenamaddy; M. B. Collins; Leenane McKeown's, Letterfrack; J. J. Coyne, Carna; M. A. Moran. In addition a significant number of cards were produced by itinerant or travelling photographers and sold through local post offices or other outlets. The development of real-photo postcard sized printing paper made it easier for small photographic businesses and, indeed, amateur photographers to produce cards, usually in limited quantities. The back was laid out and printed as if it was a mass-produced card. Foreign firms played a significant role in the postcard trade. Some of the firms involved in the production of Galway views were: Stewart and Woolf, Woolstone Brothers (The Milton Series), E. Wrench (The Wrench Series), and The RAP Company, all of London; A. Hildesheimer of London and Manchester; Judges of Hastings; Raphael Tuck and Sons; and Valentines of Dundee. Between national, local and foreign producers, an estimated 6,000 postcard views have been published of Galway city and county since the 1890s.

What follows is a personal selection of cards from a collection of some 3,500 that has been assembled over a long period of years. No doubt different selections would be made by others; however, the cards used have been picked to illustrate aspects of County Galway's history, primarily in the period 1890 to 1930. There is a slight bias towards engineering heritage, which I believe is justified as the development of the county's infrastructure has paved the way for a major improvement in living conditions for all. The street scenes, with their absence of traffic and clutter, give a good idea of the rich architectural heritage of the various towns chosen. Transport and industry are also represented, as is rural life. Educational facilities also feature as they have made an enormous contribution to the development of the county. All of the cards are from the author's own collection. Preference has been given to cards from local photographers as they are under represented in the National Photographic Archive held by the National Library of Ireland. A particular debt is due to the late Mrs Clegget of Oughterard and also to members of the Kelly family, Loughrea who supplied me with background information on the cards carrying their brand names and who generously gave permission to reproduce cards from the collection for illustration purposes.

Chapter 1 **South**

Oranmore, Kilcolgan, Tullira, Gort, Lough Cutra, Kinvara, Doorus, Athenry, Loughrea.

Oranmore

Oranmore was a strategic outpost whose castle, which controlled a river ford, guarded the southern and eastern approaches to Galway. Parts of the castle fabric date from the fifteenth century. Unfortunately no record relating to the town's first bridge seems to have survived. There was a bridge here in the 1770s which was replaced in 1795 by a large four-arch structure built by Edward Lynch and Michael and Dennis Blake. The main body of the bridge survived the hurricane of November 20th 1830, unlike the piers at Barna and Ballynacourty and the bridge at Clarinbridge; however, the force of the storm was such that the parapets at Oranmore were swept away. Some

idea of the ferocity of the gale can be gleaned from the fact that the bodies of fourteen strangers were recovered from the bridge area afterwards. The parapets were finally reconstructed in 1834 by William Clarke of Merchants Road, Galway.

No record exists of damage done to the mill by the hurricane, and if any did occur it was slight. The mill was offered for letting by T. Commins, Oranmore from January 1st 1834 'for such a term as may be agreed on'. The mill was on the site of an earlier medieval one that was, in all probability, associated with the castle. During an archaeological investigation of the site in 1998

Oranmore, Co. Galway, c.1910

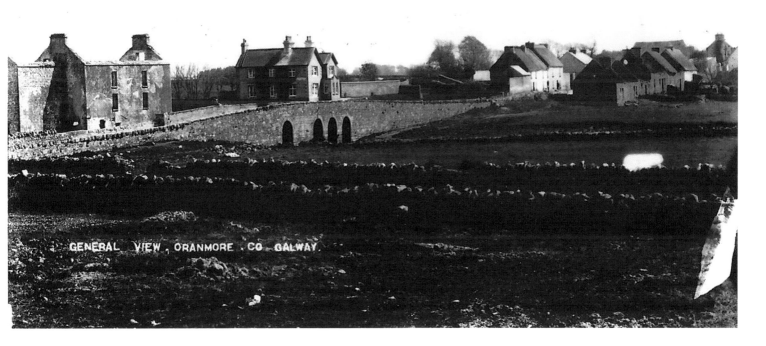

GENERAL VIEW, ORANMORE, CO. GALWAY.

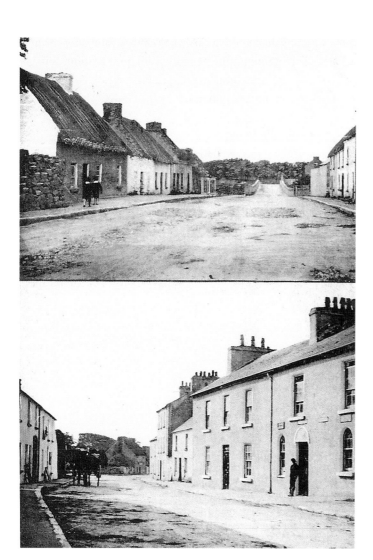

Main Street Oranmore c.1900

along the front of the premises to the wheel and discharge through the isolated arch in the bridge. The mill was tenanted in 1824 by Kearney and Stephens, who also ran the optimistically-named but short-lived Hope Brewery. In the 1850s the buildings had a ratable valuation of £27 1s., one of the highest in the county. By the end of the century the building was a ruin. It was demolished in 1955 when the humped crown of the bridge was removed and replaced by a level reinforced concrete deck supported on the 1795 piers.

On the night of August 21st 1920 British troops sacked the town in reprisal for a Republican forces' ambush on a Royal Irish Constabulary patrol near Merlin Park the same day. Constable Martin Foley was killed in the attack and Sergeant Mulhearn and Constable Byrne were injured. During their rampage the British forces burnt three houses – Keane's, Costello's, and Coen's – and wrecked several more. As many of Oranmore's houses were thatched, the town could have been completely destroyed by the fire were it not for the British airmen from the nearby aerodrome who came to the assistance of the local community in extinguishing the fires.

The aerodrome, located on the military training ground, was constructed as a base for the Royal Flying Club, the forerunner of the Royal Air Force. It may well have been here that M. G. Loder, the Irish agent for Blackburn Aeroplanes, had in mind as the Galway landing site for a proposed All-Ireland Aeroplane Tour which was to be run from September 16th to October 26th 1912. The Cynicus Publishing Company's cartoon card, which was doctored by the sender, carries a strong hint of the existence of an airstrip in the area in 1913. The message on the back concludes with a line of some significance. It reads, 'I think I shall travel by Aeroplane as I don't approve of the conduct that is carried on [with] in railway carriages.' The card was posted on May 21st 1913. Within fifteen months the world went to war and

an opportunity to examine the area was afforded by Jim Higgins. The old mill pond was fed by three sources: the well on the Claregalway Road, the river and the incoming tide. The wall that divides the pond area from the river had three sluice openings that could be used to top up the pond, which had a paved channel running along the inside of the wall. The original mill had its waterwheel on the southern gable. The later building, constructed in the eighteenth century, had its wheel on the façade powered by a stream taken around the north gable to run

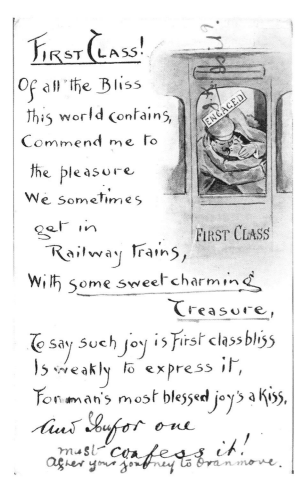

Doctored Cynicus Card Referring to Oranmore Station

FIRST CLASS!
Of all the Bliss
this world contains,
Commend me to
the pleasure
We sometimes
get in
Railway trains,
With some sweet charming
Treasure,
To say such joy is First class bliss
Is weakly to express it,
For man's most blessed joy's a Kiss,
And I for one
must confess it!
After your journey to Oranmore.

FIRST CLASS

ENGAGED

British Military Camp Oranmore c.1915

published anonymously so that the publisher, printer and photographer could avoid prosecution. Visible amongst the camp buildings is an aircraft hanger which was eventually purchased by the Galway Urban District Council and re-erected in Salthill Park as a summer season dance hall.

In this period a RAF plane on a flight from Oranmore to Cork was brought down by rifle fire over County Tipperary. The pilot survived unhurt, unlike many of the thousands of recruits who passed through the military camp on their way to the killing fields of the Western Front during the First World War. Most of these unfortunates would have travelled from the military camp to Dublin to take ship to the battlefields of Europe.

One small group of reluctant Connaught Rangers decided to use the Galway–Dublin train service in April 1902 whilst deserting. They took the midnight train according to newspaper reports. Not wishing to draw attention to themselves, they hitched a ride standing on the engine buffers where they were found hanging on for dear life when the train reached Oranmore. The three, named as Dillon, Fay and Murphy were taken in charge and brought back to Galway and handed over to the military by constables Fitzgerald and Costelloe. Fay and

all cards were required to meet the approval of the Censor's Office of the British Ministry of War. The cartoon card shown would most likely have received the go-ahead; publication of the view of the British military camp in Oranmore on the other hand would not have been allowed. Cards showing any scene that might give information to the enemy on military barracks or the area surrounding them had to obtain approval from the Censor's Office. The back of the card had to indicate the date that this approval had been granted. A view of the docks area and town bridge of Athlone had to be submitted for just such approval in 1917 in case it showed any detail of the local barracks. The Oranmore card was

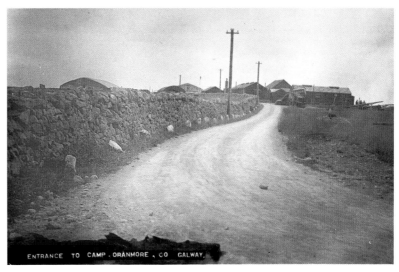

ENTRANCE TO CAMP. ORANMORE, CO GALWAY.

Murphy bolted but Fay was quickly recaptured. Murphy seemed to make good his escape but shortly afterwards cries for help were heard from Lough Athalia. Murphy had jumped over the side of the railway bridge in his endeavour to escape. The three were charged with desertion.

Oranmore was connected to the railway system in 1851 when the Midland Great Western Railway Company completed their Athlone–Galway line. In common with many other private enterprise schemes, a public subsidy funded by way of a Baronial Guarantee had to be paid. Any shortfall in income to cover the running costs of the line had to be covered by way of a levy charged to all the baronies of County Galway. Even the Aran Islands had to pay this charge. Oranmore station closed in 1961. There was a double line of tracks from the station into Galway. One set was lifted in 1929 and it is now proposed to relay it as part of the Western Rail Corridor.

Kilcolgan Castle

The original Kilcolgan Castle was described in 1843 as being composed of three independent towers linked together by strong walls to create a courtyard. One of the towers was constructed to project out into the

Kilcolgan Castle c.1950

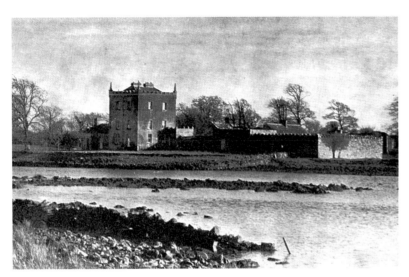

river. There was a mill associated with the Castle which apparently was still at work in 1823 even though the old castle had been completely demolished. The mill was described as a primitive one, quite possibly a horizontal one (where the wheel rotates parallel to the water surface) and constructed of unmortared stone. The Castle belonged to the de Burgos or Clanrickards.

An old tradition has it that Honoria – Norah na Kistla, the widow of Ulick de Burgo – set herself up in the Castle with a small army and went about recovering lands and castles that had been taken by the Lord Deputy. She met with some success until she tried to regain Ballydonnelan Castle. She sent the occupants a barrel of fine wine that she had captured from a galley on its way to Galway, with the promise of more to follow. She next dispatched a number of her troops hidden in empty wine casks. The carts were led by other troops in disguise whilst a detachment of her army concealed themselves near the Castle, ready to attack once the barrels were inside the Castle. The unfortunates inside the casks never got a chance to draw their weapons and were all killed on detection. No doubt some of the defenders had heard the saga about the wooden horse of Troy and were not going to be surprised. She finally met her end when she was thrown from her horse after it was startled by a cowhide flapping in the wind. Seemingly her troops had taken a cow belonging to an old woman as payment for rent due. The animal was slaughtered before the old woman could plead her case. Honoria dismissed her out of hand and sent her away with the hide. Some days later Honoria rode by the old lady's house and her horse bolted when the hide crackled in the wind.

Sometime about 1800 Christopher French St George demolished the old castle. He used the stone to construct the present house and moved in with his mistress, leaving Tyrone House to his son. Some English visitors were scandalised by this, in best tabloid newspaper fashion of course. What seemed to cause the

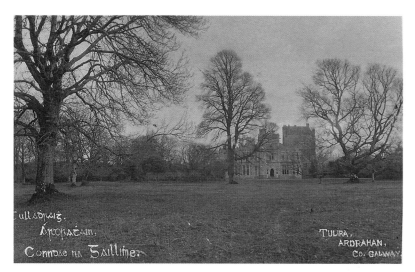

Tullira Castle
c.1910

greatest upset was that Christopher turned 'papist'. Tyrone House is now a ruin, having been burnt in 1922.

Tullira

The MacHubert Burkes, a branch of the de Burgos, built a tower house at Tullira in the fifteenth century. In 1564 Ulick, the third Earl of Clanricarde married Honoria Burke – the Norah na Kistla of legendary fame – and the Clanricardes acquired the property as her marriage portion or dowry. The property then came into the possession of the Martyn family in 1598, the property transfer again occurring as a result of intermarriage. The Martyns managed to hold onto the property through the Cromwellian and Williamite confiscations and the Penal Laws. Tullira only passed out of the Martyn family on the death of Edward in 1923.

In 1641, during the Cromwellian War, Oliver Martyn rescued a party of Protestants from being massacred at Shrule. As a result of this he was allowed to keep his estate during the confiscations that followed the defeat of the Irish. Again after the defeat of James II by his son-in-law William III the Martyns avoided the resultant confiscations. In 1709 the British Parliament exempted the Martyns from the Penal Laws, which meant that they could stay Catholic, practice their religion and own and inherit property. The exemption specifically stated that it was granted in recognition of the actions of Oliver at Shrule and also because of the loyalty of the Martyns to the English cause in Ireland.

During the early years of the eighteenth century a new mansion that incorporated the original tower house in its design was built. The mansion was badly damaged in a fire and a new house, designed by George Ashlin, was constructed on the site. Again the tower house was included in the design, as were those portions of the house that had survived the fire. The works were financed by Anne Josephine Smyth of Masonbrook who had married John Martyn in 1857. Anne Josephine's father, John Smyth, had made a large fortune by speculating in land after the Famine. He had given his daughter a dowry of £20,000 on her marriage. When John Martyn died in 1860, his son Edward, then aged fourteen months, inherited Tullira. As Edward grew up he displayed a remarkable dislike for the mock-Tudor residence financed by his mother and preferred to live in the old tower house. Edward was a prolific writer and keenly interested in theatre. Along with Thomas MacDonagh and Joseph Mary Plunkett he founded the Irish Theatre in 1914. He was president of Sinn Féin in the years 1905 to 1908 and a strong supporter of the Celtic Revival movement. He was instrumental in having the cathedral at Loughrea decorated by many of the outstanding Irish artists of the day. Neither Edward nor his brother John, who died in 1883, married and when Edward died in 1923 Tullira was inherited by a cousin, May, who had married the third Lord Hemphill and so history repeated itself and Tullira passed through marriage to the Hemphill family.

Gort

Nineteenth century directories describe Gort as being remarkably clean with wide streets and well-built

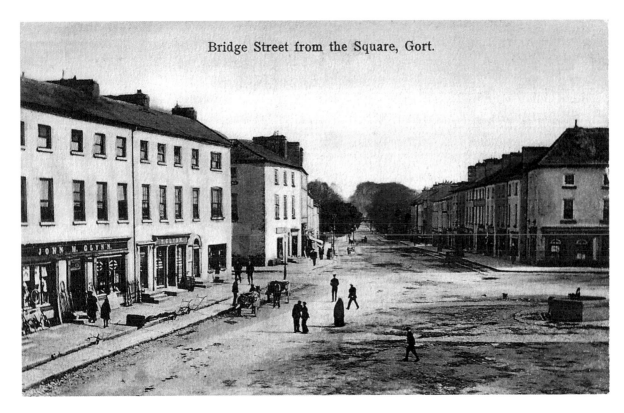

Bridge Street from the Square, Gort.

Bridge Street, Gort c.1900

houses. The description of the town given in the *Galway Vindicator* on September 18th 1850 advertising the sale of the Gort estate through the Encumbered Estates Court makes it clear that the town was, basically, a creation of the early to mid-nineteenth century. The buildings were described as being of 'recent erection, and permanently built of limestone, and the houses slated, most of them being three or four stories in height'. The public buildings in the town were: a military barracks for a cavalry detachment; a constabulary barracks, which was on the site of the Convent of Mercy; a court house, erected in 1815; a bridewell, built in 1814 and replaced by a new prison located near the present railway bridge. The town also had an elegant cruciform-shaped Church of Ireland church with a spire designed by the Pain brothers of Limerick, and a Catholic chapel, which was also designed by the Pains and cost £1,300 to construct. The

Catholic church has been altered and enlarged almost beyond recognition. Both churches were on sites donated by the first Lord Gort. There were substantial flour mills in the town, as well as a tuck mill, tan yard and brewery. Along with the weekly market there were four annual fairs held in the Square.

Bridge Street, which takes its name from the bridge dating from 1771 that spans the river, acquired a second bridge when the town was connected to the railway system through the Athenry and Ennis Junction railway in 1869. The railway company got into financial difficulties several times during the construction of the line. Construction work started in 1863 but came to a halt due to a lack of funds. Work recommenced in the spring of 1865 but stopped a second time because the contractor went bankrupt. The railway company eventually finished the line themselves. On November 6th 1870 the County

Sherriff for County Clare seized a train on foot of a judgment in favour of the London City Bank for the sum of £3,000. He agreed to let the company run the train under the custody of bailiffs who travelled on the engine. On November 10th the Galway County Sherriff seized the train in Gort station. A battle broke out between the bailiffs on the platform. The carriages belonged to the Midland Great Western Railway Company so they were released but the engines were sold in mid-December. They were bought by the Athenry and Tuam railway for a knock-down price. The new owners owed money to the Ennis and Athenry railway for supplies of coal and gave them the engines as payment of that debt. Within two years the Ennis and Athenry Company handed over the

running of the line to the Waterford and Limerick railway who eventually acquired it outright. The railway bridge can just be seen behind the trees in the view of Bridge Street from the Square whilst the second view of the street is taken from the bridge itself.

This latter view features two helmeted RIC men as part of the group with their backs to the camera. They are at the entrance to the 'new' bridewell. During the six-month period ending December 31st 1848 some 340 prisoners were confined in Gort Bridewell. There average stay was four days and they consumed 1431 pounds weight of bread, 1316 quarts of milk and 10 hundred-weight of Indian meal. One should not judge the lawlessness or otherwise of the Gort area by this figure which, in reality, is a reflection of the level of destitution and desperation amongst the population due to the Famine. A minor crime or misdemeanor was sufficient to have people committed to the bridewell for a few days where they would get something to eat. This was recognised in W. H. Gregory's report to the Grand Jury at the Spring Assizes of 1849 when he pointed out that the superior accommodation and diet of the county prison in comparison to the poorhouse 'whereby poverty was made to suffer more than crime' was a contributory factor in the increase in committals for petty crime. He suggested reducing the prison and bridewell diet to that prevailing in the workhouse and that 'hard labour and solitary confinement be employed as much as possible to diminish the present inducement to commit offences'. He also recommended the use of corporal punishment for juvenile offenders. The number of vagrants admitted to the county prison rose from 3 in 1844 to 482 in 1848 and the inmate death rate rose from 1 in 1844 to 485 in 1848. By 1872 the number committed to Gort Bridewell over the last six months of the year was 17 male and 2 female prisoners. The average stay was five days. No record of their diet seems to have survived. Six of the male prisoners were committed for drunkenness.

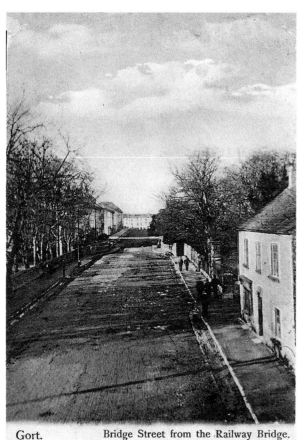

Bridge Street, Gort c.1895

Gort. Bridge Street from the Railway Bridge.

Convent of Mercy,
Gort c.1905

Convent of Mercy, Gort, Co. Galway.

Gort fared well in the Extraordinary County Presentment Sessions held by the Grand Jury in May 1846 under 9th Victoria Chapter 2, which authorised Grand Juries to institute famine relief works. William O'Neill was contracted to cut down the hill and fill the adjoining hollow in Georges Street at £70. He was also contracted to lay thirty-six perches of sewer with a paved channel from the post office to the river for £20 in addition to two sections of public footpath. One path, eighty perches long with a paved channel alongside it on the Gort Corofin road 'between the bank house ... and the turn to Newtown' was costed at £30. The second path, ninety-three perches long and costing £34 17s. 6d. was on the Gort to Tubber road between Mr Glynn's house in the Square and the turn to Canahown. O'Neill also had the contract to construct thirteen perches of a gullet or sewer on the Limerick road at the Blackwater at £6 10s. A Patrick Hynes was contracted to make seventy perches of footpath between Thomas Plunket's house and Pat Fahy's for £24 10s. Hynes was also contracted to make a paved channel between Thomas Daly's house in Crow Lane (later Crowe Street) and James Guinnin's house for £6 6s. He also had the contract to build a sewer or gullet between David Lowrie's house and Mr Rosengrave's avenue in the town of Gort at £25.

By and large the various road contractors involved seem to have maintained the streets of the town in reasonable condition. There were of course exceptions, such as John Smyth. In his report to the quarterly meeting of the County Council dated May 2nd 1908 P. J. Prendergast, the County Surveyor for the Western Division, recommended that Smyth's contract be nulled or cancelled. He had served a ten days notice on Smyth to either carry out the work contracted for and, subsequently, prosecuted him for failing to comply with his contract. This was Smyth's second time to be prosecuted and fined for breach of his contract. It would appear that Smyth had tendered for the contract at an uneconomic price. Despite being ordered by the Court to pay £20 penalty and costs on each occasion the penalties and costs were never recovered by the Council.

Lough Cutra Castle c.1900

Convent of Mercy

In 1857 the Sisters of Mercy were given Lawn House, located on Church Street, so that they could establish a convent. However, it was decided that the building would be too small to house a convent and the school the nuns hoped to establish. A large amount of money had been collected at church collections in the diocese of Kilmacduagh to help the sisters establish themselves. Bridge House, a former residence of Lord Gort, was acquired. The house had a chequered history prior to the nuns' arrival. The house takes its name from the nearby bridge, which bears the date 1771. John Prendergast Smyth, who resided there, received the title Baron Kiltarton in 1810 and was raised to the peerage in 1816, taking the title Lord Gort. Shortly thereafter, work was completed on his new mansion at Lough Cutra. In 1839 the house was in use as a police barracks. Shortly after that a Dr Mulville took up residence there but vacated the house in 1844. During the Famine it was used as an auxiliary workhouse and was,

again, vacant in 1852. It had been acquired the previous year by James Lahiff. Finally in 1857 the house became the Gort Convent of Mercy under a lease from James Lahiff. The sisters bought the property outright in 1877. The first convent school was opened in May 1859. Dressmaking classes were introduced in 1864 and by 1890 the nuns had developed classes in hand and machine knitting, weaving, lace making and the domestic production of shirts and children's clothing. In 1897 courses in shorthand and typing were introduced. A secondary school was established in 1942 but the convent suffered a severe setback when a disastrous fire on January 28th 1944 severely damaged the schools. Temporary accommodation was provided locally to allow classes to continue. By 1946 the schools were back in operation in their former site. In 1968 the secondary school was enlarged with the construction of a new building. In 1995 the three second level schools in Gort amalgamated to form a new community school, which was located in a new centre.

Lough Cutra Castle

The Castle was designed by John Nash, the famous English architect in 1811 and has a strong resemblance to East Cowes Castle in the Isle of Wight. His client, John Prendergast Smyth, was a descendant of Thomas Prendergast, a Jacobite who turned informer and betrayed his colleagues who were plotting to kill William III. He is supposed to have informed the authorities of the plot merely to prevent the assassination and on the understanding that his fellow conspirators would not be arrested. Arrested they were and executed very promptly thereafter. William rewarded him with a grant of the confiscated O'Shaughnessy lands at Gort. Thomas was a military man and was killed in action at the battle of Malplacket in 1709. Thomas's heir, also Thomas, was embroiled in a protracted lawsuit with the O'Shaughnessys over his occupation of the confiscated lands. The case was finally settled in 1770 after exorbitant costs had been incurred by both sides. Thomas Jnr had died in 1760 and was succeeded by his sister's son, John Smyth. Even though Smyth adopted the name Prendergast he was known as Prendergast Smyth. He built Bridge House in Gort and spearheaded the development of the town by giving encouragement to industries, such as tanning and brewing. The then existing mill was considerably enlarged also. Plots were leased on favourable terms to promote the construction of substantial town houses. The impact of this latter measure on the Gort streetscapes can still be seen today. Prendergast Smyth died without male heirs; but having adopted his sister's son, Charles Vereker, the estate passed to him. Despite having inherited the accumulated debts of the O'Shaughnessy litigation and the construction of Bridge House, Vereker pressed ahead with the construction of his uncle's mansion which is reputed to have cost £80,000 to build. His son John inherited the estate and its massive debts on the eve of the Famine. John contributed £3,000 to the Gort workhouse and created much-needed employment

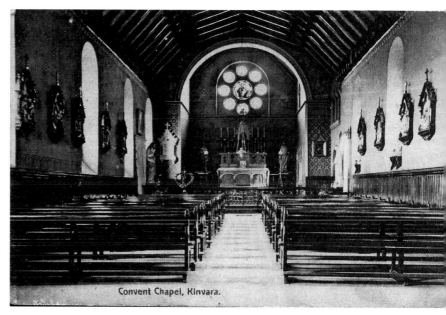

Convent Chapel, Kinvara.

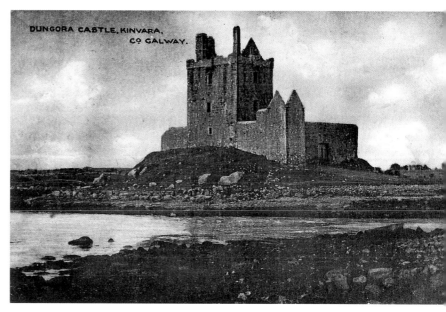

Convent Chapel,
Kinvara c.1905

Dun Guaire Castle,
Kinvara c.1910

on the estate through famine relief schemes. He was bankrupted and had to sell the property in the Encumbered Estates Court in 1852. The Loreto Sisters from Rathfarnham, Dublin were the purchasers. Their intention was to set up a boarding school for girls. Within two years the nuns had sold the Castle and grounds to Lord Gough for £24,000. Gough renovated and enlarged the Castle. The Goughs retained ownership of the Castle until the 1950s when it passed to Michael Russell, a film producer who sold it on to the descendants of John Vereker. An ambitious restoration plan was put into action but the costs proved too much and Lough Cutra Castle changed hands again.

Kinvara Convent of Mercy

In 1874 Captain Francis Blake Forster of Castle Forster, Doorus Demesne, and Forster Street, Galway donated three acres of land as a site for a convent and chapel at Kinvara. William Murray of Northampton House bequeathed £4,000 towards the building costs. Maurice Hennessy, Architect, of Limerick, designed the convent and chapel which was constructed by William Kilroy of Gort between April 1876 and April 1878. The complex was dedicated by Dr John McEvilly, Bishop of Galway on April 20th 1878 and the noted Dominican preacher Father Thomas Burke gave an hour long sermon. The paddle steamer *Cittie of the Tribes* was chartered by a Mr Guilfoyle and brought three hundred passengers from Galway. The Saint Patrick's Temperance Society Brass Band and an impromptu string ensemble provided the musical entertainment on the trip. They also played on Kinvara quay as the passengers disembarked. They then led a parade into the town where they were joined by the Gort Total Abstinence Society Band with a large crowd in attendance and all marched to the ceremony.

The church was remodelled in 1920 and extended by twenty feet. In 1938 Saint Joseph's was transferred to the parish of Kinvara. When the Sisters of Mercy acquired Seamount House in 1962 they vacated their original convent which then became the parochial house. The church was extensively refurbished in 1973. A new altar was installed and the tabernacle was installed in a white marble column taken from the old Saint Patrick's church in Forster Street, Galway. New Stations of the Cross, carved by Albert O'Toole, were also installed whilst the Oppenheimer mosaic in the sanctuary was retained. A new roof and ceiling, as well as a porch were also installed and a new presbytery was constructed in 1997.

Dun Guaire Castle

The Castle was named from the much earlier fort or dun that originally stood on the site. It is believed by some that the Castle was built by Rory More O'Shaughnessy about 1520, however there is also the view that it was constructed at a much later date. Murtagh O'Heyne is also credited with its erection in 1585. His son Aedh surrendered it to the crown in 1594 to have it regranted to him as part of the English policy of Surrender and Regrant by which Irish chieftains came to hold their lands by gift of the English crown. It came into the possession of the Martyns in the seventeenth century and Richard Martyn, a 'rank papist' and counselor-at-law was living here in 1642. In that year he was elected mayor of Galway. Oliver Martyn of Tullira owned the property in 1741. Colonel Daly of Raford was resident in the Castle in 1787 and in 1826 it was in use as a barracks. This, no doubt, was placed there to help stamp out smuggling which was rife in the area. By the end of the century the Castle was roofless. Edward Martyn sold it to Oliver St John Gogarty. Lady Cristobel Ampthill acquired the property in the 1960s, restored it, and when she died she was cremated and her ashes were scattered over the Castle. The Shannon Free Airport Development Company bought it in 1972 and opened it as a tourist

Doorus House, Kinvara, Galway

increased tenant's rents. James was in the French Diplomatic Service and rarely visited the area but his son Florimund spent most of his time in Ireland and built Doorus House as a summer home. He was interested in literature and entertained writers regularly. Edward Martyn met Guy de Maupassant, Maurice Barres and Paul Bourget amongst others there. In 1897 Martyn met Lady Gregory and W. B. Yeats at the house and discussed the possibility of having the plays *Maeve* and Yeats' *Countess Cathleen* staged in Dublin with the prospect of establishing a national theatre where Irish playwrights could have their plays performed. This discussion led to the formation of the Abbey Theatre. Lady Gregory described the garden of Doorus House in 1913 thus:

> The Garden was full of flowers, lavender and carnations grew best and there were roses also and apple trees and many plums ripened on the walls. This seemed strange as outside the sheltered garden there were only stone strewn fields and rocks ... and fierce storms from the Atlantic.

attraction, holding medieval-style banquets there. The Gort river, which flows underground for a considerable portion of its lower course, surfaces near the Castle and this area was used in the past to wash sheep some days before shearing. This area was to be the terminus of a proposed Gort–Kinvara canal which never materialised. This proposed canal seems to have grown out of a much earlier and far more ambitious scheme: a proposed inland navigation from the Shannon estuary at Clarecastle to Galway Bay utilising the Fergus River. This, like many other abortive inland navigation proposals, arose out of the 1715 act, and subsequent amending legislation, concerning inland navigation.

Doorus House, Kinvara c.1950

Composite View, Athenry c.1895

Doorus

The de Basterot family inherited land in the Doorus area of Kinvara after much litigation. The litigation began in 1791 and continued for several years. The legal costs were such that they had to sell off a large portion of the estate but the remainder ran to a considerable acreage. James, who had succeeded his father, Bartholomew, died in 1849 and was succeeded by another Bartholomew, who sold off a considerable portion of the land to Comerford of Galway, who immediately

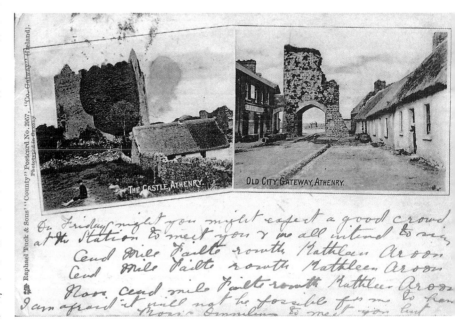

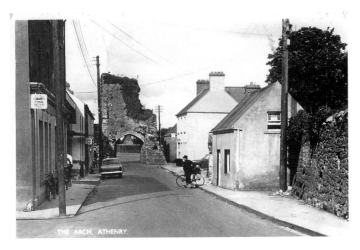

Northgate Street, Athenry c.1955

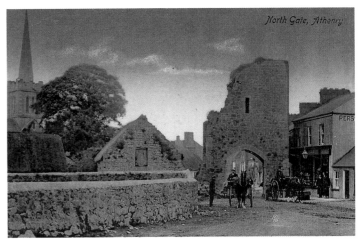

North Gate, Athenry c.1900

Obviously Florimund thought the house more a home than a holiday retreat and knew the benefits of high walls for shelter.

Athenry

Athenry owes its origins to the construction by the Meyler de Bermingham of a castle at the ford on the Clareen River. Bermingham's Court was built on an earlier dun or fort built by the Irish to control the ford. The river was altered in the 1850–1855 period as a result of drainage works and all traces of the ford were removed. A settlement began to develop around the outside of Athenry Castle, which was in need of some form of protection from attack by the disposed or discommoded Irish or indeed whatever warlord was on the rampage in the vicinity. By the second decade of the fourteenth century the town walls were constructed, enclosing an area of about twenty-five Irish acres – almost twice the size of the walled town of Galway. The extent of the town walls indicate that it was intended to create a settlement of some considerable size. Tradition has it that after the battle of August 13th 1316 the bodies of the defeated Irish were plundered and the proceeds were used to pay the costs of fortifying the town. The

walls were repaired or remodelled in areas and so portions of the surviving sections display evidence of fifteenth- and sixteenth-century workmanship. The greatest difficulty Athenry faced in defending itself against attack was the extent of its walls. In the latter part of the sixteenth century the enclosed area was effectively cut in half by the construction of an internal dividing wall. However, this was too late to assist the townspeople to defend their walls against the Clanricardes who attacked the town in 1574 and burnt it. They attacked again in 1577, burning a new town gate and driving away the masons who were working on the wall. Prior to these attacks the Clanricardes had been charging the unfortunate inhabitants of Athenry protection money. Sir Henry Sidney recorded that in 1567 the inhabitants were so destitute as a result of the Clanricarde extortions that they could no longer keep the town and so they presented him with the keys of the town. Neither Sidney nor his political masters did anything to curb the warlords.

The town had six gates: Britten Gate; Castle Gate; Spittle Gate; Nicolroe or North Gate; Swan Gate; and Temple or Chapel Gate. Only Nicolroe Gate survives. It is more commonly known as North Gate today. At the Spring Assizes of 1871 the County Galway Grand Jury

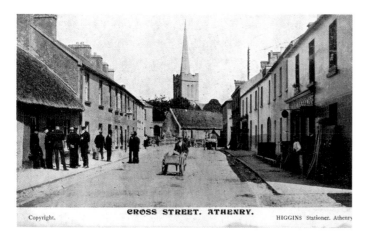

CROSS STREET. ATHENRY.

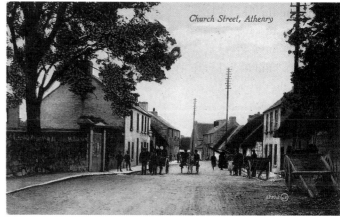

Church Street, Athenry

voted the sum of £18 16s. to Martin Broderick to repair this arch. The County Surveyor, J. F. Kempster had recommended that urgent repairs be carried out as the arch was 'so dilapidated as to be a danger to the public'. He considered that the only way to stabilise the structure was to rebuild the arches on each side of the tower 'as much in accordance with its ancient character as circumstances will permit'. This may well explain the heavily mortared joints at either side of the tower and also why the arch stones look much fresher than the remainder of the structure in early photographs. One of the side arches was removed subsequently as can be seen in the composite view postcard. A little over a hundred years later Galway County Council carried out repair and restoration works to the top of the gate tower. The street leading to the gate is now, appropriately, known as Northgate Street. The channel leading to the gate, shown in the composite card, would appear to have originated in 1843 when Michael Hennelly was paid £17 4s. to pave a channel from the Rev. Daniel Cullinane's house to the North Gate. A small portion of Britten Gate survives near the Castle and in 2008 the foundations of Swan Gate were discovered during roadworks to construct a roundabout. The town walls are a national monument therefore these foundations, being part of the walls, automatically became a national monument also. As a

Cross Street, Athenry c.1910

Church Street, Athenry c.1905

result they had to be left *in situ*. Swan Gate is supposed to have drawn its name from an inn, known as The Swan that was formerly located in the area. The gate was also known as Laragh Gate. Spittle Gate would appear to have been named for the lepers' hospital that was located in the southern part of the town and whose outline is still traceable. The hospital was located in an isolated area to prevent the spread of the disease. Unfortunately there were no isolation facilities for the local inhabitants when the town was afflicted with an outbreak of smallpox in 1874.

Streets

The street system in the town is linked to the positions of the four principal and two minor gateways in the town walls. The market square was the centre of commerce during the medieval period. It had its own very distinctive market cross. The base of the cross is modern but the body or core dates from the fifteenth century and is of a type found in the south of England. Described as a tabernacle cross, it is the only one of this type known from Ireland. Sir William Parsons obtained the right to hold a regular market within the town walls in 1629. Parsons also got the right to hold a fair outside the walls each October. Prospect, a townland outside the walls, contains a field that is still known as Parson's Fair

Green. The field has a large stone with a rectangular socket cut into it to cater for a market cross where bargains would be sealed. Overlooking the market square was Saint Mary's Parish Church. This dates from the end of the thirteenth century and became a collegiate church when John de Burgo founded a college for a warden and eight priests. Pope Innocent VIII issued instructions that it revert to being a parish church after de Burgo had been excommunicated for burning Abbeyknockmoy Abbey in 1483. However, these instructions were ignored and the church remained collegiate until 1576 when it was suppressed. Both the college and church were burnt by the Clanricardes in 1577. Part of the ruins were built up and adapted as a Church of Ireland church in 1828 and continued in use until the 1930s when a dwindling congregation could no longer maintain the building. The building has been restored and converted into a heritage centre. The spire dominates the skyline in the card showing Cross Street, so named because it led directly to the market cross which is located at the gable of the thatched house that can be seen in the distance. The street is fairly quiet. What is remarkable about the scene is the number of RIC men in front of the thatched house in the left foreground. Athenry was not so lawless that it needed such a large police presence. It raises the question as to the extra duties these people performed outside of normal police work. Church Street on the other hand is devoid of any police presence and aside from the carts only has some curious onlookers facing the photographer. It was called Chapel Lane in the 1840s as a result of the construction of a new Catholic chapel. This had replaced the old chapel which was located near the Swan Gate. It in turn has been replaced by the present parish church.

The Ivy Hotel,
Athenry c.1900

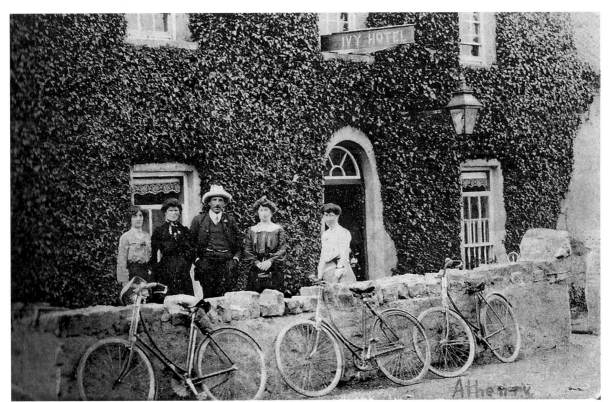

The Ivy Hotel

By the 1890s the bicycle had become so popular in Ireland that a major cycling exhibition was held in Ballsbridge in 1897. The enormous growth in popularity of cycling led to demands for improvements in the public road system. Indeed in February 1897 a paper was read to the Institution of Civil Engineers of Ireland on the subject of 'The Bicycle and Common Roads'. It set out the improvements necessary to cater to this new, popular

Dominican Friary, Athenry c.1900

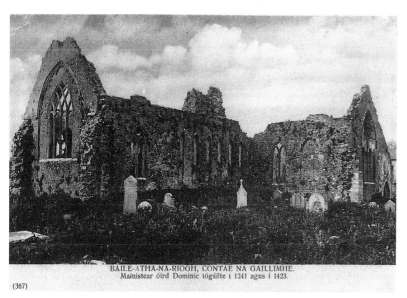

BAILE-ÁTHA-NA-RIOGH, CONTAE NA GAILLIMHE.
Mainistear óird Dominic tógáilte i 1241 agus i 1423.

(367)

and widespread mode of travelling. The author, Edward Glover, suggested clean, dust-free, steamrolled surfaces free from loose stones. He also suggested dedicated cycle lanes along the road sides. The best surface for these he thought was a concrete one. Concrete is long out of favour now as a road surface and cycle lanes have only begun, in the past few years, to appear in urban areas. However, the growing popularity of the bicycle did lead to improvements in the road network. It also created major growth in business for family-run hotels. Cyclists' hotels appeared in many towns and villages. These catered to overnight stays by people on cycling holidays and also provided lunches and high teas. The Ivy Hotel

certainly catered for such people. The three strategically placed, and rather new looking bicycles on the hotel postcard would inform any potential cycling tourist that they would be welcome here. Subliminal messaging was quite common on early postcards. The card was, in all probability, produced for the hotel by one of the many itinerant photographers that travelled the country seeking commissions. The group on the left may well have been the proprietor's family, whilst the lady on the right may well have been the manageress. The Ivy was built about the year 1855 and was, initially, occupied by a Doctor Leonard. Later it was acquired by John and Ellen Fallon. John Fallon was a cattle and sheep dealer and also ran a butcher shop in Athenry. His son, the poet Padraig Fallon, was born in 1905. The Ivy later became the home of J. M. G. Sweeney, a solicitor who was for many years Professor of Law at University College Galway.

Dominican Friary

The friars claimed exemption from certain obligations due to the Archbishop of Tuam so when the Archdeacon, whilst acting on behalf of the Archbishop, summoned them to a visitation they protested and abused him. The Archdeacon retaliated by excommu-

Our Lady's Well, Athenry c.1930

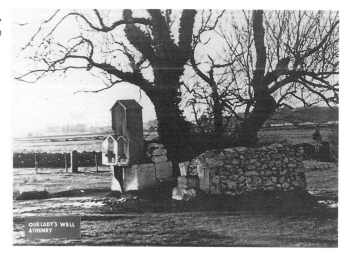

OUR LADY'S WELL
ATHENRY

nicating them. The Archbishop was not satisfied with this and went one step further. He issued a proclamation forbidding people to enter the Friary or to give either food or alms to the friars. The friars appealed this to the Lord Chancellor on February 11th 1298. He ordered the Archbishop to lift the prohibitions contained in the proclamation with immediate effect. The Archbishop was also instructed not to impose similar sanctions in future. He replied that he had always acted for the good of the friars and that if he had done them any wrong he would rectify the matter immediately and laid off the blame for everything on his subordinate the Archdeacon. However, the friars pointed out that it was the Archbishop who had issued the proclamation against them. Faced with the facts, the Archbishop said he would instruct the Archdeacon to have the proclamation withdrawn immediately. He volunteered to be available to the Sherriff of Connaught who could arrest and detain him until the proclamation was withdrawn. The friars next proceeded to lodge a claim for damages in the Court of the King's Bench against the Archdeacon, who claimed in his defence that his actions were justified. The damages sought amounted to £1,000. To put this into context, a mercenary galloglass was paid 1d. a day. When the trial came to a hearing the Archdeacon failed to appear. The Court ordered the Sherriff to arrest him and seize all his goods, chattels, and property. Unfortunately the record of subsequent proceedings does not appear to have survived.

Our Lady's Well

Our Lady's Well is comparatively new as Irish holy wells go. It would seem to date back to the first battle of Athenry in 1318. A wounded soldier made his way to the well where the Virgin Mary appeared and comforted him. The battle between the Irish and Anglo-Normans was fought on August 15th, the feast of the Assumption. The Irish forces were defeated. According to tradition, the

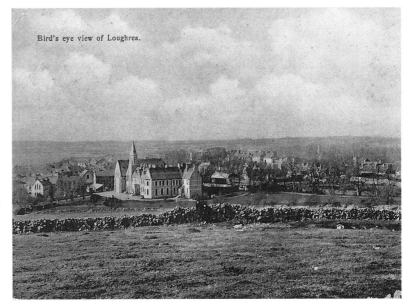

Bird's Eye View, Loughrea c.1895

Irish forces were asked to postpone hostilities until the following day but refused. They took losing the fight as a sign of heavenly disfavour and started the pilgrimage as a sign of their penitence for their profaning the feast day. By the early 1400s the well was 'much resorted to' by pilgrims. The *Edinburgh Magazine* for 1843 carried a somewhat jaundiced account of proceedings at the well:

Hard by the town is a holy well sacred to the Virgin Mary, the water of which, according to the most true legends, no fire can warm and which is consequently endowed with powers and virtues of an extraordinary kind. On the 15th of August, being the day of the Assumption, pilgrims resort to this Bethesda from various parts of the country to perform penances and other religious exercises around it, and to fasten votive rags upon a bush that overhangs it.

The rather cynical account finishes with the sarcastic observation that, despite claims that the water could not be heated, it was boiled to make 'screechingly hot' punch. Despite this cynical view of the pilgrimage, the site continued to grow in popularity. The Great Southern Railway timetables for Sunday, August 16th

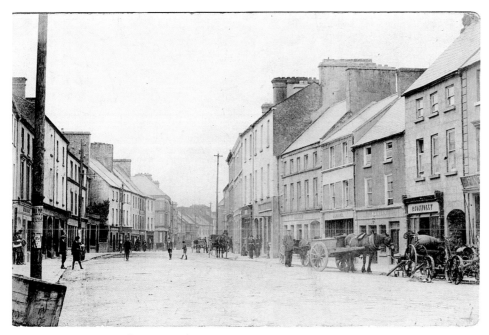

Main Street, Loughrea c.1910

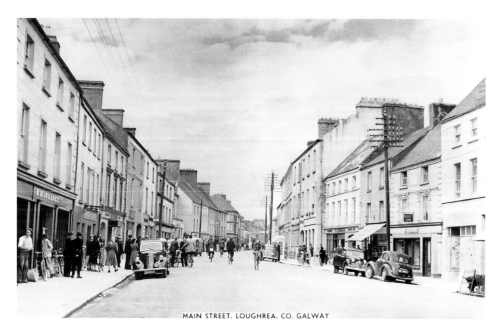

MAIN STREET. LOUGHREA. CO. GALWAY

Main Street, Loughrea c.1950

1926 give some idea of the popularity of the pilgrimage that year. Special trains were run from Clifden, Athlone, Ennis, Loughrea, and Killala. The Killala train picked up passengers from Westport, Manulla and Ballinrobe. It took on the passengers from the Knockcroghery and Sligo specials at Claremorris. The year of the Eucharistic Congress, 1932, saw an enormous increase in pilgrims. A new cross and statue of the Virgin Mary were blessed by Rev. M. Conroy PP on the Sunday of the pilgrimage. The local parishioners had subscribed over a hundred pounds towards the costs. The pilgrimage had been modified somewhat since the 1843 description of the event. The *Connacht Tribune* described it thus:

> The pilgrimage consists of walking around the well until 15 decades of the rosary have been recited, and most of the people do it in their bare feet and some were seen to do it on their knees.

Loughrea

Loughrea, like Athenry, owes its creation to the Anglo-Normans. The de Burgos built a castle here in 1236. As the settlement grew in size and importance, defensive walls were constructed to protect the inhabitants. Because Loughrea was located on the lake shore the defences were strengthened by the addition of a moat which still survives. It was fed by water from the lake and a stream which was also used to power a

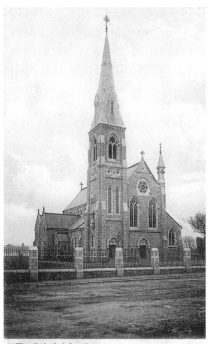

The Cathedral, Loughrea.

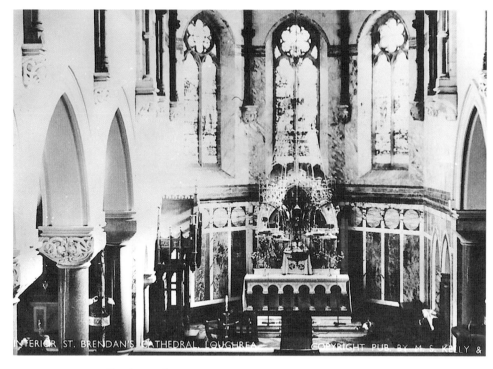

INTERIOR ST. BRENDAN'S CATHEDRAL, LOUGHREA. COPYRIGHT PUB. BY M. S. KELLY &

Left: Saint Brendan's Cathedral c.1910

Above: Interior Saint Brendan's Cathedral c.1950

mill. The fortunes of the settlement waxed and waned over the centuries but by the 1760s it was a major centre for the linen industry. The town had its own linen or scutching mill and a bleach green. Most of the linen produced in Connemara was sent to Loughrea for sale. During the early part of the nineteenth century tanning, brewing, and flour milling were important in the town's economy. It was also the venue for large cattle fairs which were held on Main Street. This led to a major problem for William Kelly, the unfortunate road maintenance contractor in 1891. The contract was 'for keeping in repair and free from nuisance' the streets of the town for a seven-year period. Kelly was prosecuted by the Loughrea Board of Guardians for failing to clean the cattle droppings of the street after the fairs, which were held every Thursday. Kelly lost the case and appealed it but at this hearing he gave an undertaking to clean the streets after the weekly fair. John Smith, the County Surveyor in his report to the Grand Jury at the Spring Assizes 1892 stated that he believed that it was unfair to expect Kelly to clean up after the fairs. What steps the Grand Jury took to alleviate the problem is not recorded. Main Street was the principal thoroughfare of the town from earliest times. The building lines appear to be on the foundations of the early streetscape. The street underwent very little change, except in its occupants, over the past one hundred years. Traffic was slight even into the 1950s when you could still cycle up the middle of the street. By then young lads couldn't play a game of rounders as they seem to be doing in the view from about 1900. The young man facing the camera has a hurley stick and appears to be waiting for his playmate to throw.

The street underwent major refurbishment works in 2009 once the Dublin–Galway motorway was opened and through-traffic was reduced to a minimum.

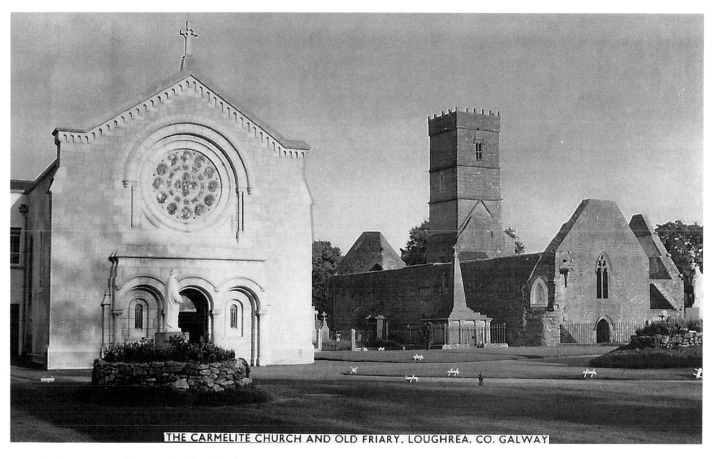

THE CARMELITE CHURCH AND OLD FRIARY. LOUGHREA. CO. GALWAY

Saint Brendan's Cathedral

The cathedral was constructed between the years 1897 and 1902. Edward Martyn of Tullira contributed handsomely to the decoration and embellishment of the building. Martyn, who knew many of the principal Irish artists of the time, persuaded the Bishop to employ them and influenced the choice of decorative style employed. The result is a masterpiece of Celtic Revival artwork. The cathedral is a treasure house of work by Sarah Purser, A. E. Child, Evie Hone, John Hughes and Michael Shorthall, amongst others. The cathedral was designed by William H. Byrne of Dublin. Much of the interior design work was carried out by Michael Scott.

Carmelite Church and Old Friary c.1950

Loughrea Friary

The Friary was founded by Richard de Burgo for the Carmelite friars in about the year 1300. In 1305 Richard made a grant of lands and rental income to support twenty-four friars. By the 1430s the Friary needed major repair work and in 1437 indulgences were granted by Pope Eugene to anyone who contributed to the costs involved in carrying out the works. When the monasteries were confiscated and sold Loughrea was left undisturbed, possibly because of the power and prestige of its Clanricarde patrons. In 1570 the Friary was granted to the Earl of Clanricarde, who leased it to Rev. Darby McCrahe or McGrath. When the Earl died in 1582 he was buried in the Friary. The friars managed to continue in

residence until the arrival of the Cromwellians in 1652. In 1653 the Cromwellian Commission sat in Loughrea to decide on the future of those who were to be transplanted to Connaught. The friars were banished under the edict of 1643 that ordered the removal of all Catholic priests from the country. However, Carmelites were back in Loughrea by 1662. They managed to keep a presence in the area despite the Penal Laws and various edicts banishing clergy from the country. In 1671 the friars were renting a house near the old friary and began work on the construction of a new monastery; however, complaints to the authorities brought unwelcome attention and they were forced to cease building works. The body of General St Ruth was taken to Loughrea after the battle of Aughrim and buried in an unmarked grave at the Friary. The Friary was raided in 1731 but the friars had received prior warning and had vacated the premises. Despite the Penal Laws the friars maintained a public church in the town in 1785. By 1816 this building was in a poor structural condition and after part of the ceiling collapsed during mass it was decided to build a new church. On May 25th of that year the foundation stone for the new building was laid and the church was dedicated on July 26th 1820. In 1948 a major extension of the church was completed incorporating a new façade with a rose window by the Harry Clarke studio.

Convent of Mercy

The first Sisters of Mercy in Loughrea came from Tullamore in 1850 but because their numbers were reduced by both death and illness they returned to their mother convent. In October 1851 new sisters arrived, this

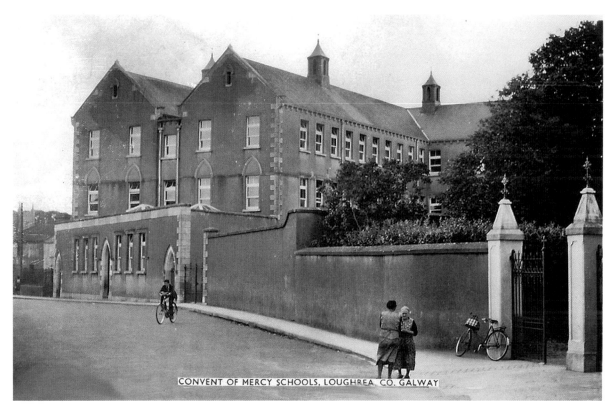

Convent of Mercy National School c.1948

CONVENT OF MERCY SCHOOLS, LOUGHREA, CO. GALWAY

time from the Baggot Street Convent, Dublin. They arrived at the invitation of Bishop Derry who had been left a legacy of £1,000 by a Mrs White to make a foundation of the Mercy Order in Loughrea. The sisters took over the national school that had been managed by the Carmelite Sisters who retired to their contemplative life. The Mercy nuns opened a new convent in 1879. The foundation stone for this building was laid with much pomp and ceremony on September 9th 1877 by Bishop Duggan. Following mass that Sunday morning Dr Dorian reportedly riveted the attention of the large congregation for two hours. Afterwards the Temperance Band led a procession to the site where the bishop laid the foundation stone. The old convent was demolished in 1929 and the site was used for the construction of a new national school, which opened in 1930. In 1917 the nuns opened a secondary school, Saint Raphael's, which catered for both day and boarding pupils. Work on the construction of a new secondary school began in 1953 and was completed in 1956. The new school came complete with its own concert hall.

Loughrea Technical School

The first report of the County of Galway Technical Instruction Committee indicates that technical education was being given in two centres: girls were being taught cooking, laundry, needlework and crochet design in the Convent of Mercy; boys were given instruction in drawing and draughtsmanship. An itinerant, or travelling, teacher Charles Emerson was appointed in 1902 and woodwork was added to the boys' course, which was held in a room in the old barracks. Such were the beginnings of Technical Loughrea. By 1930 the Vocational Education Scheme was underway and Loughrea had its own school, which occupied two rooms upstairs in the Temperance Hall. The subjects taught were woodworking, arts and crafts, cookery, domestic science, needlework, French, shorthand and typing, and

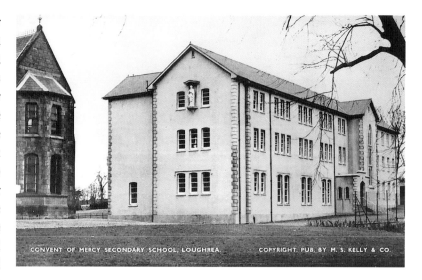

CONVENT OF MERCY SECONDARY SCHOOL, LOUGHREA. COPYRIGHT. PUB. BY M. S. KELLY & CO.

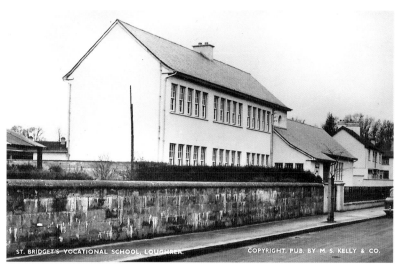

ST. BRIDGET'S VOCATIONAL SCHOOL, LOUGHREA. COPYRIGHT. PUB. BY M. S. KELLY & CO.

bookkeeping. The teachers were a Mr O'Connell for woodworking and arts and crafts, and Miss Bohan who taught the commercial subjects. By the 1940s the accommodation proved to be totally inadequate and a new school was built on Abbey Road, opening for students in 1950. This in turn was replaced by a much larger school premises at Mount Pleasant. Since 1983 the Abbey Road building has served as the Saint Brendan's Training Centre.

Above: Saint Raphael's Secondary School 1956

Below: Saint Bridget's Vocational School c.1950

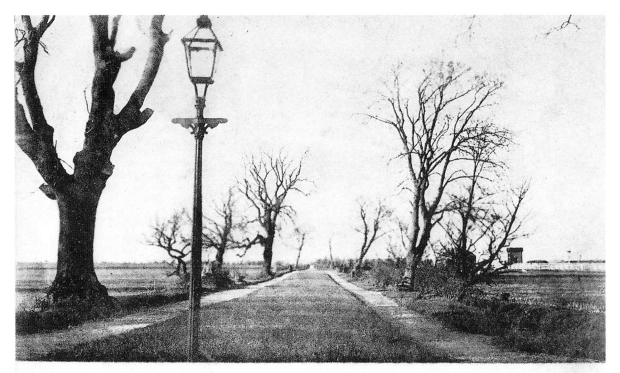

THE WALKS, LOUGHREA.

Wynne, Photographer, Loughrea.

The Walk

Writing in 1824, Hely Dutton mentioned that the Mall or Walk had only recently been laid out but was not being maintained. The Mall was already in existence for about fifty years at that time. It was the gift of the Clanricardes to the townspeople and had been in use as a promenade for the town. It is probable that some refurbishment works were carried out in 1824. The Walks were laid out on the outside of the town wall and moat. The card shows the view towards the railway station. Loughrea was the terminus for the Loughrea and Attymon railway that opened on December 1st 1890 and closed in 1975. The tracks were removed some ten years later. The Dublin–Galway Motorway Scheme impacted on a portion of the old track bed which had to be removed. The railway station water tower can be seen on the right-hand side of the trees. The iron tank on top of the tower was made by Ross and Walpole Iron Founders of Dublin. Under its original name, Ross and Murray, the company maintained a small branch foundry and distribution centre in Ballinasloe for many years. The Grand Canal was used to transport goods from the Dublin foundry to Ballinasloe for onward distribution. The development of the country's railway network led to the closure of the Ballinasloe branch as the new transport system provided a more efficient delivery system to virtually all parts of the country.

Loughrea Lake

The lake was selected as a proposed harbour as part of an ambitious plan to link Dublin and Galway Bays by a ship canal. The idea of linking the two ports had been around for quite some time before a company was formed in Liverpool for the purpose of cutting a ship

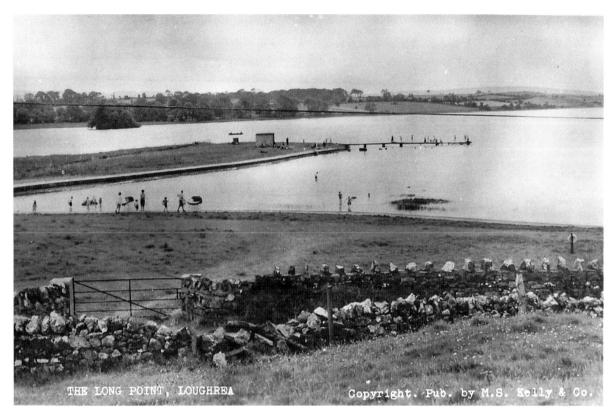

THE LONG POINT, LOUGHREA Copyright. Pub. by M.S. Kelly & Co.

canal across Ireland. The initial plan put forward called for two tidal basins, or harbours. One was to be located at Kingstown (Dún Laoghaire) Harbour and the second at Rinville or New Harbour on Galway Bay. The canal was to be 132 miles long, 20 feet deep, 80 feet wide at the bottom and 160 feet wide at the top water level. There were to be seventy-two locks each 40 feet wide and 180 feet long. Two hundred new bridges would have to be provided. The route as outlined was to be from Dún Laoghaire, crossing Merrion Strand and on by Haig's Distillery, with a link into the Grand Canal Harbour, Gallarstown, Celbridge, an aqueduct over the Liffey, and further aqueducts over the Backwater at Moyvalley and the Boyne near Castlejordan, then on to Tullamore, Ballycumber, and Ferbane to enter the Shannon at Shannonbridge. The navigation was then to run upstream to the river Suck and cross to Loughrea, Craughwell and into the sea at New Harbour. The estimated cost was £5.5 million, about €2 billion at 2012 prices. The proposal stalled primarily because of the cost and modified plans were put forward. These called for the conversion of Loughrea Lake into a steamer harbour and the construction of a double line of railway to Galway docks. This would have eliminated the necessity of flooding several valleys, the excavation of the line into Galway Bay and the construction of a tidal basin. However, the railway age had arrived and the ambitious plan was abandoned. It did have a legacy though. Proposals for a Dublin–Galway–Bertroughboy railway were brought forward in 1834, some seventeen years before the railway did reach Galway. This was the first proposal to serve Connemara with a railway. However,

before the Galway–Clifden railway opened for business another sixty-one years had elapsed.

The town's namesake, Lough Rea, serves as the source for the town's water supply, although *Slater's Directory* of Ireland for 1846 put forward the suggestion that the water was 'unfit for culinary purposes'. It was also used to supply water to the old workhouse, now Saint Brendan's County Home. This was built between the years 1840 and 1842. On February 26th of that year the first admissions took place. Water was pumped up into a large cistern in the yard by means of a hydraulic ram located near the lake shore. An incline into the ram was created to provide a head or fall of water to power the machine, which could pump continuously. Once a town water supply was established and a water main laid to serve the building the ram became redundant and was removed.

Men's Bathing Area, Loughrea c.1948

The lake is also used for recreational purposes. The local angling club keeps it well stocked with fish for the benefit of its members. Swimming has long been popular and there were two bathing places, one for men and the other for ladies and children. During the 1930s there was some controversy when mixed bathing took place from time to time. This was preached against on more than one occasion. By the 1950s attitudes had relaxed somewhat and during the next decade the practice was the norm. As swimming became ever more popular a problem arose with pollution. The heat wave in July and August 1982 led to an enormous increase in people using the Long Point. Fears were expressed that the water in this area was becoming polluted due to the lack of toilet facilities. This problem was eventually remedied.

THE BATHING PLACE, LOUGH REA, LOUGHREA, CO. GALWAY

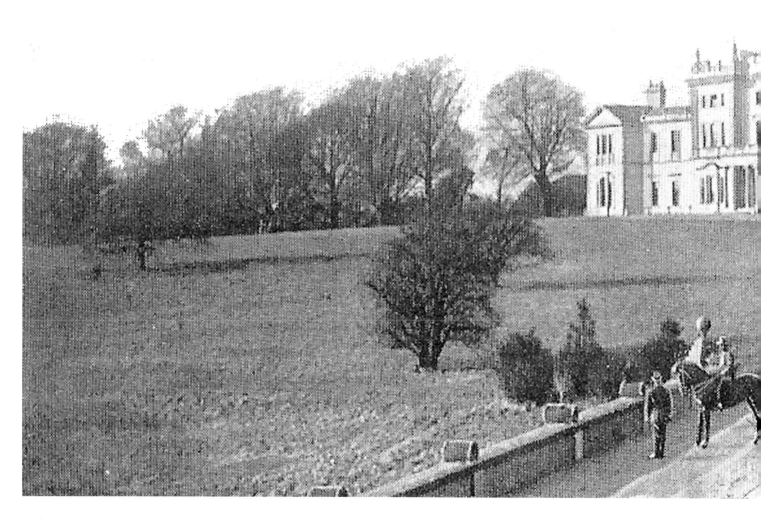

Chapter 2 **East**

Woodlawn, Kilconnel, Ahascragh, Ballinasloe, Killimor, Woodford, Portumna.

Woodlawn House c.1905

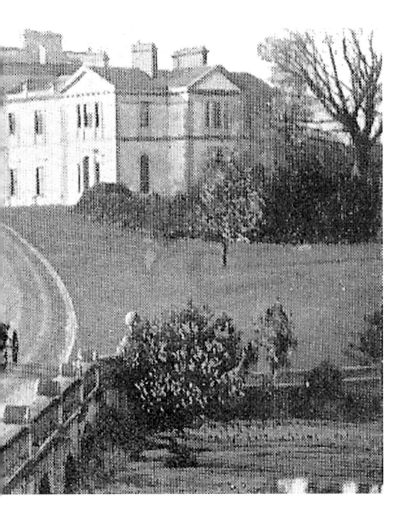

Woodlawn House

John Trench, Protestant Dean of Raphoe and brother of Frederick Trench of Garbally, acquired the lands of Woodlawn in 1703. By judicious marriage alliances and political opportunism the Trench family increased in social importance and influence. The original Woodlawn House was built in the early eighteenth century. The house and grounds were improved and an artificial lake was created about 1776. The lake was stocked with fish. The house, originally a three-storied Georgian one, was refaced, extended and remodelled with the addition of two-storied wings with projecting bays. The work was executed about 1860 to the design of Francis Kempster, county surveyor for the Eastern Division of Galway. The client was Frederick Mason Trench, the second Baron Ashtown. The artificial lake was not just ornamental, it also provided a barrier to safeguard the house, which is probably why a gate was erected on the bridge. The fourth Baron Ashtown sold the house in 1947 to Derek Le Poer Trench, who later resold it. It has been empty for a number of years and is slowly going into decay. The house is reputed to be haunted.

Kilconnel

Two possible dates, 1353 and 1414, have been put forward for the foundation of Kilconnel Friary. Irrespective of which date is correct, the Friary ruins are one of the best preserved Franciscan friaries in the west of Ireland. After the Reformation Franciscans

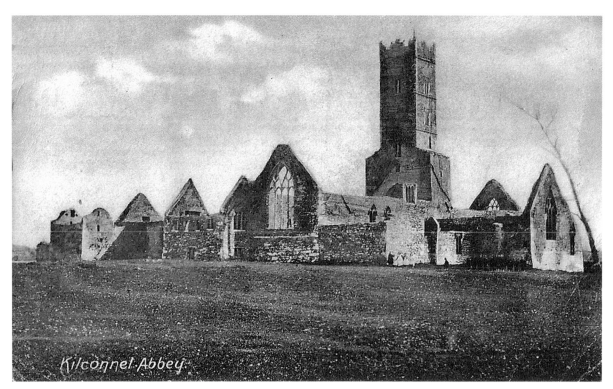

Kilconnel Abbey.

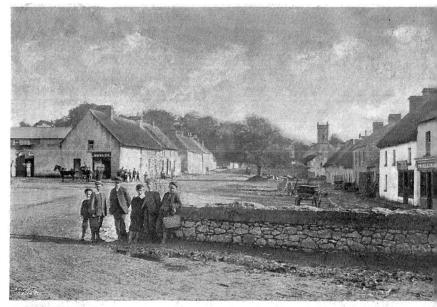

Ahascragh c.1900

AHASCRAGH.

continued to live in the Friary. In 1569 it was used as a barracks for English soldiers for a period. The friars returned when the troops vacated the buildings. A subsequent occupation of the Friary occurred and the garrison wrecked some of the tombs in a search for treasure. The friars returned again when the garrison moved on. They continued to reside either in the Friary or the locality, depending on troop movements, until the Battle of Aughrim when the Friary was vacated for the last time.

Ahascragh

Ahascragh is the anglicised version of Áth Eascrah, the ford of the esker. This in turn comes from Ath Eascrah Cuain or the ford of (Saint) Cuan's esker. Cuan is remembered at a holy well about two miles from the village even though he is more associated with the Mount

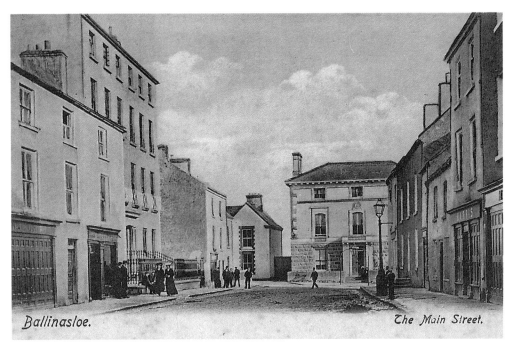

Ballinasloe. The Main Street.

In 1910 a bitter strike occurred when the Ahascragh Trade and Labour Union lodged a claim for increased wages for labourers on the Clonbrock estate. The wages paid were considerably lower than those prevailing elsewhere. Strikebreakers, supplied by the Property Defence Association, were brought in by the estate agent and after a two-month struggle the strike was broken and the men had to return to work at the old rate.

Ballinasloe

Ballinasloe began to develop as a town towards the end of the sixteenth century after the completion of the Elizabethan bridge. Initially the town developed slowly but by the early years of the eighteenth century its expansion was rapidly spurred on, no doubt, by the development of the great fair and other major markets. In 1659 the emerging settlement had

Brandon area of Kerry. The postcard shows the view down Chapel Street toward the Catholic church. The photographer had his back to the mill, the low wall in the foreground is a protection wall constructed to prevent coaches and carts going off the road as it rises to cross the mill race. The mill was a large concern in its day and bought extensive amounts of grain from the local farmers. It would appear to have been constructed as a flour mill during the boom years in the late eighteenth century when Ireland was the principal supplier of grain, flour and oatmeal to the English market. It was subsequently converted for the production of oatmeal and as such enjoyed a considerable export trade, sending some 20,000 barrels of oatmeal to the London market annually. With the development of the Australian and American grain fields the business slowly went into decline. By the latter part of the nineteenth century most of the employment in the area was generated by the large estates, particularly that at Clonbrock.

Main Street, Ballinasloe c.1890

Main Street, Ballinasloe c.1900

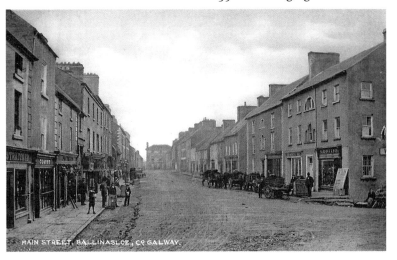

MAIN STREET, BALLINASLOE, C? GALWAY.

thirty-six people living in the area. By 1791 the population was over 1,800 and this had increased to over 2,400 by 1811, growing to 2,843 in 1824. There was a major spurt in growth over the next seven years and by 1831 the town had 4,615 inhabitants living in 632 houses. Some idea of the physical growth of the town can be gleaned from the fact that 265 of these houses had been constructed between the years 1821 and 1831.

Employment in the locality was provided by four flour and oatmeal mills, three tanneries, a felt hat manufactory, a carriage manufactory, two breweries, a bacon curing establishment and the limestone quarries at Brackernagh. Much of this employment was seasonal, and with no social welfare system to fall back on people turned to whatever they could to eek out a living. One source of income came through the manufacture of street manure in large dunghills. All sorts of refuse, and offal were gathered together with street waste, piled into a large mound and left to ferment. When the mounded material was ripe it was sold to local farmers as fertiliser. Whilst it wasn't the most hygienic way to make compost, it did allow people the opportunity to earn some money. This source of income was closed off with the arrival of the Rev. Charles Le Poer Trench as landlord's agent for his brother, Lord Clancarty,

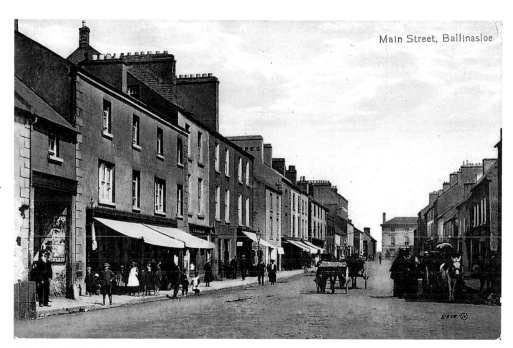

Main Street, Ballinasloe c.1905

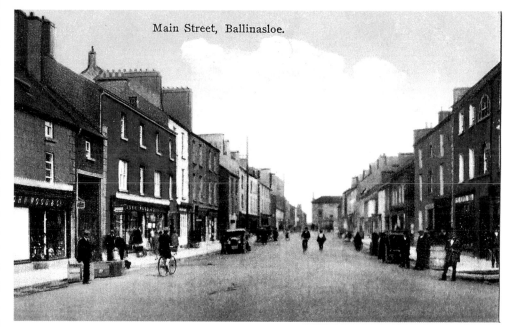

Main Street, Ballinasloe c.1914

some time before 1810. Charles had a viscous reputation and fully lived up to his nickname 'The Flogging Parson of Ballinasloe'. He took a strong stand with the local alehouses and forced them to close early. He also had the footpaths cleaned and re-gravelled and had posts fixed on the roadside edges to stop carriage wheels mounting and damaging the new surface. Trench had the dunghills cleared in a day and brooked no opposition from the street manure manufactures. The people were driven from their mounds and put to flight. Ballinasloe was no different to many Irish towns in regard to the dunghill nuisance. J. C. Curwen M. P. writing in 1818 remarked on the size of Colraine's dunghills. The same nuisance existed in many British towns also. Thereafter the streets were swept every day. How the unfortunate seasonal workers and unemployed coped with the loss in their meager income is not recorded. While the town gained a reputation for cleanliness, this did little to resolve the underlying employment situation as the population continued to grow. By 1841 it had reached 5080. The Famine decimated the population, which dropped to 3909 in 1861. Though the population suffered a sharp decline, the town seems to have recovered fairly rapidly. The small local industries survived, the local landlords remained solvent and the great fair still continued.

Main Street

The high ground along the site of the present Main Street was the ideal location for building activity during the town's expansion in the eighteenth century. The early cards of Main Street give an excellent view of a late Georgian or early Victorian streetscape because of the absence of traffic. The earliest view would appear to have been taken on a Sunday morning, a favourite time for early photographers as there was little movement that could result in blurring of the image. The shops are closed and the shutters are up. The only names that can be identified are Naughton on the left and Harris on the right. In 1910 some of the businesses in the street were: James Cogavin, select family grocer, tea, wine, spirit and hardware merchant; Mrs Concannon, publican; Eliott and Sons, grocers, wine and spirit merchants; Stephen Faller, watchmaker, jeweller and optician;

Mrs L. Flannigan, game, poultry, wool, hide and skin merchant; Thomas Hartigan, grocer and publican; John Murray, grocer, wine and spirit merchant; Francis Naughton, publican; James Nixon, general draper; Miss Power, publican; Miss Margaret Sharpe, grocery and provisions, wine and spirit merchant and Italian warehouse; John Ward, publican; Mrs Delia Ward, grocer and spirit merchant; Louis Ward, publican; James G. Whyte, grocer and spirit merchant; James Young, bootmaker; John Wood, woollen and general draper, outfitter and boot merchant; Parsons and Son, boot merchants, who also had a shop in Athlone at the corner of Northgate Street and Church Street.

Main Street was a market street. Potatoes, vegetables, fowl and eggs were sold on market days by local farmers. Turf was a regular commodity offered and was usually sold by the cartload. Corn was sold in the open market, as there was some competition amongst the proprietors of the four mills. During the Famine it was alleged in the local newspaper that the millers conspired together to depress the purchase price of grain and increase the price of oatmeal. It would appear that the millers not only persuaded the local workforce not to bid on the grain but also to keep out outside buyers. They were promised, in return, a low price on the oatmeal produced. Lo and behold the price of oatmeal went up.

Society Street

Society Street was originally known as Soldiers' Row because of the large military barracks that formerly stood at the north-western end of the street. Part of the site was later occupied by Saint Joseph's National School. After the First World War the British Ex-Service Men's Association had a centre across the road where the fire station is located today. After the foundation of the Ballinasloe Agricultural Society and its subsequent affiliation with the Royal Agricultural Society of Ireland the street was renamed as Society Street, primarily because of the Agricultural Hall, which was built to house the Ballinasloe Society and cater for its annual meeting held every October. The Society maintained a model farm and paid an agricultural instructor who visited farms, gave advice and arranged for grants to be paid in aid of improvements.

Ballinasloe had the benefit of two agricultural societies in the early years of the nineteenth century. The Farming Society of Ireland, which was founded circa 1800, held its shows at Garvey's premises on Main Street and also in Dublin at Smithfield. Their Ballinasloe Show was held in early October each year in conjunction with the great fair. They awarded cash premiums and medals to winning exhibitors in various categories of livestock. In 1811 the show was held on Monday October 7th when seven gold and two silver medals were awarded to prizewinners. Cash premiums of £10 and £5 were also awarded. The prospectus for the Ballinasloe Show to be held on October 5th 1820 shows a complete revision of the medal awards. The gold medal prizes have disappeared to be replaced by a total of twenty-two silver medals in the livestock section. Awards were also to be made for the importers of the best seed corn and also for the best wheat, oats, barley, peas, beans, vetches and clover grown in Ireland. Clearly the society was branching out into horticulture. The prospectus laments the fact that due to the financial constraints of the time the cash premiums would not be as generous as heretofore and also that the premiums for district ploughing matches were to be postponed. This, no doubt, was a reflection of the considerable drop that occurred in agricultural prices that year. The drop in prices not only affected the great October fair but would seem to have affected the banking sector also. A number of private banks failed in 1820.

With the closure of the Waterloo military barracks a large site became vacant and a portion of this was eventually acquired by the Sisters of Mercy who constructed a new national school, Saint Joseph's, there in 1873, which was extended in 1879. The courthouse stands between the school and the convent. Working drawings for this were prepared by Henry Clements, the county surveyor and it was opened in 1838. It became the headquarters of

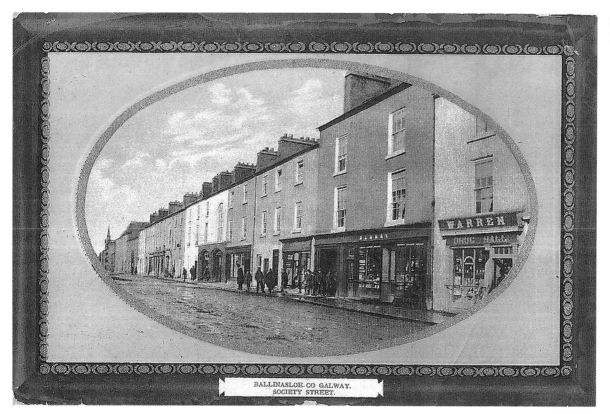

Society Street, Ballinasloe c.1895

BALLINASLOE, CO GALWAY.
SOCIETY STREET.

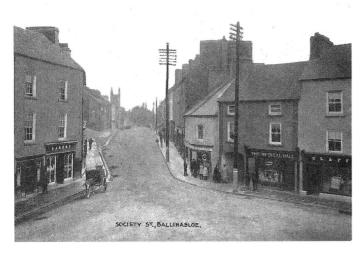

Society Street, Ballinasloe c.1915

the Eastern Division of County Galway. J. F. Kempster, the first county surveyor for east Galway relocated his office from Portumna and took up duty here shortly thereafter. The courthouse remained the headquarters for engineering services for east Galway until 1940, becoming the local area engineer's office following that.

The sisters first convent was in Main Street on the corner opposite the Bank of Ireland where they opened a temporary school. This greatly displeased of Lord Clancarty who maintained

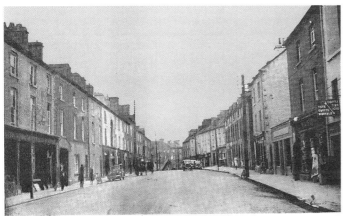

Society Street, Ballinasloe c.1945

a school for the children of his estate workers. He forbade his workforce to send their children to the new school and fined any who disobeyed 6d. a week, to be deducted from their pay. Despite this the numbers attending the new school grew. In 1856 the sisters bought two houses in Society Street and moved there in 1857, relocating their school there also. In 1863 they acquired two more adjoining properties and opened their new convent church on this site in 1866.

Immediately west of the new convent was the workhouse which had been built in 1841 and cost £9,600. It was designed to cater for 400 people. In the months of June and July 1849 there were over 4,000 inmates there. Between June 13th and July 20th of that year 85 of these unfortunates died. The census returns for 1851 shows that the workhouse housed 2,487 inmates. Attached to the courthouse were two small bridewells; one for male prisoners and the other for females. During the period July 1st to December 31st 1848 a total of 423 prisoners passed through these prisons. The average length of stay was four days. By comparison, for the same period in 1872 a total of 41 males and 11 females were incarcerated, the average stay being four days also. The 1848 figures are indicative of the desperation caused by the Famine while the 1872 figures represent the average figure for more normal times. The workhouse is no more but Ballinasloe's famine victims are remembered in the Famine Memorial Garden at Cleaghmore which is on the site of a mass grave for the workhouse famine dead.

In 1910 some of the businesses located along Society Street were: John Burke, grocer and spirit merchant; Andrew Cahill, wholesale and retail wine and spirit merchant; Joseph Devitt, painter and plumber; Timothy Dolan, grocer and spirit dealer; John Finnegan, general draper; Flannigan and Sons, Irish timber merchants and sawmill proprietors, tool handle manufacturers, cartwheel makers, etc.; P. J. Green, grocer and spirit dealer; William J. Harney, select family grocer tea,

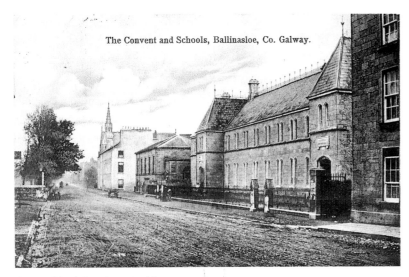

The Convent and Schools, Ballinasloe, Co. Galway.

Convent School, Courthouse, and Convent, Ballinasloe c.1900

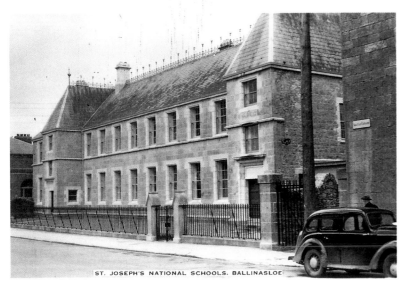

ST. JOSEPH'S NATIONAL SCHOOLS. BALLINASLOE

St Joseph's National School 1948

Dunlo Street

The early name for the Ballinasloe area was Dun Leodha, named for the fort that guarded the old ford on the Suck. The name has been preserved in the street name. The street was almost completely developed by 1840 and the only vacant stretch of frontage was the site of the present Garda Síochána station. The site was a large garden at this time.

The earliest postcard view of the street does not portray it in a flattering light. The photograph appears to have been taken on a wet day. On the left is the then relatively new RIC barracks and on the right is Hayden's Hotel. Outside the hotel there is a man, with his cart which contains an upright barrel. It could well be that he is selling milk. He could also be collecting urine. Heated stale urine was used to scour or degrease raw wool prior to washing it. There were a number of small tuck or fulling mills still at work in the vicinity of Ballinasloe until the 1920s. The Wrench Series photograph was taken some time later as can be seen from the alteration to the roofline of the building before the gap in the building line. The presbytery occupies this site, the building line being maintained by the railings. At the far right end of the street is a large prop to prevent the collapse of a building. Problems with building foundations are not a new phenomenon. There are several large pothole repairs visible also. Potholes were a major problem in urban areas where there was a large volume of heavy horse-drawn traffic and in particular wagons or carriages with narrow wheels which ploughed through any area of the gravel surface that was soft. When steamrolling of roads was introduced this problem was reduced. The introduction of tarred and chipped surfaces reduced the incidence of this nuisance further. However, the problem has never been fully eliminated. The 1940s view shows the former RIC barracks, now the Garda Síochána Station, with an extra storey added. This was

wine and spirit merchant, emigration agent; Daniel Hogan, grocer and spirit dealer; Edward S. O'Loughlin, stationer and newsagent; Mrs H. Raftery, publican; Margaret Walsh, grocer and spirit dealer. Flannigan and Sons sawmill was on the site of a coach and cart manufacturing works.

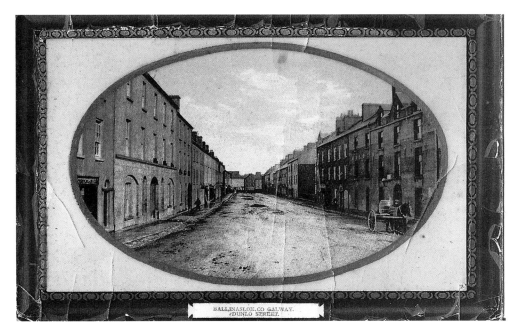

Dunlo Street,
Ballinasloe c.1895

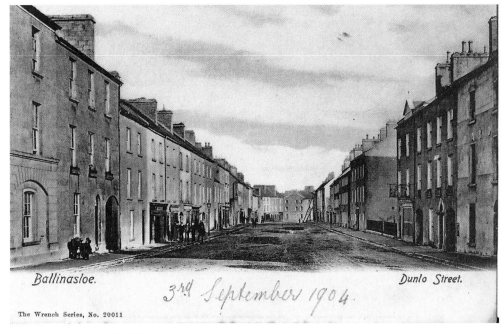

Dunlo Street c.1945

done to provide accommodation for unmarried members of the force who were transferred to the town. It now serves as office accommodation.

Brackernagh

Brackernagh began to be developed as a suburb of the town about 1795. Initially workers on Garbally estate lived here. When the quarries opened and went into full production in the first quarter of the nineteenth century the quarrymen also took up residence here. Stone was supplied for the construction of the Connaught and District Lunatic Asylum, the Workhouse, Saint Michael's Church, Saint John's Church, Garbally Park, the extension and renovation of Woodlawn House, Lough Cutra House, Gort and many other large building projects. Stone was exported to Britain and New York. The O'Connell Memorial statue in Ennis was carved from an eleven and a half ton block of stone specially quarried for the project. More recently the quarries supplied the stone for the construction of Galway Cathedral. A significant number of Jacobite troops camped in the area before the battle of Aughrim. Souvenirs of their stay are occasionally turned up. A significant find of Emergency or Gunmoney coins of James II from 1690 was made whilst digging a garden in

Garbally Drive in 1986. Another find was made several years previous to this in a garden near the main road. Gunmoney got its name from the metal used to produce the coins, copper, brass, old bells and obsolete cannon. James had no silver to supply his Irish mints so they had to use whatever metal they could lay their hands on. After the Williamite victory in Ireland James's currency was devalued to the basic value of the metal it contained. Accordingly, the crown, or five-shilling piece, was reduced in value to a penny or about two per cent of its face value. This caused widespread hardship, not just to James's supporters but to the community at large because the Gunmoney coins were the only coins in circulation.

Garbally

An older house on this site was destroyed by fire in 1798 and was replaced by the present house, which was built in 1819 to the design of Thomas Cundy, an English architect. The large square house was originally designed around a central courtyard. This area was roofed about 1855 and converted into a picture gallery. The Trenches lived here from the early seventeenth century when Frederick Trench acquired Garbally by purchase. His son, also Frederick, added to the property in 1678 and became owner of Ballinasloe and a large area of the surrounding countryside. The Trenches sided with William of Orange and supplied his army with valuable information on the pass where the Williamite troops were enabled to attack the Jacobite army. They also made their house available as a hospital for the wounded of King William's army. The family became one of the most politically important in County Galway. Through advantageous marriage alliances, and political manoeuvres, the Trenches moved into the highest ranks of the peerage. Richard Trench was made an earl for his support for the Act of Union. His father was made a Viscount in 1801 and became Earl Clancarty in 1803. The family got into financial difficulties in the early years of the last century and vacated

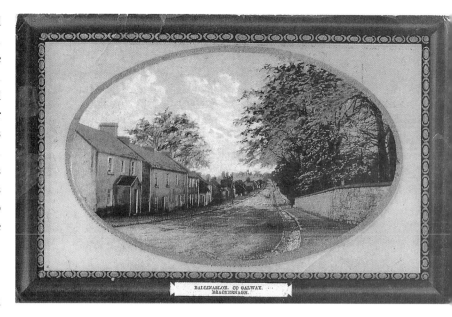

Brackernagh, Ballinasloe c.1895

the house about 1910 after the fifth earl was declared bankrupt. During the War for Independence the house was used as a barracks for the Black and Tans, who caused considerable damage to the property. The house and a hundred acres of land were purchased by the Diocese of Clonfert in 1922 for £6,750 and opened as the Diocesan Seminary, Saint Joseph's Secondary School, in 1923. As the later card shows, there was very little

Garbally Court, Ballinasloe c.1900

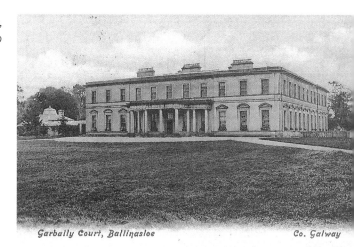

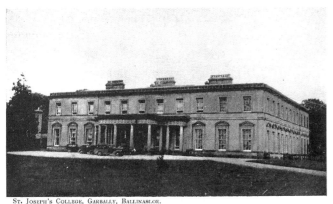

St Joseph's College, Garbally, Ballinasloe c.1946

St. Joseph's College, Garbally, Ballinasloe.

Sean McGuire was working at Garbally Park when the Clonfert Diocese acquired the property and relocated the boarding school from a building known as the Pines on the Shannonbridge Road. Many of the estate staff were retained, including Sean, who was born in Woodford around the time of the Famine. He was about eighty years old when the photo reproduced on this postcard was taken. As can be seen, he is dressed in his waistcoat and hat, as was the style at that time. The students, blissfully unaware of the contrast they make with the industrious Sean, are off for a game of tennis.

alteration to the main building. The glasshouse on the left-hand side has been removed, with only the large chimney remaining. The central courtyard, which had been converted into a ballroom and picture gallery in 1855, was converted into a chapel by the new owners.

Sean McGuire

Many boarding schools issued postcards for sale to the pupils so that they could write home occasionally. Garbally College was no exception. The photograph used on this card was taken by Fr Eric Finn, a noted Irish scholar. At the time the card was issued Garbally was an 'A' school or an all-Irish college; and as a result the school's early cards are all in Irish. The back of the card carries two verses, in Irish, which were reprinted from the 1928 issue of *Gearrbhaile*, the school's annual, as indeed was the photograph. The verses read as follows:

Innis duinn, a Sheain a chroidhe,
Cread a mhill na tiarnai?
No cread a sguab o Bhreacarnach
Clann Charthaigh choir na n-Iarla?
Tri treithe a dhamnuigh iad,
Dfhreagair Sean go ciallmhar,
Sainnt a gcroidhe, a's tart a mbea
A's leirsgrios ar na daoinibh?

Given the amount of Irish used in this postcard it is interesting to note that it was printed in Italy by Majella di a Chicca, Tivoli.

Sean Maguidhir, 1928 Photo by Fr Eric Finn

SEÁN MAGUIDHIR

(Rugadh é 'san naomhadh céad déag i nGráig na Muilte Iarainn. Tá sé ag obair fós 'san dara ceathrú den ficheadh aois).

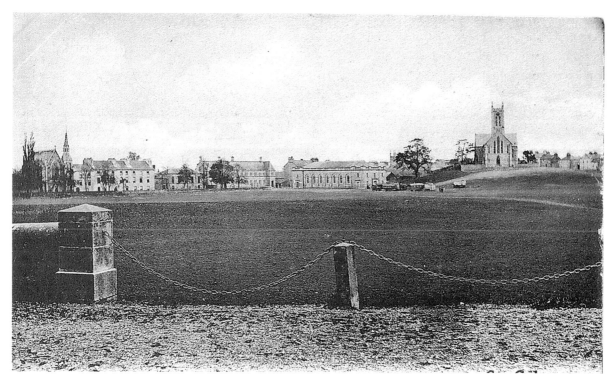

*Fair Green c.1895
Note wagons at
bottom of Church
Hill*

Fair Green

Ballinasloe has long been noted for its horse fair but in an earlier time the town was equally famous for its cattle and wool fairs. The wool fairs were so large in the mid-eighteenth century that they sometimes lasted up to six weeks. A poor wool fair only lasted about a fortnight. During the seventeenth century Galway became a victualling port for the British West India Fleet. This meant that the Galway merchants required large amounts of beef to salt and sell on to the navy. Ballinasloe was well placed to develop as a major cattle trading centre as large herds, made up of animals from all over the midlands, could be assembled there before being moved to Galway. East Indiamen still assembled in Galway Bay as late as 1793 but Limerick and the Shannon Estuary soon became pre-eminent for this trade. In the early 1800s representatives of Ffrench's Bank, Tuam attended the fair. Bills of Exchange were the payment used for large sales. These were promissory notes promising payment in thirty, sixty or ninety days and could be cashed at a discount in exchange or discount houses. The earlier the bills were cashed the greater the discount that was applied. Ffrench's Bank bought up any bills offered at face value and paid for them with their own banknotes. In this way the bank flooded Galway and much of Connaught and the midlands with their banknotes. When the bank crashed in 1814 these notes became worthless and were never redeemed. The knock-on financial effects of the crash caused major financial damage to several of the major property holders and middlemen in the region. The Anglo Irish Bank affair was not the first banking debacle in this country's history. The fairs recovered and weathered the crash of 1820 when other private banks also

failed. The wool fair was the first to go into decline, which was caused by the growth in the numbers of wool factors or merchants around the country. This greatly reduced the amount of wool being brought to market. The great cattle fair survived into the twentieth century, only beginning to dwindle in size after the First World War. The enormous length of the cattle loading banks, or platforms, at Ballinasloe railway station is testimony to the numbers of cattle passing through on their way to or from market. The horse fair alone survives and is still a major event every October.

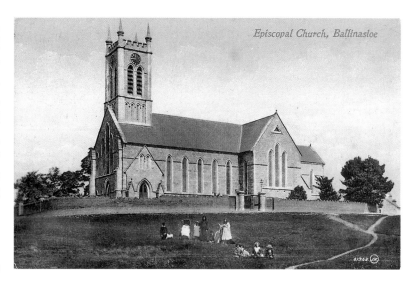

Episcopal Church, Ballinasloe

Saint John's Church

Saint John's Church serves as the parish church for the Church of Ireland community from the greater Ballinasloe area. The original parish church had been located in Creagh but in the early nineteenth century it was decided to relocate this into the town. The site would appear to have been chosen very carefully. Anything built on this crest of this hill, which is supposed to have been the site of an Anglo-Norman motte, would dominate the town. The building was set opposite the gates of Garbally Demesne and overlooked the Fair Green where much of the town's wealth was generated. The first church was badly damaged in a fire and John Welland was engaged to design its replacement, which was erected by the noted Dublin firm Carrols and opened in 1842. A clock turret was added to the building by the third Earl Clancarty at a cost of £800 in 1879; it was presented to the people of Ballinasloe as the Town Clock – which meant, of course, that they had to pay for its maintenance and upkeep. On Ascension Thursday 1899 the building was gutted in a major fire. During the conflagration the clock continued to chime until its mechanism melted and collapsed. A fine pulpit, carved by local man James Begán, was badly damaged as was the memorial to the third Earl Clancarty which had been made by Sibthorpes of Dublin. The church was repaired and extended subsequently.

St John's Episcopal Church, Ballinasloe c.1905

Saint Michael's Church

Saint Michael's was built on the site of an earlier church as was commonplace in nineteenth century Ireland. Plans for the new church were drawn up by James J. McCarthy. The horrors of the Famine intervened and the plans were put on hold. Revised plans were prepared by Augustus Welby Pugin and the foundation stone was laid in 1852. The new church was consecrated by Cardinal Wiseman of Westminster on August 25th 1858. The Archbishop of Tuam led the large gathering of Irish bishops and clergy, which included L'Abbe Cruise, chaplain to Napoleon III of France, who had familial connections with Ballinasloe. Given the amount of clergy – some four hundred in all – and Catholic gentry present, there was an air of triumphalism about the proceedings. The same triumphalism was associated with the choosing of the site for Saint John's church. The bell tower and spire were constructed in 1887. The church has murals by Harry Clarke and Joseph Tierney and the high altar was designed by Albert Power, who also carved the figure of the recumbent Christ. The building underwent considerable repair and conservation work in recent times.

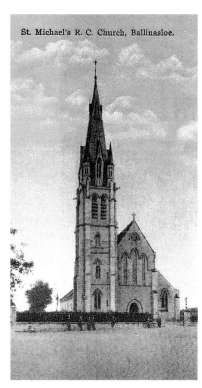

St. Michael's R. C. Church, Ballinasloe.

St Michael's RC Church,
Ballinasloe c.1910

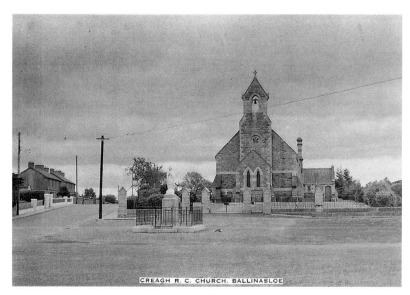

Our Lady of Lourdes
Church, Ballinasloe
c.1950

CREAGH R. C. CHURCH. BALLINASLOE

Our Lady of Lourdes Church

When Dean Crowe decided on the construction of a new church for Saint Peter's parish in Athlone he acquired the most prominent site available, the original main entrance to the army barracks at the market square. One of the buildings on that site was the garrison church. This was acquired by Saint Michael's parish in Ballinasloe, demolished carefully stone-by-stone and transported to Creagh where it was re-erected at the junction of the Shannonbridge and the Dublin and Galway roads. The site chosen was directly across the road from the old Creagh church. The new building was consecrated on August 18th 1933. Like Saint Michael's, the parent parish church, it too has undergone extensive refurbishment in recent times. It isn't the only church to have moved in County Galway; Gortanumera acquired a disused Church of Ireland church in Ballygar and re-erected it stone-by-stone in 1934–5.

Connaught and District Lunatic Asylum

This building was erected in 1833 at a cost of £27,000 when Creagh was part of County Roscommon. When the county boundaries were redrawn prior to the setting up of County Councils to replace the Grand Jury system

Creagh was transferred to County Galway. According to Roscommon folklore, the county in which the Asylum was located had to bear the heaviest proportion of the maintenance and upkeep costs; and therefore Roscommon had no objections to the hospital site being transferred to the jurisdiction of Galway County Council. The building is laid out on an X plan with the four wings

Connaught & District Lunatic Asylum c.1895

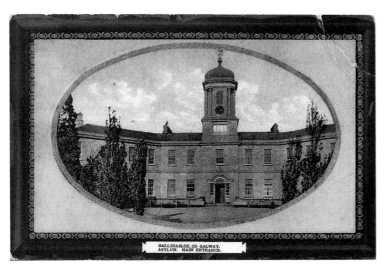

radiating out from a central block, which formed the residence of the hospital governor and provided accommodation for his staff also. All patient and staff movement from one wing to another could be monitored and controlled from this central hub. The building suffered some damage following the Night of the Big Wind in 1839. The estimate for carrying out repair work was given as £999 19s. 11d. in the newspapers. One must admit that it seems a strange figure. The buildings were improved and enlarged over the years and several new ones constructed but now, thanks to new approaches to dealing with mental health issues, an institution of this size is no longer necessary.

River Suck

Contrary to popular belief the call to drain the Shannon is not a modern political rant but dates back to 1697 when the Grand Jury of County Galway called on the Irish Parliament to make the Shannon navigable from Limerick to County Leitrim. Any navigation works, such as clearing rocks and shoals from the river, would improve the drainage also. Arising from this, legislation was passed authorising various schemes of inland navigation. The initial development of these schemes was very slow but gradually canals were constructed and river navigations improved. In 1802 the Grand Canal Company proposed to make the Suck navigable from the Shannon to Ballinasloe. The proposal failed to get approval as the costs would have been prohibitive. As the barges were horse-drawn and the lower Suck, then as now, floods high level towpaths would have to be constructed. By 1817 the company had decided on a canal link to Ballinasloe. Work started in 1822 and was completed in 1829. By this time steam-powered boats had appeared on Irish waterways; correspondingly, the Suck proposal was revisited. The new scheme was altogether far more ambitious than that of 1802. The new proposals called for the Suck to be made navigable up to

River Suck

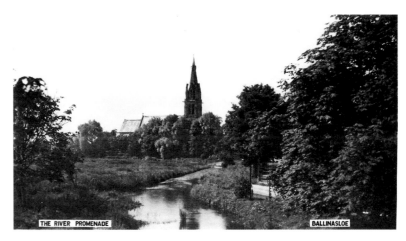

its junction with the Shiveen. The navigation was then to proceed up this latter river to Mountbellew where there were large mills. In fact there were at least nine mills upstream of Ballinasloe who, no doubt, were anxious to improve their business. Ready access to water transport meant a huge reduction in transport costs. It also opened up a much larger market with the possibility of an export trade. The Ahascragh Mills were exporting large quantities of oatmeal to the London market by the 1840s. The oatmeal was taken by road to the canal harbour at Ballinasloe, shipped to the Canal Company's harbour in Dublin and freighted to London. The arrival of the railway age and the depopulation caused by the Famine seem to have killed off the proposals even though they still lingered on until 1855. Work finally started on the Suck Navigation in the early 1990s and was completed just about two centuries after it was first proposed.

Bridges

According to the Annals of the Four Masters, Turlough O'Connor built a bridge at the ford of Dun Leoda on the River Suck. No trace of this structure survives; however, a large portion of the Elizabethan bridge, constructed between 1570 and 1579, still stands and up to recent times carried virtually all traffic travelling between Dublin and Galway. The provision of bridges at Athlone and Ballinasloe formed part of Henry Sidney's campaign to subdue Connaught and make the province amenable to English laws. Permanent bridges at both locations would make the deployment of troops much easier. Many of the 133 stonemasons employed in the construction work at Athlone came from Galway. It is quite possible that some of these men later worked on the building of the Ballinasloe bridge. The Suck flows through two main and a number of smaller channels so the bridge was, in reality, a large causeway with several

Ballinasloe Old Bridge, Upstream

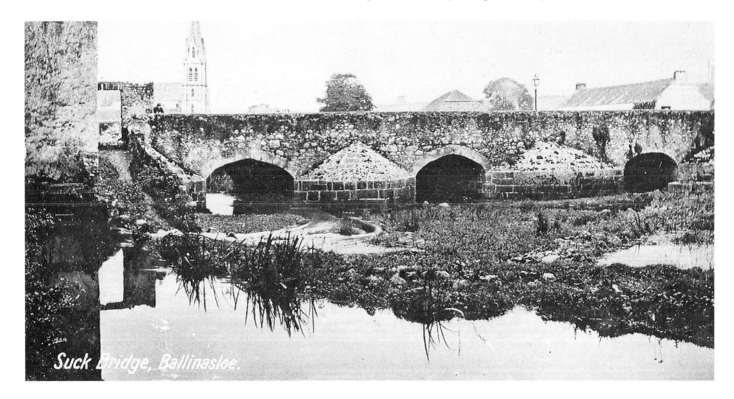

Suck Bridge, Ballinasloe.

groups of arches along its length. The section that has survived links the island containing the Castle to the west bank of the river. Three of its arches are shown in a fine Lawrence postcard produced about 1900. As can be seen, each arch is slightly different from the others. This would seem to imply that this section of the bridge, at least, was constructed in stages with different master masons in charge at each stage. This would not be unusual given the amount of stone used to build the bridge. The arches are separated by piers, each twenty feet wide, which are faced with equally large cut waters; these help to reduce the pressure on the piers by diverting the river flow directly through each arch. The ruins on the left of the picture were demolished many years ago. They were the remains of a late eighteenth-century watermill which, according to local folklore, was destroyed in a major fire in the 1860s. The chairman of the town commissioners was assisting firefighting measures at the scene when, or so the story goes, part of the roof fell on him, killing him instantly. The remnants of the wall channelling the mill race into the wheel pit can clearly be seen. Leading away from this are the remnants of the mill weir which appeared to have been quite effective, particularly when the river was low. In comparison with the riverbed, the mill (or head) race contains a substantial amount of water. The position of the sluice and waterwheel feed shows that the wheel was located within the building, similar to the arrangement at the Bridge Mills in Galway city. A bow way leading to the water can also be seen. It leads to a small area contained within a neat regular low-level weir. The overflow from the head race escapes into this area, which appears to have been provided as a pond from which to draw water or wash clothes in.

Because the riverbed was soft mud it was paved on the approaches and through the arches. This was done

Ballinasloe Old Bridge, Downstream c.1930

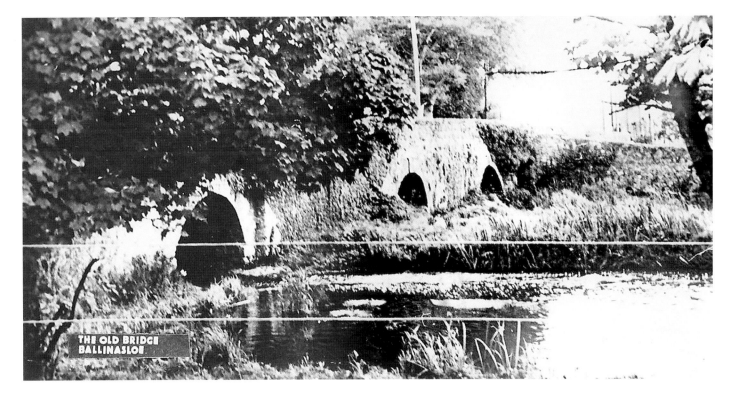

THE OLD BRIDGE BALLINASLOE

to prevent the bed being scoured out or cut through. As the bed would be cut away the bridge foundations would be undermined leading to collapse. The flow of water is speeded up as it goes through the arch and this leads to soft areas being eroded. The bridge was widened in 1745 on the downstream side. The contractor, William Brennan, commenced work in May and finished in October – just in time for the fair. It is possible to walk through the arches during very dry weather when the difference in masonry and workmanship can clearly be seen. The bridge on the eastern branch of the river has not survived. Following an inspection during the Suck Drainage Scheme it was decided that the bridge piers couldn't be safely underpinned and it was therefore demolished and replaced by the 'Big Bridge'. The initial proposal to replace the rubble weir serving Harney's Mill with a new purpose-built structure was revised and it was decided to erect roller sluices at the new bridge. The bridge was completed in 1887 and the new sluices installed. These were the first sluices of their type to be erected anywhere. When a group of English engineers visited Ballinasloe one of the party, Leader Williams, of the Manchester Ship Canal Company, was so impressed with their operation that he placed a large order on behalf of the Canal Company. Other orders were placed for drainage works on the Themes river. As the first sluices of their type in the world they are worthy of preservation. The riverbed under the new bridge was paved to prevent scour damage. A narrow arch was provided at the western end of the bridge, in which a fish ladder or pass was installed.

County Surveyors

The first county surveyor for County Galway, Henry Clements, was appointed in May 1834. As County Galway was considered too large for one surveyor to look after properly the county was divided into two parts, the Eastern and Western Divisions. Clements was given the Western area and John F. Kempster was appointed to the Eastern Division. Kempster was headquartered in Portumna, later moving to Ballinasloe and only retired in 1891 at seventy-five years of age. Clements was succeeded by Samuel Ussher Roberts in 1858 who was, in turn, succeeded by Henry T. Humphreys in 1873.

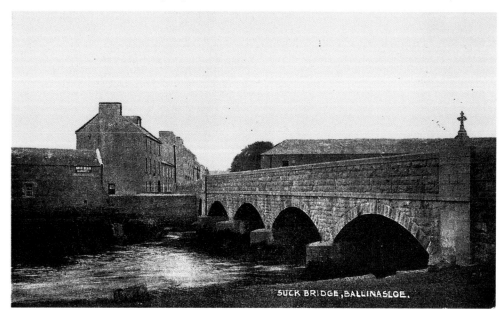

SUCK BRIDGE, BALLINASLOE.

The Big Bridge c.1910, built in 1887

Business Postcard,
George Lee, County Surveyor, 1917

Humphreys was followed by Carter Draper, who moved to Wicklow in July 1882 and was succeeded by James Perry. When Perry died the county councillors appointed his daughter Alice as county surveyor in a temporary capacity. Alice had graduated in 1906 with a first class honours degree in civil engineering and was the first woman engineering graduate in Ireland or Great Britain. When a permanent appointment was made in 1907 it was awarded to Patrick J. Prendergast, a native of Clifden. Prendergast retired on health grounds in 1910 and was replaced by John Moran in 1913 on a transfer from the Eastern Division. Moran, in turn, was succeeded by Michael J. Kennedy in 1916. Kennedy also transferred from the Eastern Division. When Kempster retired from the Easter Division he was succeeded by John Smith and on Smith's death in 1907 he was replaced by John Moran. When Moran transferred to the Western Division he was replaced by Michael Kennedy and on Kennedy's transfer he, in turn, was replaced by George Lee in 1919. Lee was a native of Gort. Following Kennedy's death in 1938 Lee took over responsibility for the entire county. Under the new legislation that created county managers he became county engineer in 1940 and the post of county surveyor was abolished. Lee was therefore Galway's last county surveyor and first county engineer and retired in 1956. From the time Kempster moved his headquarters to the courthouse in Ballinasloe the Eastern Division was headquartered there. After 1940 the engineering head-quarters for the entire county was based in Galway city.

Killimor

The original settlement at Killimor would appear to have grown up around a ford located where an esker was intersected by the Killimor River. The importance of the ford in medieval times can be inferred from the size of the church ruins located on the esker. The building was the largest medieval parish church in Ireland and as it was obviously sited to command the river crossing it was no doubt in receipt of alms and donations from those using the ford. With the construction of a bridge

at Banagher the road through Killimor became one of the principal roads leading from Dublin to Galway and accordingly the early crossing point was replaced with a bridge at a later stage. As the road is shown on Hermann Moll's 1714 map showing the principal roads of Ireland this bridge dated from the seventeenth century at the latest. The first edition of the Ordinance Survey map of the area indicates that this structure had seven small arches which raises the possibility that the bridge dated from the sixteenth century. Unfortunately no records relating to it seem to have survived. The bridge was replaced by a new four-arched structure in the first Killimor Drainage Works during the period 1852–4. As can be seen from the postcard, the roadway is doglegged over the bridge which is at right angles to the riverbank. Given its size it is understandable that it was not constructed on the skew to cross the river at an angle. Skew bridges were developed by Robert Chapman, an English engineer, when he was working on the construction of the Kildare Canal in 1788. The problem with skew bridges was that the voussoirs, or wedge-shaped arch stones, had to be cut to individual shapes to fit into particular locations in the arch. As these angles had to be worked out very precisely, the design of skew bridges was a slow and costly exercise. The arrival of the railway age created an essential need for skew bridges: one cannot dog-leg a railway line over a road or river. In 1868 Professor Edward Townsend of the Galway Engineering School devised a graphical method to establish the correct angles for any degree of skew that greatly simplified and shortened the design process resulting in a major reduction in the cost associated with this aspect of bridge work. Townsend had an extensive private practice as a railway engineer and was, no doubt, familiar

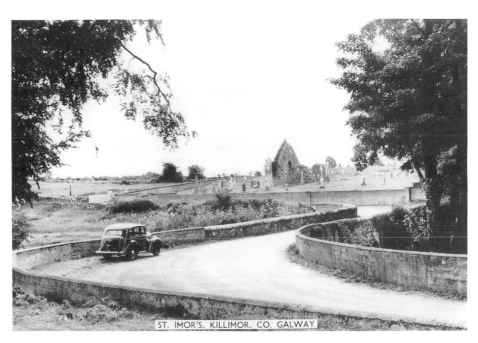

ST. IMOR'S, KILLIMOR, CO. GALWAY

St Imor's, Killimor, Co. Galway c.1948

with the 304 foot long skew bridge that carries the Deerpark River under Ballinasloe Railway Station. Townsend played a major role in the saga of the Galway–Clifden railway from 1881 onwards until a line was finally constructed and opened in 1895. The new bridge was built by the Board of Works but paid for by the Grand Jury of County Galway. It was bypassed by a new section of roadway with a reinforced concrete bridge in the 1960s.

Killimor had benefitted from the absence of a bridge in Portumna. For over a century, from 1690 to 1795, the only way to cross the Shannon at Portumna was by ferry. This meant that a considerable volume of stagecoach and goods traffic crossed at Banagher and travelled west or south-west through the Killimor town. This traffic was reduced considerably once Portumna Bridge was constructed. With the completion of a new and much better road from Portumna to Killimor in 1849 there was some improvement in the business generated by passing traffic. The town depended heavily on its

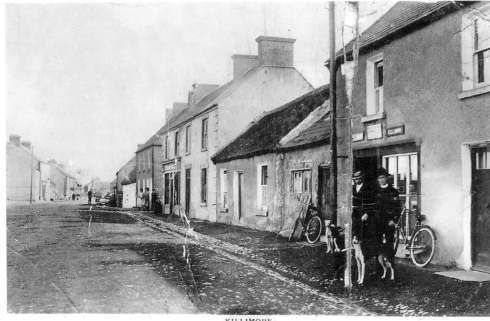

KILLIMORE

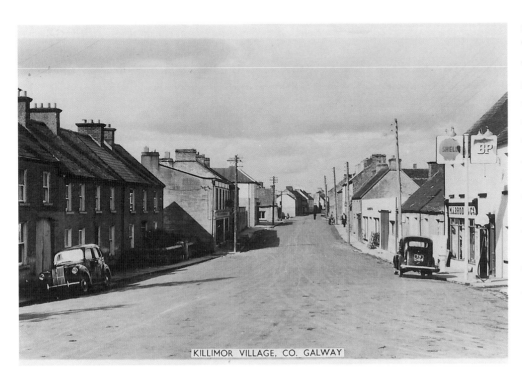

KILLIMOR VILLAGE, CO. GALWAY

agricultural hinterland for business. There were three large mills in its vicinity: Ballycahill, Meagheramore and Lisduff, all of which required a considerable quantity of grain on an annual basis. Ballycahill had a tuck or woollen mill also, which was larger than the average country tuck mill. Wool was not only scoured and cleaned here it was also processed into thread for the manufacture of worsteds. Killimor also sent large quantities of raw wool to the great wool fairs in Ballinasloe during the late eighteenth and early nineteenth centuries. When the wool trade declined it was replaced by flax growing and Ballycahill woollen mill

was adapted as a flax scutching mill. The revival of Galway's linen industry failed and the mill reverted to its original usage in 1870. Wool production continued as an important source of income for the local farming community. In 1920 the site of the ruined Hardy's Mill was put forward as a possible location for a large woollen mill. Darrell Figgis, from the Commission of Inquiry into the Resources and Industries of Ireland was very impressed with the potential of the site. A local Industrial Association was formed to progress the idea. However, Civil War, with its post conflict reconstruction, and sundry other events stymied the proposal.

Woodford

Convents conjure up an image in most peoples' minds of calm, quietness and peace. I am sure Woodford Convent was no different in its day. Woodford itself had a somewhat lawless reputation in the eighteenth century. Once the ironworks had closed in 1765 there was very little employment in the locality. The works smelted haematite, or bog iron ore, and converted it into pig iron that was shipped down the Rossmore River to the Shannon navigation system. A large number of people were employed in digging out the ore, cutting timber and making charcoal from it, manning the furnaces and transporting the iron to market. The area, because of its seclusion and good cover, became a hideout for bandits from Tipperary and elsewhere who could slip in and out using Lough Derg and the Rossmore River as their route. In 1837 a company of infantry were stationed in a barracks in the town which also had a detachment of constabulary. In the early 1800s illicit distillation was a major problem in the district. Many of the small islands near the Galway shore of Lough Derg were used for this purpose; this is remembered in the names Whiskey Island and Still Island. A large number of the Galway excise men were transferred to the Bannagher excise area

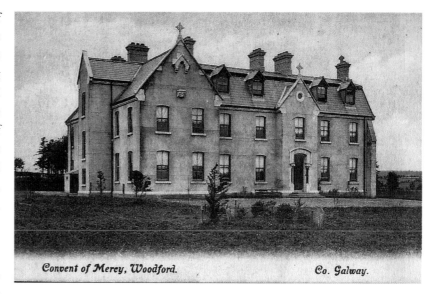

Convent of Mercy, Woodford. Co. Galway.

Woodford Convent of Mercy c.1901

to stamp out the trade. To be fair to Woodford, the moonshiners were primarily Offaly men. Despite the alleged lawlessness of the district, Woodford had the second lowest level of committals to the bridewell during the second half of 1848. At 114, the number was less than half of the next lowest district and just over ten per cent of the figure for Loughrea. The prison returns for the second half of 1872 show that there were no committals to Woodford Bridewell. The area was peaceful until 1872 when Clanricarde increased the rents in the area because the local voters did not support his candidate in the 1872 election. Thereafter, tenants in Woodford began to organise themselves to resist rack renting and evictions; this eventually lead to the commencement of the Land War in 1886. The agitation continued into the 1890s and began to peter out about 1894. As late as 1901 there were still a number of evicted tenants living in huts in the Woodford–Portumna area. Against this background, the Sisters of Mercy came to Woodford in 1900. The convent was designed by W. H. Byrne of Dublin who also designed their school.

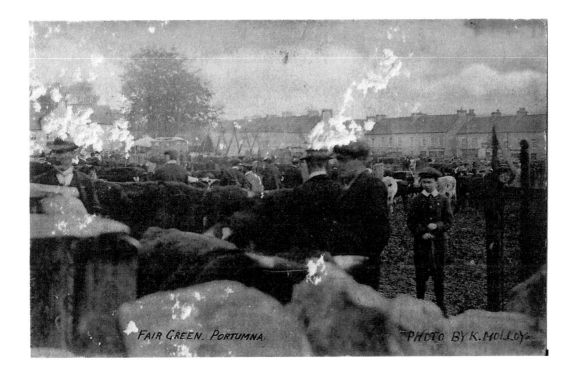

Main Street,
Portumna c.1905

Fair Day,
Portumna c.1905

Portumna Main Street

The town of Portumna grew up around the Castle and initially consisted of a line of houses stretching from the Castle gate towards the river. This street was, for a time, known as Main Street. It subsequently became Old Main Street and is now called Abbey Street. The new Main Street was initially called New Street but by the beginning of the twentieth century was known locally as Main Street even though its original name was still its official one. It is now called Saint Brendan's Street. With the construction of the Catholic and Church of Ireland churches and the laying out of the Fair Green, the old Main Street lost its prominence and New Street began to be developed. The construction of a new courthouse at one end of New Street copper-fastened its pre-eminent position. The streetscape is a fine example of late Georgian and early Victorian architecture. The Fair Green wall is on the left. The photograph was taken shortly after Kathleen Molloy set up her photographic studio in the town in 1903. Everybody is facing the camera, possibly because seeing a professional photographer at work was a novelty. There is a large group of children in the middle distance; many of them are girls as can be seen from the number of white smocks visible. There is also a very large pothole visibly repaired in the street.

Fair Green

When the Clanricardes secured the return of their estates after the Cromwellian confiscations in 1663 they also secured the right to levy tolls and customs on the town's fairs and markets. A market was held every Saturday and by the end of the eighteenth century six fairs annually were being held. Fair days were February 15th, May 6th, July 1st, August 16th, October 17th and November 15th. With so many fairs the toll income must have been significant and it is no wonder that a designated and walled-in fair green was created in 1825. Up until the Famine and indeed for some time afterwards large numbers of pigs were sold here for both the Limerick and Dublin markets. The Limerick market was a substantial one because of the large bacon factories. The pigs were shipped out on the Shannon navigation to Limerick and the Grand Canal to Dublin. The fairs were specifically mentioned in a clause of the 1795 act authorising the construction of Cox's timber bridge at Portumna. The bridge tolls were to be reduced by half on fair days. Portumna was unusual in that from an early date it had this enclosed fair green and as a result it had no street fairs.

Saint Brigid's Church

Described as an elegant, cruciform church with a tower, Saint Brigid's Church was completed in 1830 at a cost of £1,200 on an enclosed site of one acre. The tower was added about 1858. The Earl of Clanricarde gave the site as a free gift in 1825 and personally laid the foundation stone. This church would seem to have replaced an earlier chapel which was located on a laneway off what is now known as Abbey Street and known to have been in existence pre-1791. The laneway has been developed as Church Road and Marian Villas would appear to have been constructed over the site. This early chapel is not shown on the 1839 Ordinance Survey map of Portumna. It would appear to have been demolished after the new church was built. As construction work began before Catholic Emancipation, Saint Brendan's was located on a discrete site behind the then New Street. It had two entrances: a pedestrian entrance off Saint Brendan's Street and the main entrance off what is now Saint Bridget's Avenue. When the new parish church was built in the 1950s Saint Bridget's was converted into a parish hall. The upper section of the tower was removed shortly thereafter.

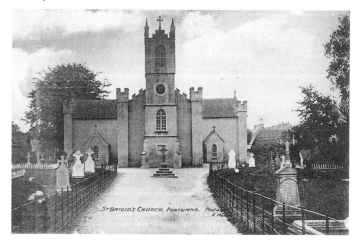

St Brigid's Church, Portumna c.1905

Technical Education

The Convent of Mercy was founded as a daughter house of the Loughrea convent in 1892 and opened a residential Domestic Science School for girls sometime pre-1898. The third report of the Galway County Committee of Technical Instruction (1904) mentions that the school had been in operation for many years. The founding manager was Sr Mary Joseph Pelly and the school's aim was to provide 'instruction in the science and practice of Cookery, Laundry Work, Dairy Management, Poultry Management, General Housework, Domestic Economy, and Needle-work'. Girls were to be trained in improved modes of dairying and household manage-ment, and trained for either domestic service or given special instruction if they were to become technical instruction teachers. The school timetable made it abundantly clear that there was to be little time for distractions. The day began at 6 a.m. with half an hour allocated to dressing and prayers. From 6.30 a.m. to 7.30 a.m. pupils were allocated various tasks such as kitchen or household duties, milking, or work in the laundry, dairy or poultry yard. Breakfast was at 7.30 a.m., followed by bed making and dormitory cleaning. The girls then changed into their uniforms for the day's work, which began at 9 a.m; from then until 1 p.m. they were allocated duties in the workroom, kitchen or laundry. Lunch and free time was from 1 p.m. to 2 p.m., and from 2 p.m. to 4 p.m. the girls were reallocated in rotation to the aforementioned departments. Lecture or examination time followed from 4 p.m. to 5 p.m., followed by tea until 5.30 p.m., then work at milking, or in the dairy, or poultry yards or kitchen. Following this they all went to the

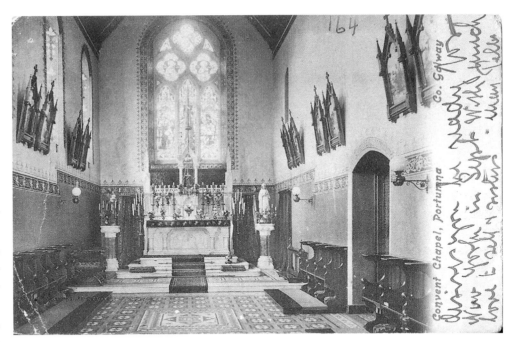

Convent Chapel, Portumna c.1895

Convent and Technical School c.1903

workroom from 6.30 p.m. to 8 p.m. Supper and night prayers filled the last hour, with bedtime at 9 p.m. Reading, writing, arithmetic and geography were also taught. Despite the rigorous timetable there was considerable demand for places in the school. There were eighteen boarders in the year 1901–2. This had increased to twenty-three the following year. Prospective students had to be over sixteen years of age and had to

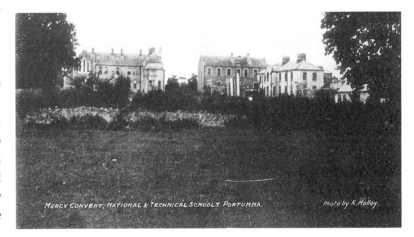

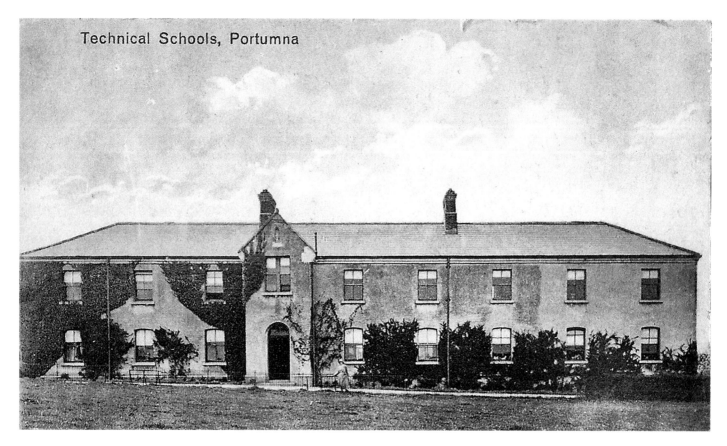

Technical Schools, Portumna

Technical School c.1905

have their application signed by a responsible person. They had to be able to read, write 'with a fair hand', spell with tolerable correctness and know the basic rules of arithmetic. They had to supply serviceable dresses and aprons of plain washing material as well as one good outdoor dress, hat and jacket, house shoes, two towels, hair brush and comb, toothbrush and clothes brush.

At the end of term, which was one year's training, an examination was held under the auspices of the Department of Agriculture and Technical Instruction for Ireland. Prizes were awarded for best exam results, neatness and best notebook. The girls were expected to show an aptitude for the work of the school and if they failed to do so within two months they would be sent home. When they had finished their training those students who had earned it received a Certificate of Merit relating to their conduct and exam results. The school also provided classes in cookery and general household management for non-resident pupils at ten shillings per quarter. Recognition by the County Committee gave pupils from all over the county access to the school through a system of scholarships. Pupils from outside the Portumna Rural District Council area had to be nominated by their local Rural Council or Committee and have their names sent forward to the County Committee for final approval. Initially the scholarships were for £7 per annum. They were increased in value to £15 per annum from 1902. They could also be extended for a second year.

What follows is a list of County Scholarship winners and their nominating Local District Council 1902–3 & 1903–4.

Rural District	1902/1903	1903/1904
Ballinasloe	Catherine Donoghue Kate Glynn Josephine Dunny	Catherine Donoghue
Clifden		Nora J. Lydon
Galway	Mary Lardner	Mary Lardner
Gort	B. Jordan	Margaret Geoghegan Delia Lydon
Mountbellew	Nora Burke Delia Madden L. B. Kelly	Delia Burke Lucy Kelly Annie Delaney Kate Ruane
Portumna	B. O'Carroll Agnes Keegan M. Langtry Ellie Mannion Minnie McDonnell Nora McNamara Bridget Matthews	Mary Kelly Mary Cunniffe Mary Kearns Maggie Grady
Tuam	Norah Cloonan Kate Cunniffe Bridget Daly Nora Lyons	Nora Burke Nora Joyce Tessie Mullarkey Lizzie Nally Bridget Connolly Margaret McWalter
Dunmore		Nora Mannion Nora Lyons

The teachers were Margaret M. Riordan, Elizabeth M. Riordan and Annabelle Gillespie.

In 1902 the inspector from the Department of Agriculture and Technical Instruction reported that the school was the best of its type that he had visited. As a result of his report the Department requested a set of six full-plate photographs showing the various sections of the school at work. The photographs were to form part of the Department's exhibition at the Industrial Exhibition to be held in Cork. Portumna was used to set the national standard for excellence. In 1905 the Department took over the financing of the school and augmented the courses being taught. In this way the school became a model school similar to the Munster Institute in Cork.

Portumna's Bridges

For centuries the only way to cross the Shannon at Portumna was by ferry. Richard de Burgo was in possession of the ferry in 1291 as part of his manor lands. It wasn't until 1657 that proposals were first brought forward for a bridge at this location. In that year Daniel Thomas, a Cromwellian engineer, proposed to Henry Cromwell, Oliver's second son that a toll bridge be constructed here. Henry had been awarded the Clanrickarde estates under the Cromwellian confiscations. No doubt being Oliver's son strengthened his claim. Thomas, who was engaged in building fortifications at Ballymoe at that time, offered to carry out some modifications to Portumna Castle and build either a timber or stone bridge, whichever would considered appropriate. In return he sought a grant of lands and the tolls from the bridge. Though historians doubt whether the proposals were ever acted upon, east Galway folklore indicates that a timber bridge was in existence by 1690 when it was burnt to the waterline by Jacobite forces to deny King William's army a crossing point here. The petition of the group of promoters to the Irish Parliament seeking an act to allow them to construct a toll bridge explicitly states that the previous bridge had been destroyed in the 'late war' between William and James. Whether this was Daniel Thomas's bridge or not has still to be decided. A portion of this bridge still survives on the riverbed according to local anglers. Having received their Act of Parliament, the Trustees set about gathering funds from shareholders and appointed Lemmuel Cox, an American, to construct a timber bridge. Cox had come to Ireland to build a timber bridge at Derry and stayed to construct similar bridges at Wexford, Ferrycarrig,

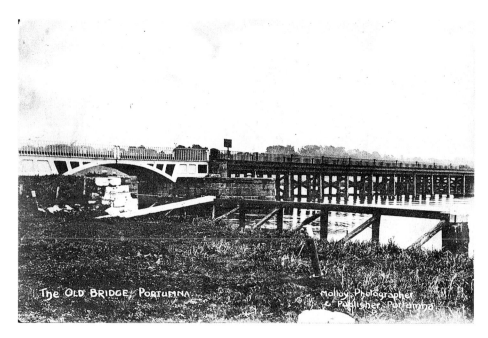

The Old Bridge, Portumna

Molloy, Photographer & Publisher, Portumna

New Ross and, after Portumna at Waterford. Portumna cost £8,000. Cox's method of construction was simple; the bridge trusses were assembled on the riverbank and floated out into the water where one end was weighted down to sink so that they were vertical in the water and then they were driven down into the soft bed of the riverbed. Each pier was composed of seven timber piles, cross braced by both diagonal and horizontal ties. Each pile was pointed at the bottom and shod with iron with a hook attachment to connect the weights. Once the pier was in its correct position planking was run out onto it and cart loads of stone pushed out over the planks to weigh down the piles and drive them down into the mud. They were then stabilised by tipping large quantities of stone into the riverbed around the base of the pier. Disaster struck in 1814 when floods swept away the Galway half of the bridge. The trustees appointed Alexander Nimmo to rebuild the section from the Galway bank to Hayes's Island. It took four years to complete and cost £3,000, which was raised by way of a mortgage from the Board of Works on the toll income.

The mortgage payments went into arrears and in 1824 the Court of Chancery auctioned the toll income for a three-year period to clear the debt. By 1834 the timbers of the entire bridge were so rotten that a new bridge was needed. The structure was vested in the Commissioners of Public Works who built a replacement in 1835 at a cost of £24,000. The new bridge was a 'temporary' one, built to last about twenty-five years. A permanent replacement had been planned but after an investigation of the riverbed by William Bald it was decided that the costs would be prohibitive. The new bridge had five piles per pier and had iron plates covered in gravel as the deck. An opening span for navigation purposes was provided near to Hayes's Island. During the Shannon drainage and navigation works this was replaced by a cast-iron opening span made by the internationally famous Mallet Foundry Dublin. Portumna's temporary third bridge lasted seventy-five years before being replaced by the present structure in 1910. During construction the old bridge was used as a construction platform. A temporary bridge had to be provided for local traffic. The new

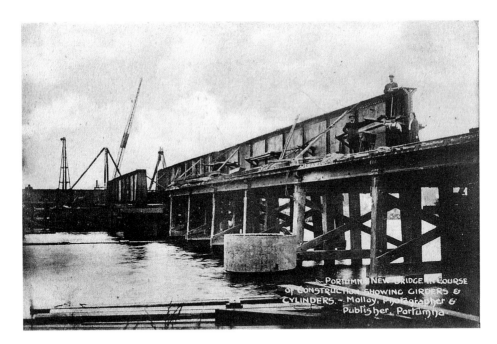

bridge is a joint-jurisdiction one, the maintenance costs being borne by Tipperary North and Galway County Councils. Both councils contributed to the construction costs, as did Roscommon, Offaly and Clare County Councils and also Limerick City. The construction works were featured in a postcard issued by Kathleen Molloy. Whilst some might be surprised to see a lady in front of the girder, she is a reminder of Alice Perry – Ireland's (and possibly the world's) first woman to graduate with a degree in Civil Engineering, graduating in 1906. She assisted her father James, county surveyor of Galway's Western Division during her undergraduate years and when he died shortly after her graduation the county councillors unanimously appointed her as temporary county surveyor until a permanent appointment could be made. She qualified at the technical interview and was one of five candidates (out of eighteen) nominated for the councillors to vote on. She was unsuccessful at the election stage. She didn't canvass for votes and even if she did she could not have been appointed as she was younger than the minimum age set down by statute for the position. Alice was twenty-one and the required minimum age was twenty-six.

Navigation

As an inland navigation centre, Portumna was a regular port of call for barges and river steamers such as the *Ballymurtagh* and the *Countess Cadogan*. Both vessels have been immortalised on postcards. The *Ballymurtagh* was built for the Wicklow Mining Company and named for their principal mine in the Vale of Avoca, the largest copper mine in Europe during the late eighteenth and early nineteenth century. The company was involved in both prospecting and mining operations around the country. Some of these sites were in areas served by navigable rivers or canals so the firm had its own small fleet of barges. These were sold on during the 1860s. The *Ballymurtagh* was bought by the Grand Canal Company in 1868 for £650 (€835.33 in today's money) and saw regular service on the Shannon until she was scrapped

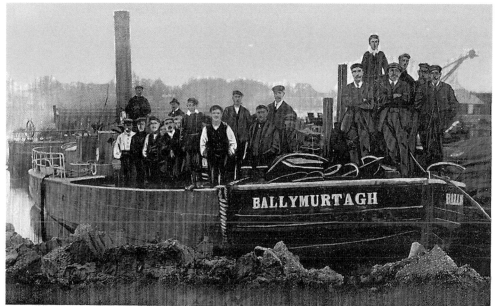

CANAL BOATS PORTUMNA.

Photo by K MOLLOY

Ballymurtagh Portumna, originally photographed c.1905; reissued in 1910 with at least ten poeple added

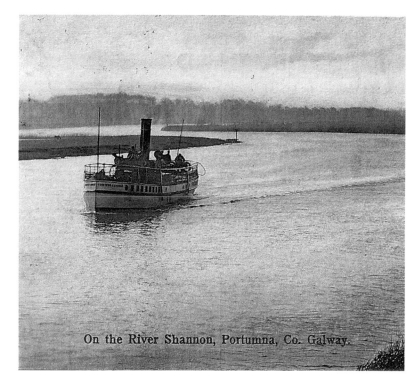

On the River Shannon, Portumna, Co. Galway.

Countess Cadogan 1900

in 1928. She was a frequent visitor to Portumna during her working life and was photographed by Kathleen Molloy in the Canal Company's harbour upstream of the old bridge. The original photo showed only a small group of people on board. The six people on the bow and another group behind the man and boy were added in at a later stage during the printing process. The extras added were, in all probability, involved in the construction of the present bridge and if so this would date the issuing of the card to 1910.

With the abandonment of the country's inland navigation system for the transport of goods, the harbour became overgrown and inaccessible but, thankfully, the revival of interest in our inland waterways led to it being cleaned out and given a new lease of life. Although officially called Connacht Harbour, it was known to generations of Shannon boatmen as Spooky Harbour as the ghost of a drowned bargeman was reputed to have appeared on more than one occasion. The spectral apparition may well have been induced by indulgence in some bottled spirits.

The first steamer to work on the Shannon was the *Lady Lansdowne*, which arrived on the river in 1831. Steamers were used both to carry passengers and tow cargo barges across the lakes. After the Famine the

Portumna Castle
c.1903

Old Castle Portumna Photo by K Molloy.

passenger trade increased substantially as emigrants were ferried downriver to Limerick docks. The passenger trade went into a decline during the 1870s but was revived in the late 1890s by the Shannon Development Company who, in 1897 placed six steamers on the river including the *Countess Cadogan*. They had secured grants from the various counties adjoining the Shannon. Galway's contribution was £1,750. At the Summer Assizes of 1897 the County Galway Grand Jury were complaining about the slowness of the company in implementing its services from Williamstown Harbour (then in County Galway) and Rossmore Quay. The Board of Works did not complete the quay until 1898 and in time-honoured tradition it fell to the Grand Jury to construct the roadway leading to it. The public purse being used to subsidise private enterprise is not a new thing. *The Countess* was built by Bow McLachlan of Paisley, Scotland. As well as being used for regular passenger services, she was often charted for excursion trips like the La Sainte Union Convent Banagher outing in 1902. She also saw regular service ferrying pilgrims up river to Athlone where they boarded the train to Claremorris on their way to the Knock shrine. In 1913 *The Countess* was transferred to Lough Corrib where

she remained in service until 1917 when she was sold off to Nicholas Cook of Aberdeen. She was still in use as a working boat in 1930.

Portumna Castle

The Castle was, in reality, a semi-fortified house and was built sometime before 1618 for Richard Burke or de Burgo, fourth Earl of Clanricarde at a reputed cost of £10,000. The Castle is a fortified manor house. It has a central rectangular block with four flanking towers and musket loopholes built into the walls so that attackers could be fired on without the defenders having to expose themselves to risk. The house and lands were confiscated by the Cromwellians and granted to Henry Cromwell but after the restoration of the monarchy in England the Castle and estate were returned to the Clanricardes, who lost them again as a result of supporting James II in the Williamite War. John, the ninth Earl was declared on outlaw, which meant he could not regain the estate. John bought a private act of the English Parliament which reversed his outlawry in return for a fine of £25,000 and an undertaking to have his estate put under the management of trustees for the

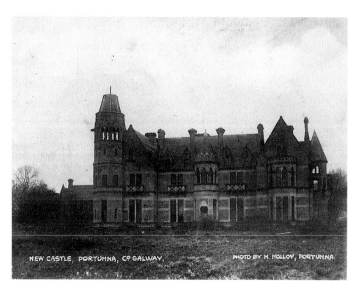

New Castle, Portumna c.1903

benefit of his sons who were to be raised as Protestants and educated at Eton. Thereafter the Clanricarde clan was loyal to England. In 1793 John, the thirteenth Earl was instrumental in raising a new regiment for the British army: the 88th or Connaught Rangers. The Castle was reduced to a shell in an accidental fire in 1826. Some of the estate buildings were fitted out as temporary accommodation for the occasional visit of the family. In 1862 Sir Thomas Newenham Deane designed a gothic-style mansion for Ulick John Burke, the fourteenth Earl and first Marquess Clanricarde. The house was never fully completed and remained unoccupied for most of its existence. Ulick John's successor, Hubert, lived the last years of his life as a semi-recluse in rooms in the Albany Club in London. He is remembered as a bitter foe of tenant rights and for his bitter stand in the courts in opposing the reinstatement of evicted tenants. He never married and on his death the estate passed to a distant relative, Henry Lascelles, sixth Lord Harewood, who was married to Princess Mary. Lascelles proposed restoring the Castle and engaged a noted architect, John Bilson from Hull, to prepare the necessary plans. However, due to the War of Independence the idea was shelved. The new gothic-style Portumna Castle was burnt in 1922. Its ruins were demolished during the 1950s to provide stone for the new Catholic Church, which was built on the old fair green. There is a framed architectural drawing of Deane's house hanging in the Portumna branch library.

Priory

The original church on the site of the Priory was founded by Cistercians who had come from Dunbrody Abbey, Co. Wexford. The church was dedicated to Saints Peter and Paul. The Cistercians had come to Ireland following the Norman invasion. Their first foundation was at Dunbrody. When the Normans began to settle west of the Shannon the Cistercians followed. William de Cogan, a tenant of Richard de Burg, invited the Dunbrody community to establish a daughter house on his lands sometime after 1226. They named their foundation for Saints Peter and Paul. The history of the Cistercian occupation of the site appears to be shrouded in the mists of time. By 1414 their foundation was an empty ruin that the Dominicans had taken over as a site for a new foundation. In that year a Papal Mandate was issued granting a ten year indulgence to anyone contributing to the building of the church of the 'Annunciation of Saint Mary' and the convent. This was renewed in 1426. The Portumna foundation was closely connected to the Dominican Abbey in Athenry for very many years. Most of the building remains date from the fifteenth century. The friars lost possession of the Priory about 1584 when the property was granted to Ulick, third Earl of Clanrickarde. A John King, one of the commissioners of Connaught was in possession of the Priory from 1606 until 1611. It would appear that the Dominicans resumed discreet occupation of some of their lands about 1613. In 1640 the Dominican convent was elevated to Priory status. The Cromwellian confiscations saw Henry Cromwell take possession of the Clanrickarde estates. After the restoration of Charles II as King of England the estates reverted to the Clanrickarde family. Again the Dominicans returned but after the Williamite War and the introduction of the Penal Laws they finally abandoned the Priory and moved to the nearby, but secluded, Boula. In 1762 a portion of the church was re-roofed and adapted for use as a parish church by the Church of Ireland. The church was described in the early years of the nineteenth century as small, plainly decorated and

East Window, Dominican Abbey,
Portumna c.1905
Looking into Priory

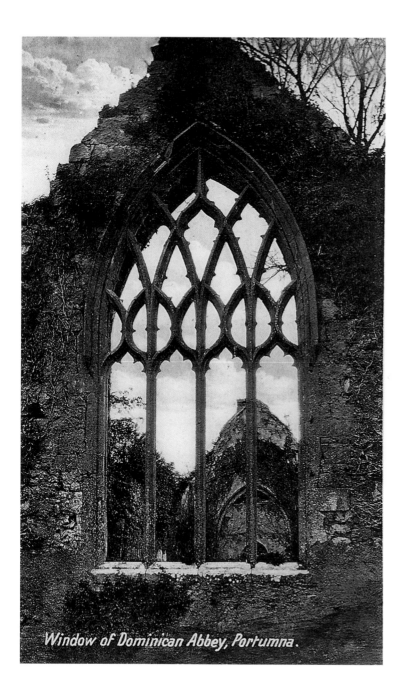

Window of Dominican Abbey, Portumna.

gloomily lit. This was, no doubt, caused by the ivy growing across the windows. Some of the ivy had by then grown into the church under the roof. The church remained in use until 1832 when the new parish church was opened. The ivy continued to grow over the Priory ruins until they were taken into state care in 1951. The Office of Public Works completed conservation and cleaning of the site in 1955. The two cards feature the east window of the Priory: one photograph was taken from the outside looking in and the other was taken from the inside looking out and features an open tomb below the window.

Portumna Union

Grand Juries were essentially an administrative system set up to enforce the legal system by presenting prisoners within a county area for trial. By 1634 they had acquired the power to tax areas to maintain, repair or construct causeways or bridges. This began their involvement with the road network. Road maintenance and repair was still carried out under the Statute of Labourers or seven day labour system. This meant that tenants had to provide seven days free labour on roads that required repair. In 1765 French of Monivea introduced legislation which abolished this archaic feudal system and introduced the presentment system where taxes were raised to provide funds to have the work done by contract labour. Gradually the Grand Juries acquired other powers such as enforcing the Weights and Measures legislation. They had, from 1635, the power to raise taxes to build and maintain 'houses of correction' or prisons in their respective counties. In 1727 further legislation was passed enabling the Grand Juries to construct and maintain hospitals and lunatic asylums, support dispensaries, carry out poor relief measures and pay police. As the Jury members were selected by the county sheriff and not elected they were, essentially, non-democratic bodies. There were regular

complaints of corruption, favouritism in paid appointments and jobbery in road contracts. To try and deal with this latter problem the office of county surveyor was set up in 1834. The Poor Law Union was introduced into Ireland to administer relief and the workhouse system. Its members were to be elected by those who paid the Poor Law rates which were levied on landowners and tenants, thus introducing the first step in democratising the Irish administrative system. Gradually the remit of the Unions was extended to cover regulation of slaughterhouses, bake houses, cemeteries and graveyards, and to appoint sanitary inspectors to control pollution. They also were given powers in relation to providing housing

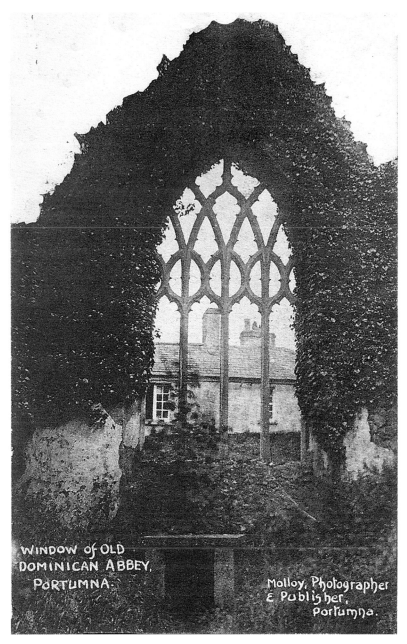

East Window, Dominican Convent c.1903
Looking out. Note open tomb in foreground

Business Postcard
Portumna Poor Law Union
1910

in rural districts. In 1899 when the Grand Jury system was abolished the Unions' functions were merged into the Local District Councils and their controlling authorities the County Councils. The southern boundary of the Portumna Union was north of the then county boundary with a number of Galway parishes in the Scarrif Union. These areas were transferred to the newly formed Clare County Council. Similarly a portion of the Barony of Ross was transferred to Mayo and the old parish of Creagh was transferred from Roscommon to Galway. County boundaries were never sacrosanct; they were created as administrative boundaries and as such can be altered to suit changing circumstances.

Kilconnel Friary c.1900

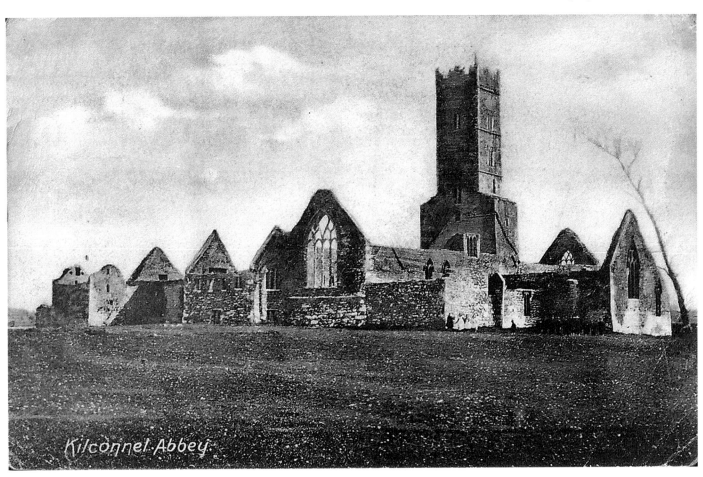

Chapter 3 **North**

Claregalway, Tuam, Kilbannon, Milltown, Glenamaddy, Moylough, Kilkerrin, Monivea.

Claregalway

Claregalway Friary was founded sometime between the years 1250 and 1256. After the suppression and confiscation of the monasteries in the reign of Henry VIII, the Friary was granted to Richard de Burgo by Elizabeth I in 1570. The friars, however, continued to live in the area. During the Elizabethan wars Sir Richard Bingham quartered troops there and the church was used as a stable. Considerable damage was caused to the buildings. After the rebellion of 1641 the friars started to restore the Friary but had to abandon the work due to the troubles of the time. However, the friars didn't abandon

Claregalway Friary c.1890

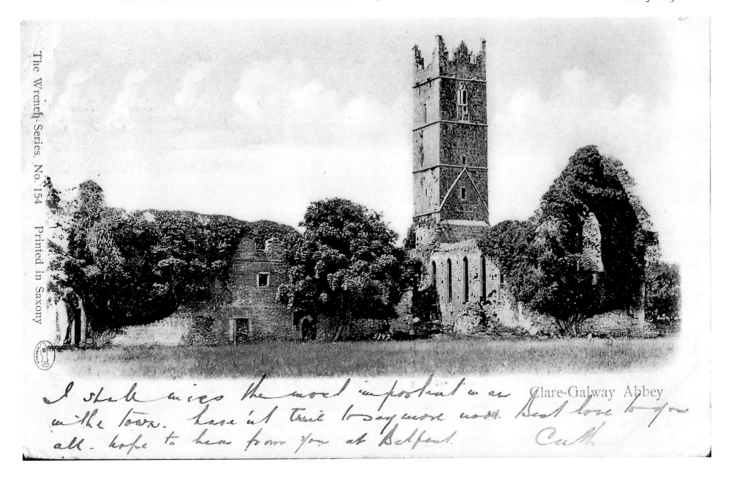

the area and were recorded as having a mass house in a part of the church which they had fitted up for this purpose. In 1798 some English militia stopped off here on their retreat from the Battle of Castlebar. Having taken all the food and provisions from Father Blake, the prior, they proceeded to wreck the little church. The friars continued to live on in the area and managed to restore their little church, which served as a parish church for Claregalway until a new church was built. Work began on this church in 1838 but the building was badly damaged on the Night of the Big Wind, January 6th 1839. The new church was finally consecrated in 1858. Thereafter, the small church in the friary was used to celebrate mass once a year until 1909. The new church was demolished in 1974 and its replacement was consecrated on August 15th 1975. The friars only ceased living in the Friary in 1847, ministering to their flock from their friary in Galway from then on.

Tuam

Tuam is said to derive its name from Tuaim dha ghualainn – the mound of the two shoulders – an ancient burial mound. Saint Jarlath established the first Christian settlement at this site and this eventually developed into the town of Tuam. It was, in former times, called a city – primarily because it had two cathedrals – and was the centre of two archdioceses, one Roman Catholic and the other Church of Ireland. Tuam was a market town and most of its businesses depended on the farming community. The major slump in the agricultural sector that occurred with the ending of the Napoleonic War in 1815 had a severe impact on Tuam and elsewhere. The collapse of Ffrench's Bank the previous year made the Tuam situation far worse than that prevailing elsewhere. The bank had debts of £250,000 including over £190,000 of unredeemable banknotes that it had put into circulation. The knock-on effect of the combination of these two events hit the agricultural sector severely and,

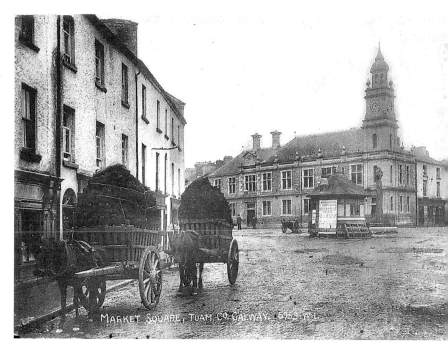

MARKET SQUARE, TUAM, CO. GALWAY. 5759 W.L.

Market Square, Tuam c.1903 Note poster for Vivograph Moving Pictures

in turn, affected the town's business community. The enormous growth in the population fuelled by evicted tenants did little for the town's prosperity. The growth in pauperism was so bad that Tuam Corporation instituted a scheme to licence beggars in June 1818. The town beggars were to be issued with badges. Anyone found begging without a badge was to be driven out of town. The practice of licensing beggars and issuing them with badges was introduced by statute during the reign of Elizabeth I and gave rise to the term 'Bang Beggars'. Tuam would appear to have issued the last 'Beggars Badges' produced in Ireland.

These badges are not Tuam's only claim to numismatic fame. The town was the centre, on an occasional basis, of coin counterfeiting. A counterfeit 1804 Bank of Ireland six-shilling piece was found under the floor of a shop in Shop Street during renovations in 1940. It had been mutilated in accordance with an act passed in 1710. It was a crime to be in possession of counterfeit coin so the mutilation was the shopkeeper's

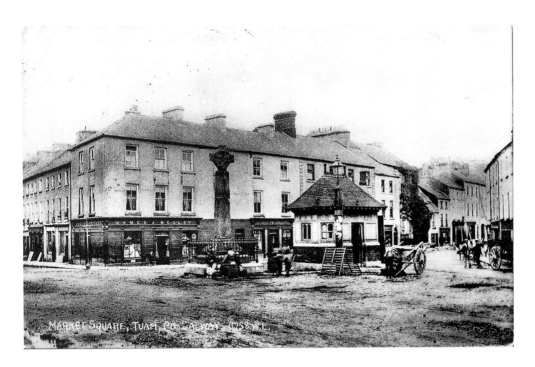

only protection as the coin could not be passed off in that condition. A hoard of about thirty counterfeit Victorian florins, or two shilling pieces, is also known to have come from the town. In November 1928 counterfeits of the new Saorstat Eireann florins were circulating in the locality. The new Irish coinage had only been issued some weeks previously.

Market Square, Tuam c.1900

Market Square

The market square played an important role in the commercial life of the town and occupied a prominent position at the urban centre. As well as catering for the local market, the square was used in the early nineteenth century for public floggings. During the agrarian unrest in the 1820s people convicted of being in the Ribbonmen were flogged here. A story is told about some unfortunates from Kilbannon who heard that their village was about to be attacked by a party of Ribbonmen one night. The Kilbannon group set out to intercept them but in the darkness mistakenly attacked a party of militia. Those who were arrested were charged and convicted of being Ribbonmen and flogged. Election riots occasionally started here also. On the nights of the 7th, 8th, and 9th of August 1837 serious rioting occurred and two people were killed. Prior to the building of the town hall the square contained a large market house which was demolished when the new civic offices were opened in 1859. The RIC went on a drunken rampage in the town on July 20th 1920, following an ambush in which two of their colleagues were shot dead. They set the town hall on fire and the building was gutted. It was restored in 1925. The old market house was replaced by a small market toll house which is shown in the two cards of the square. One of the cards features a large billboard advertisement for the Vivograph Moving Picture Company's newsreels of the Boer and China wars. Travelling cinema shows visited many towns around the country during the early years of the last century. The entire area has been revamped in recent years and the High Cross has been relocated in Saint Mary's Cathedral.

High Cross

Tuam would seem to have had four high crosses at one time. The large cross that formerly stood in the Square was created by adding the head of one cross to the shaft of another. Both parts of the hybrid cross date from the twelfth century. Despite some local controversy, the Market Cross was relocated to the inside of Saint Mary's Cathedral. This was done to protect the cross from acid erosion caused by traffic exhaust fumes and, indeed, to protect if from possible collision damage.

The cross head was in the grounds of Saint Mary's in the early years of the nineteenth century. Part of the shaft was found in the chimney of the Dean's house when it was being demolished and the base was in the Catholic Cathedral. Both churches claimed the cross and an unseemly dispute arose. A compromise solution was reached; the cross was erected in the Square for all the people of Tuam. Saint Mary's also houses the shaft of a third twelfth-century cross. This was unearthed from within the old Church of Ireland Cathedral. The head of a fourth high cross was discovered in Bishop Street in 1926. It was housed in Saint Jarlath's College until 1976 when it was moved to the Mill Museum. It has since disappeared and is believed to have been stolen in 1981. The inscriptions on the base of the Market Cross call for prayers for Turlough O'Connor and for Raflath Hessian who made the work and also for Aedh Hessian.

Saint Mary's Cathedral

Saint Mary's Cathedral is primarily a nineteenth-century gothic revival building. It was designed by Sir Thomas Deane, who had the good sense to consult with the leading antiquarian of the day, George Petrie, on incorporating the twelfth-century chancel arch into the new church. This is one of the most outstanding examples of Hiberno-Romanesque art in the country and is the only remaining part of the original cathedral built during the reign of Turlough O'Connor. The cathedral

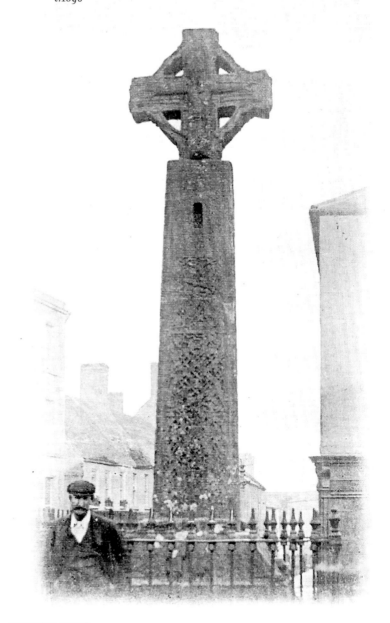

Early View of Tuam Cross c.1890

SHAMROCK SERIES.

The Tuam Cross.

St Mary's Church of
Ireland Cathedral,
Tuam c.1895

SHAMROCK SERIES.

St. Mary's Protestant Church, Tuam.

was destroyed by fire in 1184. Only the chancel survived. During the fourteenth century work on rebuilding the cathedral was commenced by George de Bermingham, who died in 1314. The work was completed by his successor. The chancel arch became the porch of the new edifice and remained as such until Deane's cathedral was erected. Deane left the arch *in situ* and ensured that it would occupy its original position relative to the rest of his church. There was some controversy about the proposal to build the new cathedral.

In 1861 Dean Charles Seymour, who headed up the campaign for the new building, claimed that during his ten years in Tuam the Protestant population had doubled in size to about four hundred people. He also predicted that the population would increase further because the town had become a railway terminus. In the event the arrival of the railway to Tuam brought competition for local industries and ready access to mass-produced, and therefore cheaper, goods, which led to a decline in the town's manufacturing base. Deane's original plan had been to demolish the old cathedral in its entirety, which meant that the fourteenth-century work would be cleared. Work began on March 4th 1871 with the demolition of the old cathedral tower. The construction work was started on the west side of the chancel, leaving the old cathedral intact but scheduled for demolition at an appropriate time. However, at a diocesan synod held in September 1876 it was decided that the old cathedral be retained and adapted for use as a synod hall. Thus, de Bermingham's building survived. The cathedral was consecrated on October 9th 1878. The new spire is 180 feet high and is surmounted by an eighteen-foot iron cross weighing one ton. The final cost of the construction work was £15,000.

The Cathedral of the Assumption

Work began on the cathedral in 1827 and the building was completed in 1837 to the design of Dominic Madden. Madden resigned in 1829 as supervising architect as there was not sufficient funds to execute the entirety of his design. He was replaced by a Roscommon architect Marcus Murray, who revised Madden's original design. Archbishop Kelly, who was the prime mover in the project, died in 1834 shortly after the building was roofed. Archbishop McHale, who is commemorated in the cathedral grounds by a statue from the famous Victorian sculptor Sir Thomas Farrell, led the project to completion. The cathedral was consecrated in 1837 but the building debts were not cleared until 1924. Unfortunately, the ceiling and organ had to be replaced that year as the timber work had been badly damaged by death watch beetles. The building suffered some damage during the Night of the Big Wind in 1839, particularly the stained-glass window by Michael O'Connor of Dublin. Some sections of the stained glass were blown in by the gale. They were subsequently replaced.

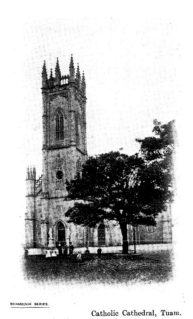

Catholic Cathedral, Tuam.

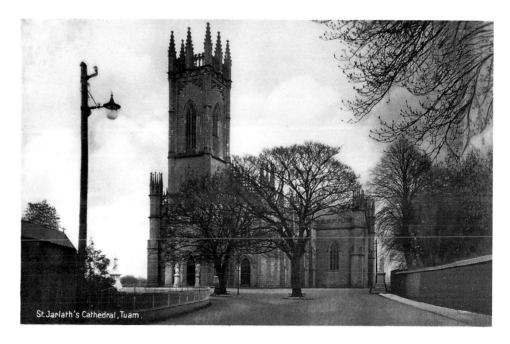

St. Jarlath's Cathedral, Tuam.

Saint Jarlath's

After the death of Archbishop O'Queely in 1645 no Catholic Archbishop resided openly in the town until the appointment of Dr Dillon in November 1798. In 1800 he established a Diocesan College with Dr Oliver Kelly as headmaster. Before the college could open he had to obtain a licence from the Protestant Archbishop of Tuam. This was sought on October 13th 1800 and was granted four days later. Kelly had to take an oath of allegiance before taking up his appointment. The school opened in two thatched cottages in the Mall but by 1817 these premises proved inadequate so the college authorities bought the former headquarters of Ffrench's Bank and relocated.

The spectacular crash of Ffrench's Bank in 1814 left debts of over £250,000 (at least €60 million in today's money) and caused financial devastation in County Galway. The bank had issued large quantities of its own banknotes and it is estimated that there were around £190,000 worth of these in circulation at the time of the crash. These were unredeemable afterwards.

Left:
Catholic Church,
Tuam c.1895

Above right:
St Jarlath's
Cathedral, Tuam
c.1910

In 1823 Hely Dutton gave the following account of the school:

There is also in Tuam the College of St Jarlath for the education of Roman Catholics, under the superintendence of the Roman Catholic Archbishop of Tuam. Many young men are educated here for the priesthood and are sent to the College of Maynooth previous to their taking orders. I am well informed it is admirably conducted and every person who has often been to Tuam must bear testimony to the respectable appearance and remarkable propriety of behaviour of the students at such periods as are devoted to study.

Fr Thomas Feeney was the College President at this time. He was appointed in 1818 when Dr Kelly was appointed archbishop in succession to Dr Dillon. He retired in 1835 when he was appointed parish priest of Kiltulla. In 1824 the school was extended by the acquisition of two properties in Bishop Street. During the early years of its existence St Jarlath's had to be subsidised by a levy of £2 per year to be paid by every

McHale's Statue, Tuam in its
original position 1900

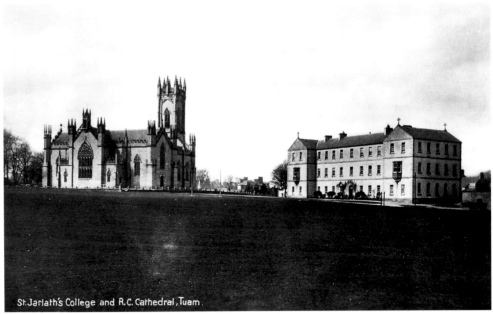

St Jarlath's College and R. C. Cathedral, Tuam c.1910

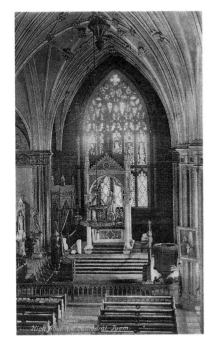

Interior St Jarlath's, Tuam c.1890

parish priest in the archdiocese. Finances obviously improved because a new school was built on Keighrey's Park after Archbishop John McHale acquired the site in 1856. McHale rented a portion of the lands to the Town Commissioners as a fair green at £35 per annum. This arrangement continued until 1875. Major extensions of the college were constructed in the 1950s and 1970s. The college would appear to have had a strong nationalist bias as two of O'Donovan Rossa's sons, John and Gerry, were educated here as was the son of Michael Larkin, one of the Manchester Martyrs. Michael McCann, the composer of 'O'Donnell Abu', taught Mathematics here during the 1840s. James Stephens, the leader of the failed 1867 Rising made his escape to America dressed as a priest from St Jarlath's.

Presentation Convent

Archbishop McHale was keenly interested in providing educational facilities for his flock and was responsible for the introduction of both the Presentation and Mercy Sisters to Tuam. Almost immediately

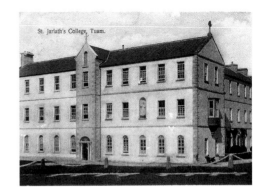

St Jarlath's College, Tuam c.1905

after his appointment he invited the Presentation Sisters from their Galway house to establish a convent in the town. The sisters established their first primary school in a thatched building that was located just off Bishop Street. Construction work started on the convent

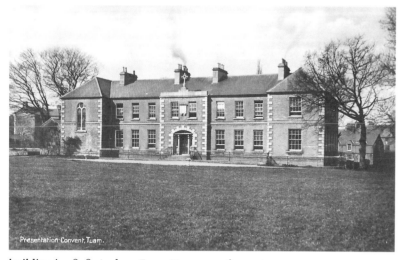

Presentation Convent, Tuam.

building in 1848. Andrew Egan, Tuam was the contractor and the architect was Henry Hart. The contract price was £4,000. McHale was opposed to the, then, new system of national schools so the nuns could not apply for recognition by the National Board of Education. This meant that they were ineligible for any grants and so had to fund the school out of their own resources. It was only in 1882 when Dr John MacEvilly had succeeded McHale (who had died in 1881) as archbishop that the school came into the national school system. By then the school was a two-storied slate-roofed building, built out of funds bequeathed by William Burke of Currylea. Once the school was in receipt of capitation grants the nuns were able to develop a series of classes for older girls. The curriculum included music, drawing, practical cookery, bookkeeping, poultry management, laundry work, sewing and dressmaking. The Presentation Convent Technical School was born. It was recognised under the South Kensington Science and Arts grants

Above: Presentation Convent, Tuam

Right: Convent of Mercy, Tuam

scheme in August 1896. The Technical Instruction Committee of Galway County Council approved a scheme of instruction in cookery, laundry and needlework in 1901. The school's first report to the committee in April 1902 mentions that twenty-five girls who had attended all classes in the three courses had secured employment. The Presentation Sisters opened an intermediate school in 1912. This was in reality a development of their technical school. Poultry management was dropped; sewing and dressmaking became ornamental; needlework and shorthand, art, typing, and French were added to the curriculum. A new intermediate school was constructed in 1924 which in turn was replaced as pupil numbers grew.

Convent of Mercy

The Presentation Sisters because of the rules of the order were cloistered, which meant, amongst other things, that they were not able to teach religion to classes of children and their parents at the cathedral.

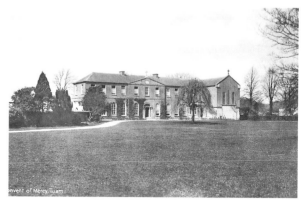

Convent of Mercy, Tuam

Archbishop McHale decided to invite the Mercy Sisters to come and set up a convent in the town. The first sisters travelled from Carlow, via Dublin, arriving in Tuam on January 13th 1846. They began working in the workhouse almost immediately and also opened a temporary hospital in a disused barracks. When conditions improved they converted this into a school before,

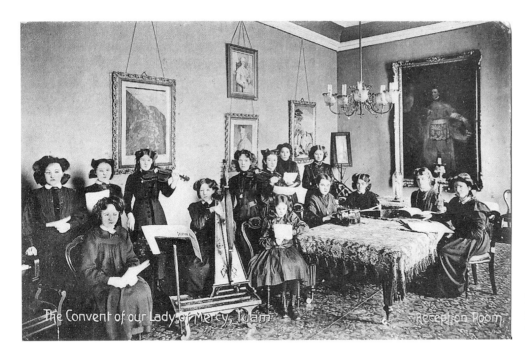

*Reception Room,
Convent of Mercy,
Tuam*

eventually, constructing a new one in the convent grounds. As Archbishop McHale was totally opposed to the national education system, the new school had to be run out of convent funds and whatever money the nuns could raise themselves. In 1882 they were permitted to enter the state system by McHale's successor. Shortly after this in 1884 they opened a boarding school. Some of the pupils of this school appear on a school postcard issued in the very early 1900s.

By 1894 the nuns were running courses in domestic science and lace making. In 1896 their efforts were recognised by the South Kensington Science and Arts grant scheme and the Mercy Convent Technical School was created. They were recognised by the Technical Instruction Committee of Galway County Council in 1901. In 1911 the nuns joined the intermediate scheme and created the secondary school. The postcard featuring the school choir and accompanists – two violinists and a harpist – was issued by the school as an advertisement for their boarding school. The photograph would appear to have been taken in the visitors parlour sometime about 1900.

Kilbannon

Benen is reputed to have been a disciple of Saint Patrick. He is venerated at the first station on the climb to Croagh Patrick and is also associated with Inish Mor. Benen built a church here within an earlier pre-Christian enclosure, Dún Lughaidh. This had been presented to him after he had baptised Lugnaid, a local chieftain, and his family. This church was reputedly burnt about 1114 and later replaced by a Romanesque structure. This in turn was replaced about 1428. The surviving ruins are the remains of this later building. All that remains of the twelfth-century church is a sandstone voussoir with floral motif decoration. The round tower dates from about the year 1000. There is considerable folklore associated with Saint Benen's Well which is located nearby. It is supposed to have sprung up when Patrick and Benen lifted a sod. The two saints then proceeded to baptise and cure lepers. There is a well in the area called Tobar na Laour or the Leper's Well. In another legend about Benen's Well it is said that as Benen was setting out on a journey his chariot driver was informed of a planned ambush. He persuaded Benen to change places with him.

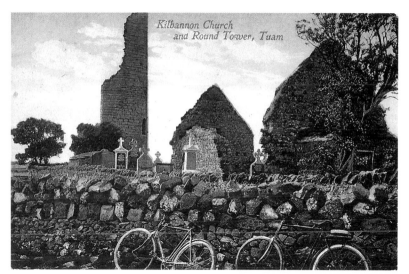

Kilbannon Church and Round Tower, Tuam

Kilbannon Church & Round Tower, Tuam

The attackers mistook the driver for Benen and beheaded him. The well is reputed to have sprung up at the place where the drivers head fell.

According to Tuam tradition, Jarlath is supposed to have set out from Kilbannon to found his own church. He was advised by Benen that God would choose the site which would be where his chariot wheel would break. The shortness of the trip doesn't say much about the quality of either north Galway roads or chariots at the time. A variant of the story comes from the parish of Moore in south Roscommon. According to the tradition here Jarlath was staying at Clonmacnoise when he got the urge to establish his own monastery. He went to Ciaran to obtain his blessing for the journey. Ciaran not only blessed him but gave him the best chariot available. Ciaran was a good judge of these things as his father had been a chariot maker. Ciaran is reputed to have advised Jarlath to travel northwards after crossing the bridge and not to stop until the wheel of his chariot would break. The story was used to explain why Moore is an island parish of the Archdiocese of Tuam. Whilst the story might appear to be merely an amusing one it, and indeed other folklore, led Bernard Larkin of Moore to locate the

remains of a timber bridge at Clonmacnoise in 1929. According to the late Fr Patrick Egan, author, historian and long-time president of the Galway Archaeological Society, he himself accompanied Larkin on the second expedition to locate the timbers in 1934. Archaeologists located the bridge remains in 1994 after being informed of an impending sub-aqua dive to locate and photograph the bridge which has been dated to the early ninth century – a bit after Jarlath's time! Whether Jarlath set out from Kilbannon or Clonmacnoise makes no difference, Tuam is content with having a broken wheel on its crest.

Milltown

Milltown Races were a major event on the social calendar for north Galway and indeed further afield, particularly after the opening of the railway between Tuam and Claremorris when Milltown was connected to the rest of the country through the rail network. The races were held at different venues around north Galway during the early years of their existence. In 1840 they were run at Dalgin but by 1877 the races had found a permanent home at Milltown. There were three races run at the meeting: the Dunmore Plate for ten guineas; the Milltown Plate for nineteen guineas; and the Consolation Plate for three guineas. The game of 'Aunt Sally' was prohibited at the grounds. The date for the races was changed to Easter Monday in 1894. Toft's Amusements were a regular attraction at the races. By Easter Sunday the hobby horses, swing boats, shooting gallery and side shows were set up and open for business. Lent was over and people could enjoy themselves again. The races were only held on an intermittent basis during the 1940s and early 1950s because of the reduced travelling facilities available. The races were revived in 1956 and a local committee was formed to organise an annual dancing carnival to raise funds for the annual race meeting. The revival in racing was, however, short lived and ceased in

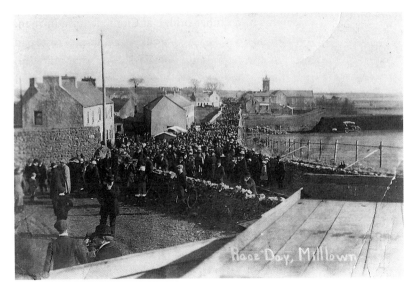

Race Day, Milltown

the 1960s. The carnival committee continued their annual fundraising event until 1981. After Milltown Races ceased the funds raised were used to fund the creation of local amenities such as the children's playground, the community centre and the amenity park by the riverside.

Glenamaddy

Under legislation passed in 1847 a number of new Poor Law unions were created. One of these unions was centred on Glenamaddy and the small straggling village of the early 1840s began to expand. The Poor Law administrative headquarters for the union was located in the workhouse thus giving the area some political status. The creation of Rural District Councils under the 1898 Local Government Act added to this as the Rural District Council was headquartered in the workhouse buildings. With the reform of the local government system in 1926 the Rural District Councils were abolished. However, the County Council maintained a local engineering office in Glenamaddy for many years thereafter before finally relocating that office to Milltown.

Glenamaddy, Co. Galway

During the Famine Andrew Finneran was awarded the contract to cut down the hills and fill the hollows on the Glenamaddy to Williamstown Road 'near the Police barrack at Glenamadda'. The contract price was £80. Finneran did not complete the contract. Pat Keaveney was contracted to complete the works for the sum of £12 at the Summer Assizes of 1848. At the Summer Assizes in 1848 Matthew Madden was contracted to maintain the road from Glenamaddy crossroads to Creggs for a seven-year period.

The workhouse is no more, the Council offices are long closed but Glenamaddy Cross lives on in official records and, indeed, in song.

Glenamaddy, Co. Galway

Summerville Lake, Moylough

During the 1950s and 1960s a major drive was undertaken to attract English coarse fishing and shooting enthusiasts to Ireland. It was seen as a mass-market as opposed to that for game fishing. There were many areas where excellent pike fishing was available. Summerville Lough was one such location as the blurb printed on the back of the postcard makes clear. It reads in part:

Summerville Lake, or Leacht Lake as it is frequently called, near Moylough Co. Galway, provides excellent pike fishing, and is also the haunt of wild duck.

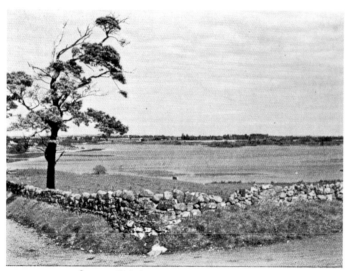

Summerville Lake, near Moylough, Co. Galway, Ireland.

lake shore was also quite some distance in from the road rather than beside it as it is at the present time.

Kilkerrin

Kilkerrin is shown on the first edition Ordinance Survey map as having only three widely-spaced houses and a Catholic church. Lewis's Topographical Dictionary (1847) records that there were three Catholic chapels in the parish, two of them located in the village. Either he was mistaken or else one chapel had been decommissioned and replaced with a new one. It is worth noting that a number of provincial newspapers from around the country were critical of the errors that had appeared in the first edition of the Dictionary. The Protestant chapel had been rebuilt at a cost of £605. The Ecclesiastical Commissioners contributed £555, and the balance was raised locally. The chapel was not located in the village which, by the 1890s, had grown somewhat to the size shown in the postcard. It had acquired a Constabulary Barrack. The whitewashed wall and gate pillars marked its roadside boundary. A market area had been created beside it and a market crane erected. Virtually all the buildings shown had been built during the post-Famine

Summerville Lake, Moylough

The value of this aspect of tourism at this period of time should not be underestimated. Significant numbers of anglers travelled to Ireland because of the relatively free access to areas such as Summerville. In Britain access to most river and canal fishing was controlled by either angling clubs or private owners. Anglers also were only allowed access to a limited length of bank due to the great demand. The visitors created a demand for reasonably priced accommodation leading to major growth in the bed and breakfast sector of the hospitality industry. The closer the accommodation was to the fishing area the better. In rural areas the concept of farmhouse guest houses took root in the provision of accommodation for anglers. Small fishing stands and piers as well as slipways were constructed to serve both local and visiting fishermen. The campaign prompted a number of vocational schools to start evening classes in boat building. This, in turn, introduced a large number of people to the beauty of Ireland's waterways. Summerville Lake has changed considerably since it was surveyed about 1840 for the first edition of the Ordinance Survey map of the locality. The lake was only about half the size it is today and is described as a turlough. The

Kilkerrin, Co. Galway

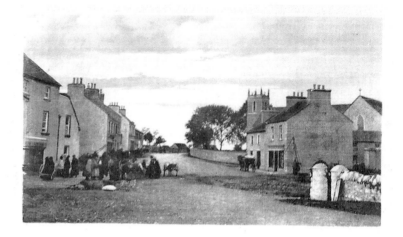

Kilkerrin, Co. Galway

era. The card shows a large group of women across the street from the market area. It doesn't appear to be a Sunday. It is probable that they are waiting for the 'Egg Man', who purchased eggs over a wide area, then boxed and exported them to the English market. The Athenry–Tuam–Claremorris railway link facilitated this. The trade was so large that the Taylor family built a

sawmill extension to their corn mill in Athenry where they manufactured egg and butter boxes for the export trade. The export trade went into decline during the Economic War. However, Cleeves Condensed Milk Company in Limerick purchased large quantities of homemade butter, which was used in the manufacture of toffee. The railway link to Limerick was used by the County Galway butter merchants to transmit large consignments of butter to the factory. These middlemen merchants often took the butter as barter in exchange for groceries and farm supplies. It should be remembered that farming did not produce a regular weekly income and a line of credit, or 'The Book', was often needed between fairs. Debts could be avoided or kept to the absolute minimum by trading in eggs and butter.

A news item from Faulkner's *Dublin Journal* for August 16, 1769 states that

at Kilkerrin, near Moylough in the County of Galway, was married a few days since a young woman about

Athenry and Tuam Railway Jurer's Card

25 years of age, whose mother about 40, granny about 60, great granny about 80, and great great granny about 109, were all present. What was most singular and entertaining was the sprightliness and vivacity with which the great great granny sang and danced.

That must have been a wedding to see!

Cormac Dall, the Bard of Dunmore

Cormac Dall or blind Charles Cummins was born in 1703 near Woodstock, Ballindangan, County Mayo. He contracted smallpox and went blind when he was only one year old. Later a benefactor organised harping lessons for Cormac; however, when the benefactor died Cormac's harping career died with him as his family couldn't afford to continue on with the lessons. Cormac had a great ability to memorise stories and songs, and he began attending rural wakes and gatherings where he earned a living by reciting and singing. He also composed songs either to praise his patrons or lament the dead in the tradition of the old Irish bards. He married twice and fathered seven children. After the death of his second wife Cormac settled at Sorrelstown, Dunmore where he lived with a married daughter. He wandered the country led by a grandson and gave his recitations at various gatherings. He is reported as having a good singing voice even after loosing all his teeth. William Ousley of Dunmore painted his portrait, an engraving of which was published by Joseph C. Walker in *Historical Memoirs of the Irish Bards* in Dublin in 1796. Cormac was still alive at that time. He is alleged to have been 110 years old when he died. He is buried at Kilclooney.

córmac o comám,
THE BLIND BARD OF GALWAY.

Monivea

The first member of the French family to own property in Monivea was Patrick who acquired the castle and lands from John Crossach O'Kelly in 1609. He was a prominent Galway trader and merchant who in 1610 was one of two emissaries sent to London to negotiate a new charter for the city. After Patrick's death in 1630 his son Robert began to acquire more land in the area and sought a baronial title from Charles the first. He took the

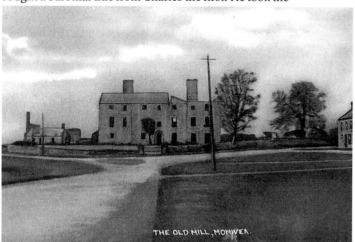

THE OLD MILL, MONIVEA.

Left: The Old Mill, Monivea

Royalist side in the Cromwellian War and had his lands confiscated. They were allotted to Mathias, the eighth Lord Trimblestown who had been transplanted from County Meath. Another Patrick French was granted lands in Corrandue; however, he died in 1701 without having regained his Monivea property. His grandson and heir Robert purchased the estate from John, the eleventh Lord Trimblestown in 1702. He conformed to the Established Church in 1709 and was a member of parliament for Galway from 1713 to 1715. He began a major programme of land reclamation and afforestation. His son, also Robert, continued this and was awarded a gold medal by the Dublin Society for his reclamation works. Robert continued the improvements and extension of the original tower house, creating a large manorial establishment.

Originally known as Newtown, the village of Monivea was Robert's creation and grew around the linen industry. Robert is credited with introducing the industry into the county in 1747, even though the trade in linen was several centuries old at that time. In 1492 Leonard Lynch of Galway sued a James Adurnus of Genoa for the cost of 6,000 bales of linen cloth. At a later date some landlords such as Patrick French, Robert's

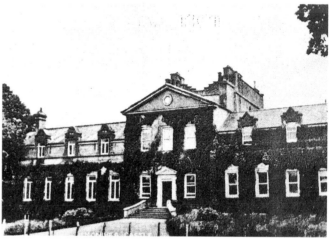

Right: Monivea Castle

father, were accepting linen in part payment for rents on his Monivea estate. What Robert did was turn a cottage craft into a highly organised local industry. After inheriting the estate Robert continued the drainage and land reclamation begun by his father. He had extensive flocks of sheep which yielded a reasonable income from the sale of wool. As the price of wool was dropping he turned his attention to flax cultivation. He brought in a large colony of weavers from the north, constructed a bleach mill and laid out a bleach green on both sides of the Galway road.

As an inducement to the initial colony of weavers, French offered small farms on lease for reasonable rent. As the colony grew he altered this policy to leasing just a cabin and small plot of ground to newcomers. The weavers had then to concentrate on weaving to earn a

Courtyard, Monivea Castle

living and wouldn't be distracted by farming pursuits. This stimulation of the industry worked well for a number of years but a slump in the demand for linen in the early 1770s affected the weavers ability to pay rent, which affected French's income. The decline in the weavers income had a knock-on effect on agricultural prices, which in turn hit French's rental income further. Robert came close to abandoning the whole operation but a revival in demand came in the mid-1770s. By 1776 Monivea had 276 houses, with 96 looms and 370 spinning wheels in operation. However, the death of Robert French in 1779 marked the beginning of a decline in Monivea's fortunes. The industry went into decline and by the 1790s the bleach mill and yards were disused. In 1797 part of the mill was converted into a wash house.

Robert had also set up a spinning school to have his tenants trained to produce linen thread for weaving under the auspices of the Incorporated Society for Promoting English Protestant Schools in Ireland. The school opened in 1755, having cost £275 to build. The Incorporated Society had given a grant of £300, and then gave a further grant of £200 to construct two other buildings in connection with the school. French then built a large 'nursery' for the province of Connacht to take in children aged between two and six years. Up to a hundred children could be taken in and groomed for transfer to the charter schools. The children were taken from different parts of Connacht and, indeed, Clare, sent to Monivea and subsequently sent on to charter schools elsewhere. The usual destination was Ulster where the children were trained for the linen industry. At least one Dublin orphan, George Hedfor, aged ten and suffering from smallpox, was sent west to Monivea in 1772. The charter school was closed after Robert died in 1779 and the children were all moved to the nursery that had been built at one end of the village facing the entrance gates to the demesne. When John Howard, the famous reformer, visited the school in 1788 he found 'twenty-two

CHURCH OF THE SACRED HEART, MONIVEA.

children, most of them from two to four years of age, in a very sickly condition, with the itch, scald head and sore eyes; some lay grovelling in the turf ashes'.

Howard blamed the Rev. Jeremy Marsh for the neglect. As head of the supervisory committee he had failed to carry out any inspection of the premises. Marsh, as trustee of Robert French's estates until the heir – Robert's infant grandson; also named Robert – would come of age was living at Monivea and so should have known of the conditions prevailing at the nursery. With the new Robert in control of the estate, which had been badly neglected, things began to improve. However, the school's days were numbered. It gradually became an institution catering for foundling girls and finally closed in 1826.

The nursery got a new lease of life in 1920 when it was converted to a steam-powered mill run by the Monivea Workers Cooperative Society, so when the postcard was issued the building was old and was a mill but was not 'the' old mill as stated. The bleach greens still survive on both sides of the Galway road through the village and are the only reminder of a once flourishing industry which supplied some ten per cent of the total Galway linen sold in Dublin in 1761. French had created and developed his village around the production of linen and when that went into a decline the village did also. The revival of the linen industry in Galway during the mid-1850s to 1860s bypassed Monivea.

The Protestant church was constructed as part of Robert French's attempt to create a Protestant settlement

at Monivea. The building was designed by Ben Johnston, who laid out the site in January 1761. The church was consecrated on October 28th 1769 by the Archbishop of Tuam. The Board of First Fruits had given a grant of £292 towards the construction costs. As well as providing the site, French paid for eight pews, the pulpit, a bible, prayer books and church linen. After Robert's death in 1779 Monivea went into a decline and the Protestant population slowly dwindled and finally disappeared in the 1940s. The church fell into disrepair and by the 1970s was an ivy-clad ruin. After the death of his wife French took his housekeeper as a mistress. She bore him seven children. Robert provided for them in his will. Local folklore had it many years ago that the lady was a Catholic and when the local priest did not show her sufficient respect as the landlord's mistress French had him evicted and his chapel demolished. This, allegedly, accounts for the division of the old Catholic parish between Abbeyknockmoy and Athenry. Thomas Reddington of Ryehill gave a site for a Catholic church at Caherlisakill, the nearest portion of his estate to Monivea village. Reddington also paid for its construction. This church is shown on the first edition of the Ordinance Survey map published in 1840.

Robert French was succeeded by his grandson, another Robert, who in turn was succeeded by his son Robert Percy in 1876. Percy married Sophie, only child of Alexander de Kindiakoff, a wealthy Russian aristocrat. Their daughter, Katherine Alexandra inherited both the Monivea estate and her grandfather's estates in Russia. After the death of her father Katherine had a mausoleum constructed to take his remains. She lost all her Russian property in the revolution but escaped to Manchuria where she lived until her death in 1938. She left the Monivea estate to the Irish people and the castle was to be converted into a home for 'indigent persons of both sexes, not to exceed ten in number and who have reached the age of sixty years'. No trees were to be cut down on the lands unless they had died. The State took a court case to have the will set aside, and so the estate passed to Katherine's cousin Rosamund and in turn to Rosamund's companion Miss Godwin Austen, an English lady. The lands and house were sold to the State, who demolished the large French house. The original O'Kelly castle was left standing.

Protestant Church, Monivea

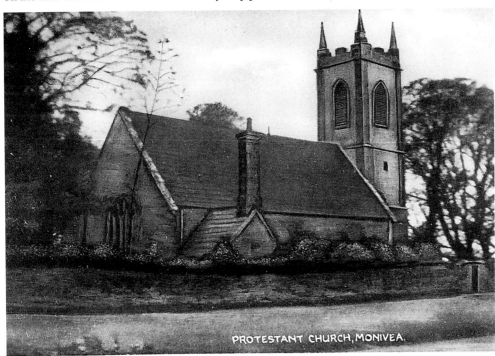

PROTESTANT CHURCH, MONIVEA.

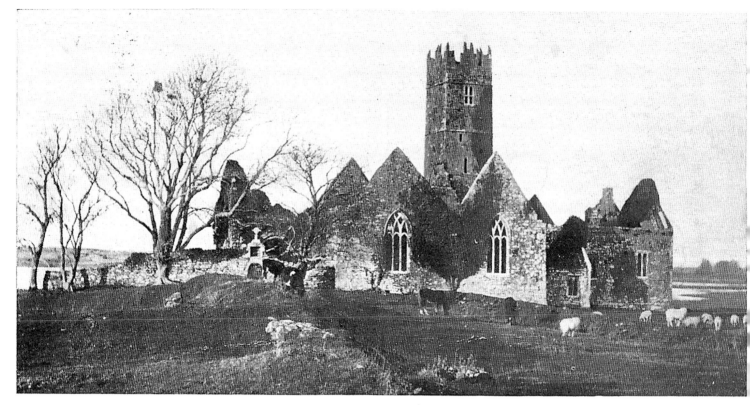

ROSS ABBEY, HEADFORD, Co. GALWAY.

Ross Abbey, ruined relic of the past,
How are thy former glories flown;
Thy Holy Cloisters open to the blast,
And thy once proud Altars overthrown.

And save some slimy things that crawl
In sinuous movements o'er thy walls,
And save the moaning of the breeze
Amid the few gray ancient shattered trees

That bend in withered grandeur nigh,
But not so withered half as I.
Beneath, around, and overhead
Thou art a holy dwelling of the dead.

Copyright.

Chapter 4 **Corrib Country**

Lough Corrib, Headford, Ashford, Coalpark, Clonbur, Carrowgarriff, Doon, Curraghrevagh, Inishanbo, Inchagoill.

Lough Corrib

Lough Corrib is the second largest lake in Ireland and is renowned for its fishing, scenery and antiquities. The works carried out as part of the first Corrib Drainage and Navigation Scheme resulted in the water level being reduced by two feet, thus reducing the incidence of flooding to surrounding lands. The lake creates a natural barrier between east Galway and Connemara. It provided a transport route for the surrounding area in an era when the road system was barely developed. It, now, provides a large recreational area which is used for sailing, cruising, angling, and simple pleasure boating. It also provides the water supply for a large proportion of the population of County Galway. Lying at the heart of the Corrib catchment, the lake is replenished by the rivers and streams of a significant area of the lands of north Galway, east Connemara, south Mayo and the area around Cloonfad in County Roscommon. The lake has a natural division at the narrows, which stretch from Kilbeg south to Annaghdown. Lower Lough Corrib, or the southern section of the lake, is relatively shallow with few islands and is lying in a limestone hollow. The surrounding country is flat and low lying and, despite two major drainage schemes, is still prone to flooding. The Upper, or Old, Lake by contrast has deep water and a multitude of islands and accordingly features on a large number of postcards, unlike the Lower Lake, which doesn't seem to appear on any.

Ross Errilly Friary

Experts differ on the date that the Friary was founded. Three dates have been put forward: 1351, 1431, and 1498. The fact that many of the major architectural features that survive date from the fifteenth century would tend to support one or other of the latter dates. However, local folklore supports the first date, as indeed does the Annals of the Four Masters and Father Luke Wadding. The local legend has it that during the Black Death that swept Ireland in 1348 and for some years after, Archbishop Malachy MacHugh prayed for divine intervention to stop the plague. He had a vision in which he was told to build a monastery for the friars. He was directed to go to Cordarra near Headford where he would receive a sign. He duly set out with two friars and when they arrived at Cordarra three swans rose up and flew before them, each carrying flaxseed in its bill, and landed on the bank of the Black River. When MacHugh arrived at the river the swans had disappeared. He found three bunches of flax growing in full bloom. This was taken as a sign as to where the Friary was to be built. MacHugh was a friar and was born in the Headford area so if he was going to have a friary constructed it seems

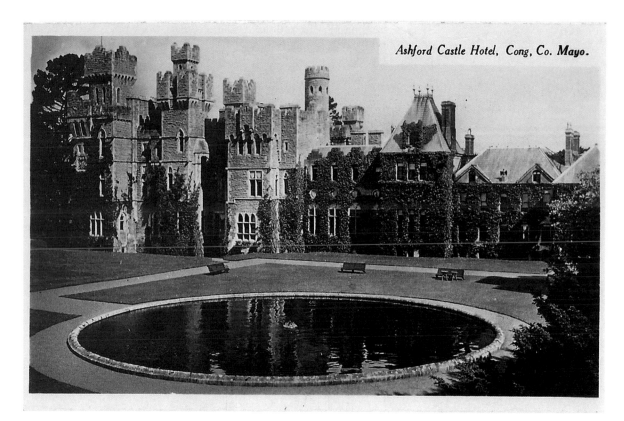

Ashford Castle Hotel, Cong, Co. Mayo.

reasonable to assume that it was going to be on his home patch. Every major religious foundation has its own miraculous story. Given Wadding's and the Four Masters' endorsement of 1351, it is possible that a friary was constructed in the fourteenth century and renovated and enlarged in the fifteenth century. The card was produced by J. McCormack about 1900.

Ashford Castle

Ashford was acquired by Benjamin Lee Guinness as a shooting lodge in 1855. His son, the first Lord Ardillaun, undertook major works to enlarge and extend the lodge, converting it into a baronial mansion. Joseph Franklin Fuller was the architect and Samuel Usher Roberts provided engineering advice and services. The revamped house incorporated a thirteenth-century tower house with the attached two-story hunting lodge that had been built by the Browne family in 1715. Benjamin Guinness had extended and altered the buildings but his son, Sir Arthur, the first Lord Ardillaun, extended it into the castellated mansion it is today. Residents of the Castle had a beautiful view of Lough Corrib from the garden terrace. The large circular water pond with its fountain was the centrepiece for a formal garden. The flower beds were laid out with bedding plants in the shape of Lady Ardilaun's initials. The bedding plants were changed before every house party. A youthful Oscar Wilde can't have endeared himself to Lady Ardilaun with his comments on her garden layout in 1872. When she asked him for his views on her garden he informed her that he found it quite dull. He suggested that she should have had the beds laid out in the shape of pigs' bodies and used flesh-coloured begonias to fill them in. This was a play on the family coat of arms, which featured a boar. The precocious eighteen year old told

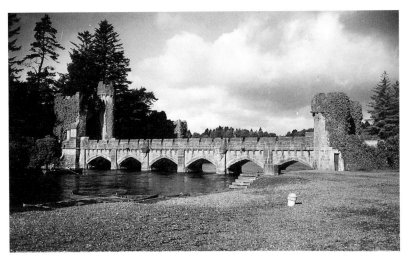

The Bridge, Ashford Castle Hotel, Cong, Co. Mayo.

In addition, a large moat was being excavated. The underlying rock had to be blasted prior to being removed. According to Moore, the moat was thirty feet wide and twenty feet deep and was to be protected by a battlement wall and cannons. Some fifty men were employed in creating the moat. George Ashlin designed a medieval style fortified bridge – including a working drawbridge – to complete the defensive works. The drawbridge tower had a heavy iron-studded gate that was closed and locked at night. As an added security measure there were two small cannons positioned near the main door of the Castle. These were trained at the bridge gate in case anyone would breach the defences. Arthur Guinness is reputed to have spent over £1 million on Ashford between 1870 and his death in 1915. The defensive works were, however, never put to the test.

her that this 'would have been the perfect culmination of absurdity'.

The Bridge, Ashford Castle Hotel, Cong

In 1880, when the Land War erupted Sir Arthur was so afraid of his mansion being attacked that he constructed some very expensive defence works. According to George Moore, who visited the house in 1880, massive demesne boundary walls were under construction and there were up to one hundred masons employed in the construction of the main entrance gate.

Lough Corrib near Ashford Castle

Coalpark

Located to the west of Ashford, Coalpark provides the motorist with their first real view of Upper Lough Corrib when travelling towards Maam. There was a quay or landing place here from the early nineteenth century onwards. It is possible that it dates back to the eighteenth century. In 1903 it became a steamer station with the arrival of *The Widgeon* on the lake. She had been brought from Enniskillen where she had traded on Lough Erne. After her arrival in Galway her name was changed to *Cliodhna*. Her captain was P. Walsh from Wood Quay. She serviced the Hill of Doon, Maam, Coalpark Quay, and Oughterard. On weekdays her timetable was: depart Galway at 7 a.m., arrive at Maam at noon after a stop at Doon, depart Maam at 2 p.m., stop at Oughterard and arrive at Galway at 7 p.m. On Fridays she would steam from Galway to Coalpark and begin the return journey at 2 p.m. This service lasted until 1908 when the *Cliodhna* was withdrawn.

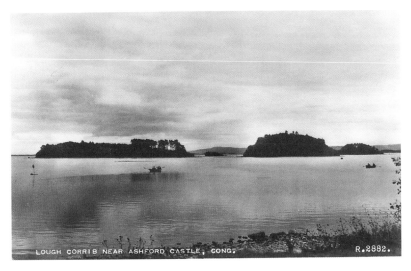

LOUGH CORRIB NEAR ASHFORD CASTLE, CONG. R.2882.

Carrowgarriff

The north-west corner of Lough Corrib was an area of sporadic mining activity over the past two centuries. Carrowgarriff is reputed to have had a lead mine in operation in 1800. David Stewart, a mineralogist with the Dublin Society, referred to a lead mine cut into the face of a mountain at the head of Lough Corrib in that year. A trial boring was made in the area in the 1870s but doesn't appear to have produced favourable results as George Kinahan states that no mining work was underway in 1889. However, in 1908 Clements' Mining Company were at work here and raised two tons of lead ore. Significant remains of this activity can still be seen. The ore was shipped down Lough Corrib to Galway for export. Records survive of a steamer carrying ore that ran onto rocks near Annaghdown and foundering.

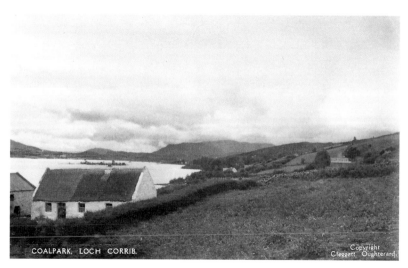

Coalpark, Lough Corrib

Doon

Further west on the Hill of Doon two shafts were also sunk. However, little is known about the activities here. Doon, a famous beauty spot is in Drumsnav townland. As the name Drumsnav (the ridge of the swimming place) suggests the narrow strip of water was used to swim cattle from one shore to the other thereby saving a long journey overland. A ferry was in operation here from the end of the eighteenth century and possibly earlier. The fare in the 1790s was three pence. With the completion of the first Corrib Drainage and Navigation Scheme the level of the lake was lowered by two feet. This rendered the old pier on the north-east shore useless as boats couldn't use it. A new pier was constructed on the south-west shore along with two landing places. As one travels from Maam and rounds the Hill of Doon one enters the wide expanse of Upper Lough Corrib. In stormy conditions this can be a dangerous place. The *Marina*, a timber and general cargo boat was caught in strong easterly winds in late February 1904, blown off course and driven onto rocks. She was eventually refloated and repaired.

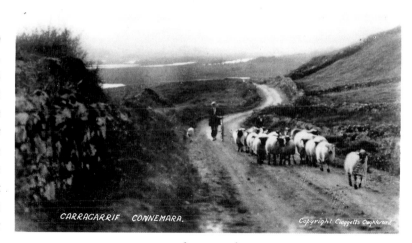

Carragarrif, Connemara

Curraghrevagh

Curraghrevagh was part of the Ballinahinch estate and when the Law Life Insurance Company bought the Martin estate in the Encumbered Estates Court they installed a caretaker in the house. In 1853 Thomas Colville Scott visited Curraghrevagh as part of a survey of the former Martin estate for a potential buyer. He found the caretaker, his family and all his livestock and poultry living in the house. The caretaker was a sensible

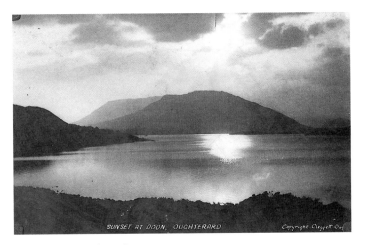

Sunset at Doon, Oughterard

man: the livestock was safe in the house and not likely to be stolen and slaughtered for food by his less fortunate neighbours. It is doubtful that Colville Scott had any appreciation of the poverty and desperation in the area at that time. This portion of the Ballinahinch estate was acquired by Henry Hodgson of Wicklow mining fame. Hodgson was active in mining operations in the Oughterard area in the 1850s and was mining for copper in Teernakill near Maam and for sulphur in Lackavrea where he also established a water-powered peat briquetting works in 1855. Both Lackavrea sites were linked to each other and to the lake shore by a narrow gauge tramway. Portions of the track bed were still visible

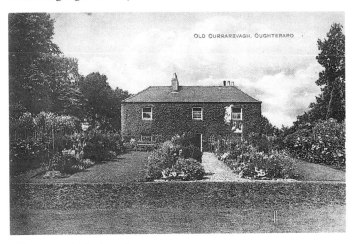

Old Currarevagh, Oughterard

in 1967 but were later ploughed out as part of forestry planting. Hodgeson, in his day, carried out extensive tree planting around Curraghrevagh. He was working Glengowla mine on a leasehold basis from 1860 to 1864.

Angling

Angling was a major tourist attraction in the area and features on several cards. Currane Point is located south-east of Doon on the opposite shore of the lake. It appears to have been a favourite area with anglers based in Oughterard where good catches were often made. Pike were regularly caught here. However, once the mayfly was up dapping was the order of the day.

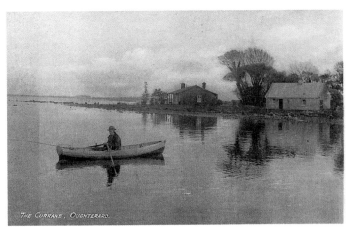

The Currane, Oughterard

The fine Monaghan study of three men in a boat, two anglers and their gilly, was recorded about 1925, according to the late Mrs Cleggett, a niece of the photographer. Anglers were catered for in all the hotels in Oughterard and also in several small hotels dotted around the lake shore. One such hostelry was the Carrick House Hotel. Occupied for a time by Sir Thomas Mason, it was subsequently converted into a shooting lodge and let by the season. It was then converted into a hotel. The postcard was issued by the hotel and gives the all-important pictorial messages to prospective clients – a boathouse for the angler and two men on the veranda, one with a shot gun the other with a gun dog, for the hunting enthusiast. Unfortunately the message on the back does

Dapping,
Oughterard

Lord Ardilaun forgot to inform the local authority some years later when the premises was reconverted to a mill. The rate collector spotted the change and reapplied the higher valuation. Lord Ardilaun was not best pleased.

Pleasure boating was also popular and often enjoyed on a fine evening after work. Lough Corrib sunsets can be glorious. However, while the lake has provided endless pleasure for those who use it for sport or recreation, it can also be a dangerous place. In common with all Irish waterways there have been several tragedies on the lake over the years. Perhaps the worst one was the drowning of nineteen people when a boat sank in the Lower Lake. The incident was immortalised by Anthony Raftery, the blind poet, in a poem 'Anach Chuain' or 'Annaghdown'. It occurred early on a September morning in 1828 when a large group of people were travelling south on the lake to a fair in Galway. The

not refer to either pastime but, rather, to the state of plant cuttings. Another small establishment that catered to anglers was Kilbride Lodge. Here the message that anglers were more than welcome is conveyed by the

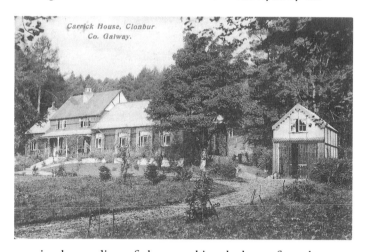

Carrick House,
Clonbur

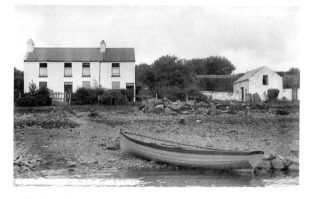

Kilbride Lodge,
Clonbur

simple expedient of photographing the house from the lake with a boat pulled up on the shoreline in the foreground.

One private establishment got into a little difficulty with officialdom. Lord Ardillaun had one of his estate mills converted into a shooting lodge for his guests. The ratable valuation of the building was lowered. However,

boat was overloaded. There were thirty-one passengers on board and ten sheep. The timbers were rotten and, it seems that a sheep put its foot through a plank causing a leak. One of the passengers stuffed his coat into the hole and this caused the entire plank to give way. Everyone on board would have drowned except that another boat in the vicinity saved twelve. Several years later three young students were drowned in another

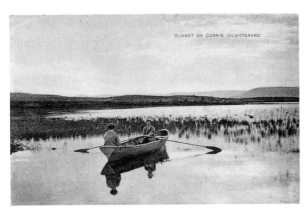

Sunset on Corrib, Oughterard

boating accident near Kilbeg. It occurred on August 17th 1887. There have been many other drowning accidents over the years. Thankfully they are not as common as they used to be. The development of swimming and lifesaving classes and a much greater appreciation of water safety has helped enormously in this regard. An old custom was the blessing of the boats to ask divine intervention to prevent accidents. It was captured in this real-photo postcard that was issued anonymously in the 1920s. The practice of blessing the boats was also followed on the Shannon at Athlone in the 1950s.

Inishanbo

A large number of islands are visible from the shoreline at Borusheen, just a little to the north of Oughterard. The larger ones are Roeillaun, Illaundawee, Inishanbo, the Bronteen islands, Urkan More, Urkan South, Inishool, Illauncarbry, and Illaunaconaun. Each island has its own story but Inishanbo would appear to have been the most important one in medieval times. Inishanbo – the island of the cow – is said to have derived the name from a magical white cow that appeared out of the lake to provide milk for the wife of an O'Flaherty chief. She was in hiding on the island with her infant child. The O'Connor clan had attacked the O'Flahertys in a raid for cattle. The lady had had just enough time to pick up her baby and flee. She had no food when she arrived on the island so the white cow came to her rescue. White cows, sacred and otherwise, turn up all over the place in Irish myth and folklore. This is evident in place names used across the country. Inishboffin – the island of the white cow – names more than one island in the country; and one should not forget the white cow's lakes, Lough Bofin, located near Maam Cross, and another one on the north Shannon.

Blessing Corrib Waters, Oughterard

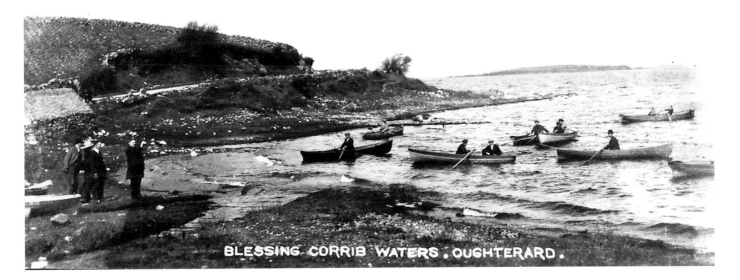

Borusheen, Oughterard

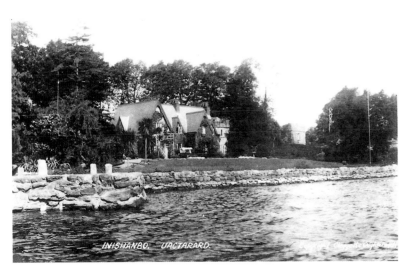

Inishanbo, Oughterard

In the 1860s Inishanbo was the home of the Reverend John D'Arcy. According to William Wilde the engraving of D'Arcy's house used in his book *Lough Corrib*, which was first published in 1867, was based on a photograph. It would seem that the craft of photography was being practiced in Connemara in the 1860s. It would be interesting to see what, if any, of those early photographs survive. The house was enlarged and totally refurbished a number of years ago.

Inchagoill

In contrast with the Inishanbo house the house occupied by Thomas Nevin as caretaker on Inchagoill was a modest one. Thomas worked as caretaker of the island for the Guinness family who owned it as part of their Ashford estate. There were four families living on Inchagoill during the first half of the last century. Tom's job was to look after the paths that had been laid out by Lord Ardilaun for the enjoyment of his guests who were sometimes brought from Ashford on an excursion across the lake to the island. Tom also had to look after the small graveyard and the early Christian monuments which were the focal point for many visitors. The Stone of Luguaedon is the most famous of these remains and has been claimed to be the headstone for the grave of Saint Patrick's nephew. It is also claimed that the stone's inscription was an early Christian attempt to turn the sun god, Lugh, into a dead ancestor as part of the process of

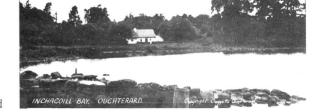

Inchagoill Bay, Oughterard

eliminating paganism from Ireland as quickly as possible. The inscription is the earliest known example of an Irish inscription written in the Latin or Roman alphabet. As well as the stone, the island contains the ruins of two early churches. The oldest of these is Saint Patrick's Church which would appear to date from the eight century. Very large irregularly shaped stones were used in its construction. The graveyard attached to this church was still in use into the 1940s by some families from the Cornamona area. The pathway linking Saint Patrick's to the second church ruin is believed to have been in use from ancient times. Templenaneeve, the second church on the island, dates from the twelfth century. The ruins underwent some restoration work during the 1860s at the instigation of Lord Ardilaun. The island also contains some early Christian cross-inscribed stone and would appear to have been an ecclesiastical site from a very early period.

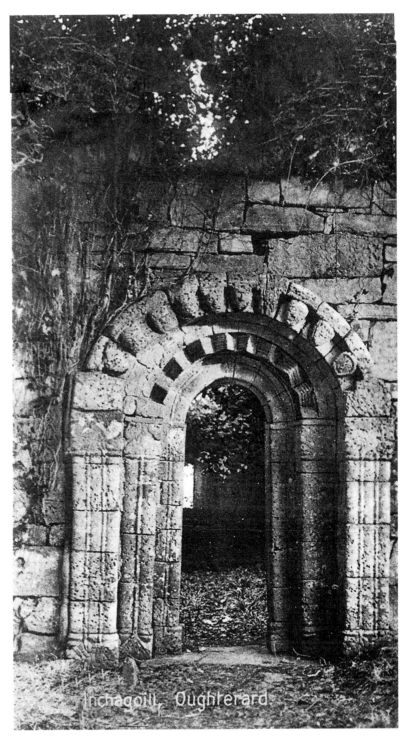

Inchagoill, Oughterard

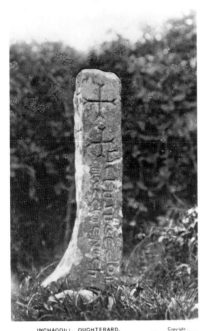

INCHAGOILL, OUGHTERARD. Copyright
 Monaghan, Oughterard.

Inchagoill, Oughterard

Chapter 5 The Road to Clifden

Oughterard, Connemara, Leam, Maam, Shindilla, Derryclare, Recess, Glendalough, Lisnabruca, Ballinahinch.

Aughnanure, Oughterard

Aughnanure

Aughnanure – the field of the yew trees – takes its name from the number of yew trees that once grew in the area. The present castle was built about 1500, although there had been an earlier castle or tower house on the site. This was possibly built by Walter de Burgo, who defeated the O'Flaherties in 1256 and drove them from their lands. However, this defeat was only a temporary setback for them and before the end of the century they were back in possession of their lands and soon were masters of Iar Connacht. In 1537 the O'Flaherties submitted to the English crown through the Lord Deputy, Lord Grey, at Galway. Despite this Murrough of the Battle-axes O'Flaherty defeated English forces in a battle near White Strand, about two miles west of Galway. He was offered a free and general pardon for all his offences and appointed chieftain of Iar Connacht by Elizabeth I in 1559 even though he was not from the senior line of the clan. The senior clan members plotted a revolt against Elizabeth but Murrough betrayed them to Fitton, Elizabeth's president of Connaught. Fitton marched on Aughnanure, then the seat of the legitimate chief, and sacked it, turning it over to Murrough in 1572. Murrough refurbished and fortified the castle and made it his principal residence. In 1618 Hugh O'Flaherty received a regrant of the castle from James I but the family lost possession of it in the Cromwellian confiscations. The castle and lands came into the possession of Lord Clanricarde who leased the property to Bryan O'Flaherty in 1687 and sold it to him in 1719 for £1,600. Bryan

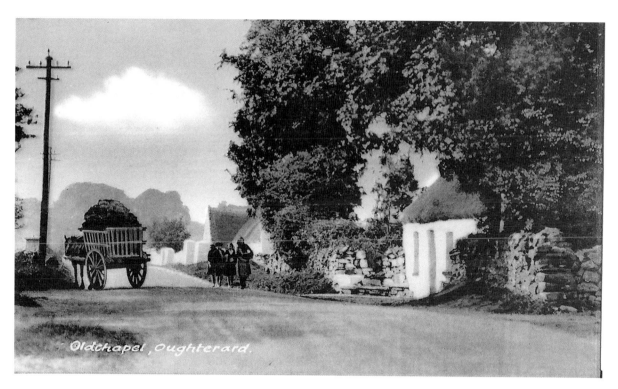

borrowed the money by way of a mortgage from Lord St George who afterwards foreclosed on it. The property was bought back into O'Flaherty ownership in the nineteenth century. The castle was vested in the Commissioners of Public Works by Peter O'Flaherty in 1952 and conservation and restoration work started on it in 1963.

Oldchapel

The early pre-emancipation church for the parish of Oughterard was located here, hence the name. When Joseph William Kirwan took up duty as parish priest his church at Oldchapel was described as a small thatched shed which had been built surreptitiously many years before. Part of the roof had caved in. Kirwan acquired a site beside the town bridge from Thomas Martin in 1828 on which he could build a new church. Ownership of the site was contested by Thomas O'Flahertie in 1838 as he disputed Martin's right to dispose of the site. Once

O'Flahertie's claim was upheld he gave Kirwan a 999 year lease on the property. There had been bad blood between the O'Flaherties and the Martins since the Cromwellian confiscations when the O'Flaherties lost virtually all their lands to the Martins. Relationships between the families had begun to improve and there was even an inter-family marriage but the animosity flared up again in 1837 over ownership of twenty acres of bog. On 8th of December, Thomas Barnewall Martin, MP led a party of his tenants onto the twenty acres. They drove off O'Flahertie's cattle and his watchmen. Reinforcements arrived from the O'Flahertie camp and a pitched battle took place. Martin secured the land temporarily but was later convicted and sentenced to two months in prison, fined £50 and bound to the peace. The dispute about the church site was a natural follow-on to the faction fight at Oldchapel and the subsequent court cases.

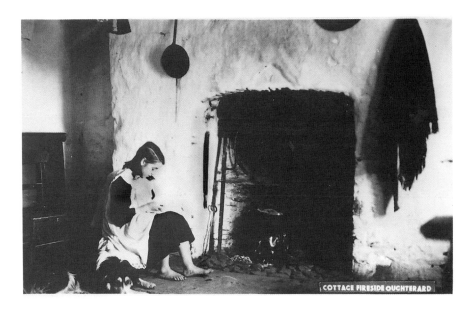

Cottage Fireside, Oughterard

Cottage Interior

The cottage portrayed in his card from the 1920s was one of the roadside cottages in Oldchapel. The interior is in stark contrast to most cottage interiors produced by the large photographic firms and is a reminder of the hardship of the times. Connemara was revisited by near-famine conditions in 1924. Thankfully the visitation was of short duration. The photograph was taken by a local photographer who, like his colleagues in other areas, had a realistic rather than a sentimental eye, which makes cards produced by small local firms such valuable illustrations of social history.

Oughterard Town

Oughterard owes its origins to Nimble Dick Martin who in 1698 was given letters patent to create the Manor of Clare which comprised all his lands west of Galway. This allowed him to hold a manor court and levy fines and penalties and convert the money raised to his own use. He was also granted the right to hold markets and fairs which provided another source of income as he could levy tolls on the produce and animals brought in

for sale. The first market place would appear to have been west of the bridge near Clareville House, which was built by Nimble Dick's grandson. The area was still the market place with its own market cross in the 1840s and subsequently became the fair green. A military garrison was stationed here in the 1760s, which prompted further growth.

There was a chalybeate spa in the vicinity that was much frequented in the late eighteenth and early nineteenth centuries and provided the modest beginnings of the town's tourist industry. Mining activity and prospecting from the 1790s onwards gave a further, though relatively short-lived, boost to the local economy. However, the development of the area's game fishing resources gave the area its first major tourism development.

Oughterard, Connemara 1933

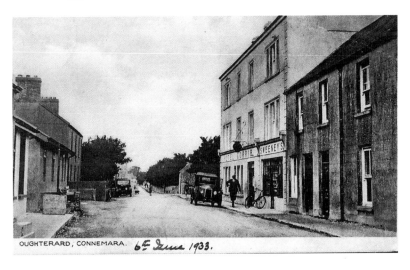

In 1910 *Porter's Directory* described the town as follows:

It is a well built market town pleasantly situated in the centre of the most beautiful district of Connemara, about half way between the sea and Lough Corrib. The scenery in the neighbourhood is of the most surpassing beauty. The chief industry is agriculture. There is excellent lake and river fishing,

Hotel Corrib

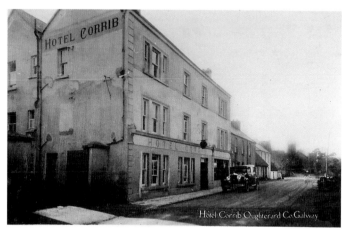

and recently a new company has been formed to develop the lead and copper mines, giving employment to upwards of 200 men. It is under the capable control of B. Bacon, Esq.

The hotels in the town are very comfortable and up to date, and charges are exceedingly moderate. Anyone desirous of exploring Connemara should make Oughterard his centre. Population 815. It is 18 miles from Galway on The Midland Great Western Railway. Market day Thursday.

The Directory lists several businesses as follows: Michael Acton, family grocer, hardware, provision, wine and spirit merchant; Clement's Mining Company Limited, lead and copper mines – B. Bacon manager; Hugh Ferguson, family grocer, hardware, wine, spirit and provision merchant; John H. Joyce, family grocer and spirit merchant; John Lydon, wine and spirit merchant; Michael McDonagh, grocer, draper and general merchant; E. J. Madden, wine, spirit and general

merchant; Joseph Monaghan, wine and spirit merchant and fishing tackle manufacturer; Kate Monaghan, wine and spirit merchant, family grocer, draper and post-mistress, private hotel; P. Monaghan, wine and spirit merchant, woollen and general draper, victualler, grocer and private hotel; Mary Murphy, woollen and general draper, family grocer; Murphy's Hotel; F. Fahy-Naughten, wine and spirit merchant; Railway Hotel; Thomas Naughten, wine and spirit merchant; Angler's Hotel; George Roe, wine, spirit and general merchant; Edward Sweeney, wholesale egg shipper, and wine and spirit merchant; Thomas Toole, family grocer and spirit merchant. In 1914 a Murphy's Hotel billhead states that Madden Proprietor and E. A. Sweeney owned the Railway Hotel. Muirhead's Blue Guide for 1932 describes the town as being 'embowered in trees' with a population of 523 inhabitants. The guide gives the prices charged by various hotels as below.

	No. of Rooms	Bed & Breakfast	Lunch	Dinner	Full Board
Corrib	20	8s. to 10s.	3s. 6d.	5s.	14–16s.
Angler's	15	6s. 6d.	3s. 6d.	5s.	14s.
Darcy's	11	from 3s. 6d.	3s.	4s.	13s.

The hotels arranged for boats and gillies for their guests if required and appeared to have had regular customers who came every year for the fishing or

Angler's Hotel, Oughterard

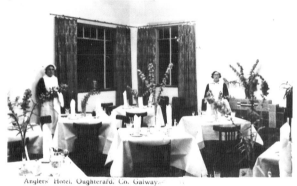

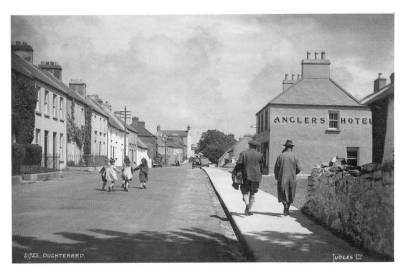

21723. OUGHTERARD.

Mayfly Market

The visiting anglers were accommodated in the local hotels and engaged the services of local gillies. They also hired boats locally and could obtain locally manufactured fishing tackle. In other words, they made a sizeable contribution to the local economy. The only other thing that they needed was a supply of mayfly when they were available. The junior economy kicked into action then and anglers had the benefit of a mayfly market. Oughterard would appear to have been the only town in Ireland with such a thing. The market was recorded for posterity in this striking Monaghan picture first published in 1926 and reissued by the Cleggets about 1950.

Market Square

In common with most Irish towns, Oughterard's fairs were held in the streets. The old fair green was some distance out from the town centre but the buyers and sellers needed nourishment

shooting. The tourist industry contributed significantly to the town's economic survival after the Clement's mining operations ceased and later when the Clifden railway was closed in 1935.

Angler's Hotel, Oughterard

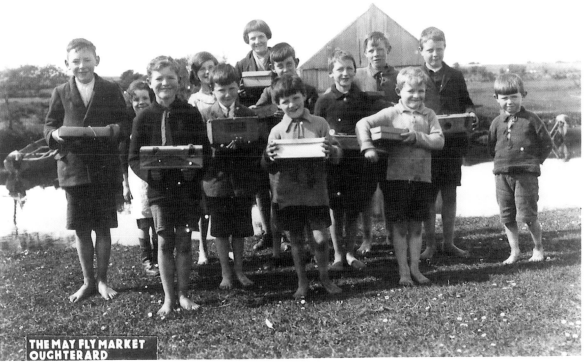

THE MAY FLY MARKET OUGHTERARD

May Fly Market, Oughterard

L to R:
Joe Lydon,
Delia Walsh,
Michael John Lydon,
Mary Rose Walsh,
Bart Monaghan,
Kate Finnerty,
Paddy Masterson,
Mickey Monaghan,
Dave Walsh,
Michael John Finnerty,
Mick Shaughnessy,
Paddy Lydon,
Mick Walsh

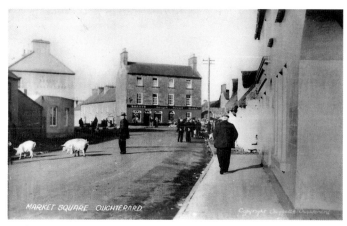

*Market Square,
Oughterard*

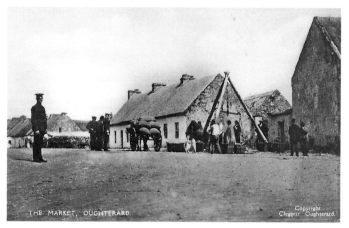

*The Market,
Oughterard*

during the day so the fair moved in. Because the town was connected to the main railway network until 1935 the pig fairs were usually quite large. Buyers or jobbers from the big Limerick bacon factories attended regularly to make purchases. In the 1890s Shaw's of Limerick were slaughtering some five hundred pigs a day for processing and were considered to be the second largest bacon curing factory in Europe. Matterson's and O'Meara's were not too far behind Shaw's in size. The Dublin processing houses also had buyers in the market places. After the Clifden railway closed the Oughterard pig market decreased in size. The card shows a small or reduced in size pig fair, therefore the photograph was taken after 1935.

RIC

Considering its size, the town had a sizable force of Royal Irish Constabulary stationed there. Oughterard was not a particularly lawless town. In 1872 for example twenty-seven males and nine females were committed to the local bridewell between July 1st and December 31st for an average stay of three days each. None of the prisoners were committed for drunkenness. By contrast, there were 214 prisoners committed to the bridewell over the same period in 1848. Indian meal didn't feature on the bridewell diet here unlike most of the other bridewells; a similar situation prevailed at Woodford and Eyrecourt. Despite the peaceful nature of the town, a disciplined police force needed to

be maintained. The card shows the local constabulary lined up in the square preparatory to inspection – they are not providing a guard of honour for the cart.

A Social Occasion

The market place provided for more than just buying and selling, it was also a major centre for the dissemination of the local news and gossip. The fine study by Mason's was captured in Oughterard market about 1926. The quality of the photography is such that the pattern on the shawls can be clearly seen. Claddagh and Connemara shawls became very popular in the United States after several different patterned shawls were shown at the Chicago World's Fair in 1893. A considerable export trade developed and lasted for a number of years.

Catholic Church

When Joseph William Kirwan was appointed parish priest for Oughterard his church was a ruinous thatched building at Oldchapel on the Galway approach to the town. He obtained a site from Thomas Martin, MP, son of 'Humanity' Dick, for a new church. Martin also donated £50 towards the construction costs. The church was designed and built by William Brady, architect of Nuns' Island, Galway, who subsequently got the contract to construct the Queen's College, Galway, now the National University of Ireland, Galway. Kirwan used his considerable skills

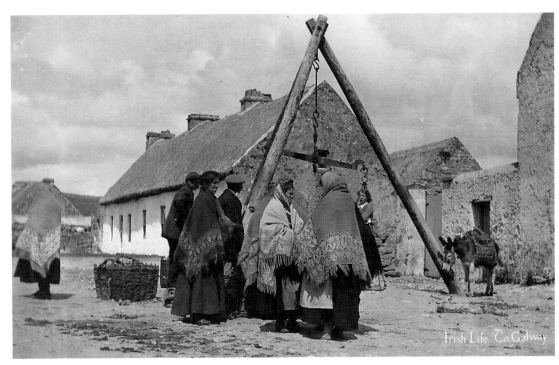

Irish Life, Galway
Oughterard Market
c.1926

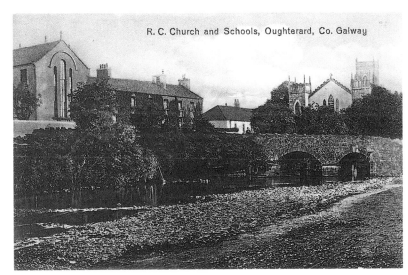

R. C. Church and Schools, Oughterard, Co. Galway

R.C. Church and Schools, Oughterard

as a preacher to raise funds for the building costs. Work began in 1828 and the church was opened temporarily on Christmas Day, 1830. The church was completed in 1836 and was consecrated in 1837. The church bell was cast at Stephens Foundry, Galway where at a later date the castings for the railway bridge over Lough Athalia Road in Galway were executed. Serious damage was caused to the church as a result of a fire in January 1879. The building was repaired and redecorated but by 1932 a major refurbishment had to be undertaken. The roof was leaking badly so it was replaced by one with a higher pitch. The church was, essentially, rebuilt at a cost of about £8,000. A new high altar in Connemara marble was installed. The Harry Clarke Studios supplied the stained-glass window depicting the Crucifixion. The elaborate decoration surrounding the original high altar was removed at that time according to the late Mrs Clegget of Oughterard. She remembered an Italian trapeze artist who, while visiting Oughterard with Duffy's Circus, went looking for his grandfather's decorative handiwork and was very upset to learn that it had been removed in the reconstruction works of 1934. She presented him with a copy of the postcard produced by her uncle, Frank Monaghan.

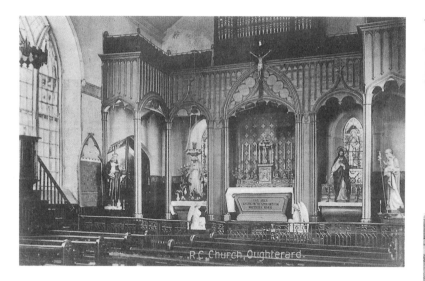

R.C. Church, Oughterard.

In 1838 Thomas O'Flahertie of Lemonfield took a legal action for ejection against Kirwan as he claimed ownership of the ground the church was built on. He contested Martin's claim of ownership and his right to have disposed of the site. The ensuing court case caused a sensation. Whilst some have claimed that it was motivated by religious animosity it was, in reality, a simple case of asserting ownership rights. Kirwan retained the services of Daniel O'Connell to defend him. O'Flahertie was able to prove that he had full legal title to the land. Once this was established he granted a 999 year lease at an annual rent of one peppercorn.

Church, Oughterard

Church of Ireland

A grant of £600 was made by the Board of First Fruits in 1808 towards the final cost of the church, which had originally been built in 1805. The church was altered and extended in 1852 in accordance with the plans drawn up by Joseph Welland. A Belfast man, William Wilson, contributed £700 towards the cost of the alterations. A special enclosed area was provided in the extension for military prisoners from the British garrison so that they could attend services. The British maintained a garrison in the town from the 1750s onwards. The barracks was

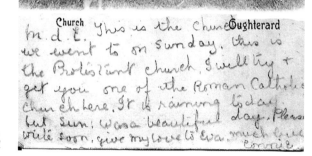

Church, Oughterard

located beside a natural rock arch over the river which provided the only bridge in the area for many years and served as a control point on movement in or out of Connemara. The church was restored and reroofed under a FÁS scheme during the years 1994 to 1996.

Bridge

The bridge has often been attributed to Alexander Nimmo because of his involvement in the improvement and development of the road system in Connemara; however, the bridge would appear to predate Nimmo's arrival in Connemara by many years. After 'Humanity'

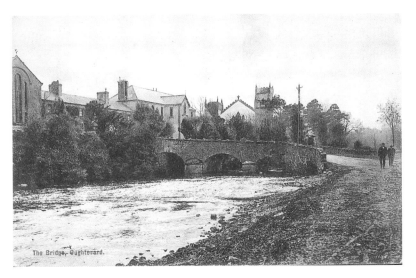

The Bridge, Oughterard

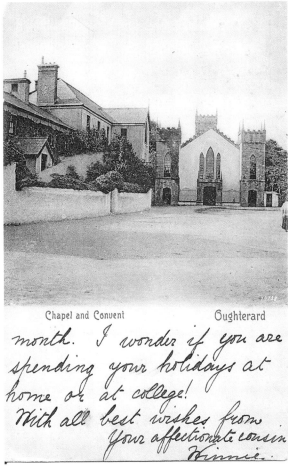

Chapel and Convent, Oughterard

Dick Martin was swindled by a mining company who were prospecting on his lands near Oughterard he engaged the services of an eminent French mineralogist, Monsieur Subrine, to survey the area and assess its mineral wealth, if any. Subrine's report was published in 1802 and the bridge is mentioned several times. It is possible that the bridge dates from the 1760s when considerable work was carried out on what is now the Galway–Clifden Road.

Convent Schools

The first convent was opened by the Congregation of the Faithful Companions of Jesus in 1843. They had come to Oughterard on the invitation of Father Kirwan. However, as the convent was not self-supporting the order relocated to Limerick in 1846. The Sisters of Mercy opened their convent in the same building on November 1st 1857 as a branch house of their Galway convent. They opened a small school shortly thereafter. The current national school was built in 1884 and a secondary school was opened in part of the original convent in 1964. A new secondary school was opened in 1991 and the old school was demolished some years later. That site is now occupied by a block of apartments.

Turf on the Clifden Road

The photograph for this card was taken in 1948 and, as can be seen, it features a young man bringing home a supply of turf. He is still in short pants and has his winter socks on: knee length with a turn down. The usual age for starting to wear 'long' pants was at confirmation time. Had the scene been captured a hundred years previously one could say that the youth was off to market as the town market was located in this area.

Bend of Road and River, Oughterard.

The Falls

Thomas and Edmund Ashworth bought the Galway Fishery in 1852. It was a several fishery, which meant that the fishing rights belonged exclusively to the owners and the public at large and the riparian landowners had no rights to fish the Corrib waters.

The fish stocks were at a very low level and the Ashworths set about improving the situation immediately. They set up a hatchery in Oughterard where salmon eggs were harvested and fertilised. Forty thousand eggs were laid down and twenty thousand of them hatched.

Bend of Road and River, Oughterard

Falls at Oughterard

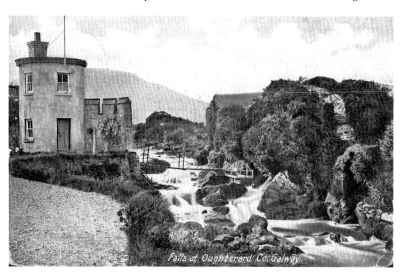
Falls at Oughterard, Co. Galway.

This created an international sensation and when some of the fish were exhibited in the Great Industrial Exhibition in Dublin in 1853 they were the focus of great attention, even Queen Victoria commented favourably on them. This put Oughterard firmly on the scientific and angling maps and led to the development of angling tourism in the area.

The card shows a fishery watch tower with net winding gear in the foreground. The large building on the right was Claremont Mill, one of two watermills at Oughterard; the other, Canrawer Mill, was upstream on the opposite riverbank. Claremont Mill was in ruins in the 1840s but was restored to working order later in the century. John Tierney was leasing it from Richard Berridge in 1905 but by 1912 owned the property. The mill was described as being 'at rest' that year and its ratable valuation was reduced from £3 to £1. Mary Tierney was in possession of the property in 1915 when the mill was still 'at rest', which meant that it was no longer a working mill. Canrawer seems to have ceased operations about 1850 and by the early 1900s it had been demolished.

The Turf Carriers

This card features one of the very few, if not the only photograph of a togher bridge in use. The word was pronounced 'toker' in east Galway. This type of bridge was used extensively in Ireland for a thousand years or more. The various Irish Annals carry many references to toghers being built or demolished during periods of intertribal strife or cattle raiding. Construction was simple but effective: large drystone piers or pillars were built in the shallow parts of a river. These were then spanned by a timber decking, usually tree trunks which were bound together with ropes. The multi-span togher that existed at Drumheriff on the northern reaches of the Shannon in the 1830s is shown in the reports of the Shannon Commissioners published in 1837. The Ough-

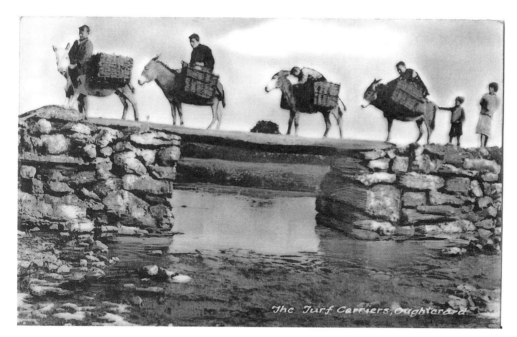

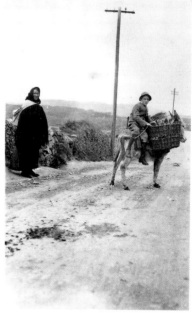

Turf Carriers,
Oughterard

Going to Market,
Oughterard, early 1900s

terard togher is a single-span structure. The abutments and causeway approaches were constructed of drystone and a simple deck of tree trunks laid down. Similar bridges were constructed across main drains to gain access to bogs in east Galway and south Roscommon and were in use in one or two places until the 1950s. Here, though, the construction of the abutments was somewhat different. The banks of the drains were cut back at an angle and the abutments were built to lean in against them. This way the weight of the stone was spread over a section of bank, reducing the weight on the soft drain bed. These toghers could carry large cartloads of turf without sinking. However, the increasing number of tractors coming into use meant the end of this type of construction.

The Oughterard togher was ideal in areas prone to flash floods. The dry stone construction allowed the floodwaters to pass freely through the causeways or embankments thereby reducing the risk of the bridge being washed away as happened to Nimmo's bridges at Maam and Leenane. At both of these locations the arches or waterway openings were too small to allow the floods to pass freely and since the water couldn't escape through the solid embankments the bridges collapsed before the pressure.

While some of the original masonry of Nimmo's bridge at Maam still survives, the Oughterard togher has vanished and its exact location cannot now be pinpointed.

Going to Market

This mother and son were photographed on their way to the market in Oughterard in the early 1900s. The mother is standing at the start of a footpath which implies that the location was just on the outskirts of the town. According to Mrs Clegget her uncle met the pair on the road and asked them to pose for him. The young man was not dressed for working at the market. He was dressed in a tweed suit. His boots were clean and appeared to be new. He was, according to Frank Monaghan the photographer, leaving the area to start serving his time in a shop in Galway. His mother was hoping to earn enough to buy him a one-way train ticket to the city and give him some cash to tide him over the three months probation that had to be worked without real pay. The

young man had to have sufficient money to cover twelve weeks pay which was to be handed up to the employer to be returned in twelve weekly installments. This ensured that the employer was paid for whatever training was given. It also ensured that apprentices behaved. If they were dismissed for misconduct during the probationary period their deposit was non-refundable. This method of paying probationers was not confined to the retail trade but was in widespread use. People had to buy their way into apprenticeships and professional training; they were then paid their wages or salary out of their own money.

The Packman

This fine studio portrait is another by Frank Monaghan of Oughterard and was taken about 1925. It features a brother of Padraic O'Connaire, according to the photographer's niece, the late Mrs Clegget. The Cleggets reproduced the card about 1950.

Wandering 'fix-its' and peddlers were still a feature of Irish rural life in the 1950s, particularly in the west of Ireland. The 'fix-its' were named for the items they repaired or serviced. 'Tick-Tock' was the clock man, 'Ribs' repaired umbrellas and 'Spokes' repaired bicycle wheels. Each had their own circuit. Tick-Tock called once a year to clean and oil the wag-o-the wall clocks that were a feature of many households. He also repaired pocket watches. Allied to this group was the wandering peddler, or packman, a descendant of the eighteenth-century chapman. He travelled from house to house selling clothes pegs, thimbles, papers (or packets) of needles, thread, darning wool and gaily coloured ribbons known as fancies or favours. The packman also travelled from fair to fair and market to market. Here their door to door range was extended by the inclusion of lengths of cloth of various descriptions. The more adventurous progressed to selling ornaments, hand tools and an assortment of hardware goods. They were known as 'Cheap Jacks' during the 1950s. By then the wandering

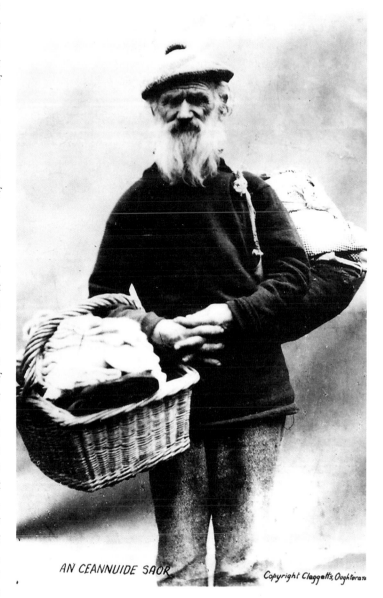

AN CEANNUIDE SAOR Copyright Clagget's, Oughterard

peddler, or packman, had all but disappeared. The arrival of the travelling shop after the end of the Second World War had wiped out their door to door trade. The 'fix-its' survived into the 1960s, in part because of the repair service on offer but also because of the gossip they carried.

An Ceannuide Saor, Oughterard

Spinning Wheel

According to the late Mrs Cleggett of Oughterard, this card was a Monaghan production from about 1930. It is a fine study in concentration as the lady is teasing out some raw wool to thread the spinning wheel. The usual views of women with spinning wheels are contrived poses set up for the cameraman. Many households in rural areas had spinning wheels to produce knitting wool. If the wool was for domestic purposes only then a small wheel was all that was required. If, however, wool was being produced for a weaver to make báinín, tweed or blankets the small wheel was not very efficient and larger wheels were necessary. During the 1890s the Congested Districts Board introduced the larger spinning wheel into the west of Ireland with very beneficial results. It meant that many households could produce enough woollen thread for their own use and also have thread for sale to local weavers. The woman has set up the wheel outdoors, as was common practice because one needed good light for spinning. McKeown's of Leenane took the unusual step of sponsoring their thread suppliers to install large windows to provide good light to the interior of their cottages so that they could work indoors during wet weather. The wheel has been set up in an area that had only just been cleared of rushes; they can be seen

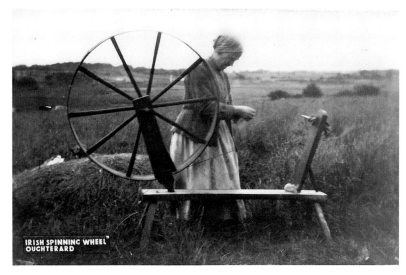

Irish Spinning Wheel, Oughterard

mounded up behind the wheel and had been harvested to provide winter bedding for the farm animals.

Connemara

Long before the construction of the Clifden railway intrepid travellers were visiting Connemara. The majority of them published accounts of their travels and mentioned various locations such as Shindilla, Glendalough, Derryclare, Lough Inagh, Kylemore Pass, Salruck, and Killary. When the railway opened it gave tourists ready access to the sites they had often read about but never thought that they would get the opportunity to see. Connemara, known as the Western Highlands of Ireland was the remotest part of what was then the United Kingdom. When the railway opened for business, passengers could get a through-ticket from Euston in London to Clifden. Suddenly Connemara was accessible and the tourists came. All of the locations mentioned in the travellers' tales about the area were photographed and reproduced in postcard format. Indeed many of the scenes were photographed in anticipation of the railway being built.

Glendalough Lake, Co. Galway

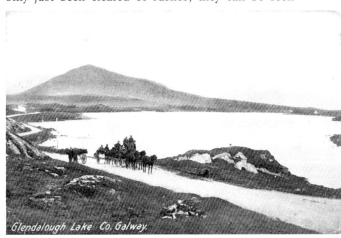

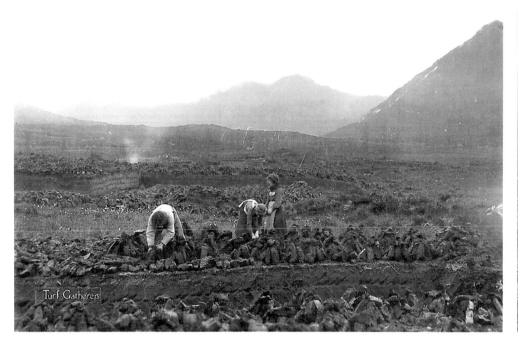

Turf Gatherers

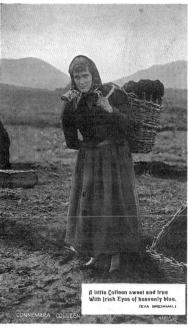

A little Colleen sweet and true
With Irish Eyes of heavenly blue.
(EVA BRENNAN.)

CONNEMARA COLLEEN.

Maam Valley Turf

Many people have nostalgic memories of the smell of peat smoke but have either forgotten or never knew the toil involved in winning and saving a winter's supply of turf. Most early postcards relating to turf harvesting give a somewhat romanticised view of the operation. Mason's of Dublin captured two bog scenes in the Maam Valley in the early 1920s. The first shows a couple bent over making footings or small open heaps of turf sods; this

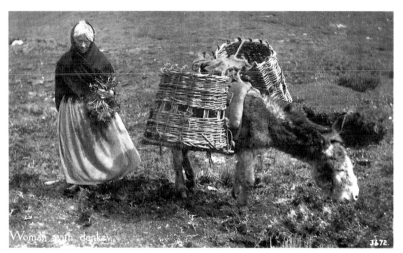

Woman with donkey.

practice allowed the air to circulate through the sods and assisted in the drying process. It was back-breaking work. The second postcard features an old woman gathering cipíns or small twigs of dry heather for fuel. Her donkey carries two empty turf creels; she has no one to cut turf for her and has to glean the bog after her neighbours have saved their own fuel. In many areas it was customary to leave trathneens or broken sods behind so that people like her could gather fuel and save face; she didn't have to ask for charity and wouldn't be embarrassed by it being offered. This was certainly the case in parts of east Galway. The third card, a Valentine and Sons' production, was originally issued as a black and white card but after the release of *The Quiet Man* in 1952 it was reissued in colour for the American tourist market in particular. It features the heavy job of carrying the dried turf out to a firm place where it could be loaded on carts for transport home. Large quantities of turf were sent to Galway city by gleoiteog from Maam in the nineteenth century.

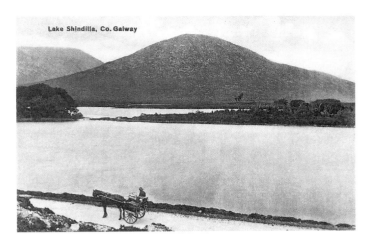

Lake Shindilla, Co. Galway

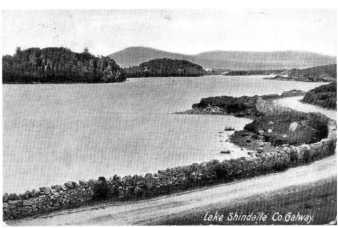

Lake Shindalla Co.Galway.

Shindilla

Shindilla is supposed to have derived its name from *sindile*, the Irish word for a flax beetle. The beetle was used to split the stems into fibres. The name is one of the very few relics of a once thriving cottage industry in south and central Connemara. There are fragmentary remains of a flax drying kiln in the Cashel area. During the late eighteenth century and later Connemara linen was sent to market in Loughrea.

Shindilla's claim to literary fame rests on colonel William Francis Lynam of the 5th Royal Lancashire Militia who was born there. He created the humorous character Mick McQuaid. McQuaid first made his appearance in *The Shamrock* magazine in 1867 and the

Two views of Lake Shindalla, Galway

Leam Village, Oughterard

readership liked the character so much that the circulation dropped when he failed to appear. Repeats of the serials kept on appearing until the magazine ceased publication in 1920. Lynam had died in 1894.

Leam Village

The bridge here was immortalised in the film *The Quiet Man* and the opportunity was taken to reproduce this postcard in the 1950s to capitalise on the increase in American tourists to Connemara. The bridge dates from the late eighteenth century.

Derryclare

Derryclare Lough was known as a tourist eye-catcher and a fisherman's paradise. Both aspects are showcased to great advantage in early cards that feature the lake. The earlier card, a Lawrence production, features an unusual view of the lake. The island with the trees is not visible but does feature in the somewhat later Valentine postcard, which also shows the fisherman's shelter and the fishing jetties built by the Berridges as part of the Ballinahinch fishery. Subliminal messaging was just as important here as in the postcards featuring the small fishermen's hotels on Upper Lough Corrib.

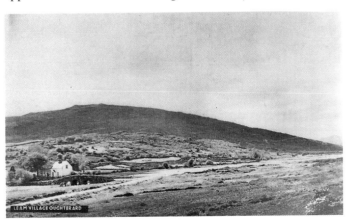

LEAM VILLAGE OUGHTERARD

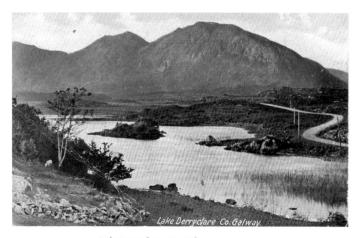

Lake Derryclare, Co. Galway

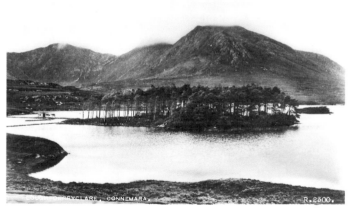

Lough Derryclare, Connemara

Recess

Recess was a popular area with travel writers in the nineteenth century. Its hotel, which was in operation as early as 1852, catered initially for anglers. The improvement in road transport facilities made the area more accessible and led to it featuring in many published accounts of Connemara. The opening of the Clifden railway led to a major increase in tourists and by 1895 the hotel, which had been acquired by the railway company, was advertising its darkroom facilities as an added attraction for visitors. Given the promotion of the scenic attractions of the surrounding countryside it is hardly surprising that Recess features on a significant number of cards. The first view, photographed from the west, shows Recess station complex with a Clifden-bound train at the platform. The site for Recess station was chosen, it would seem, to allow for a possible branch line to be constructed leading down the Inagh valley to Killary. One of the proposed railways brought forward in 1890 called for just such a branch line, having its junction with the main Clifden line where Recess station was eventually built. If the station was to serve Recess and the immediate locality then the ideal site would have been on the east side of the lake near the hotel. The second view was photographed after the

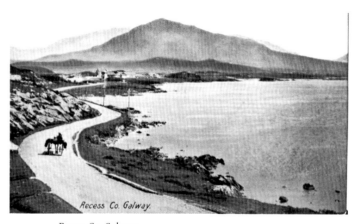

Recess, Co. Galway

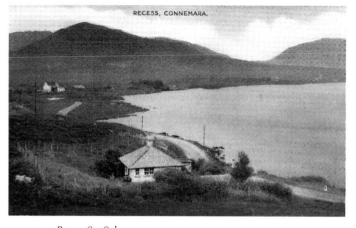

Recess, Co. Galway

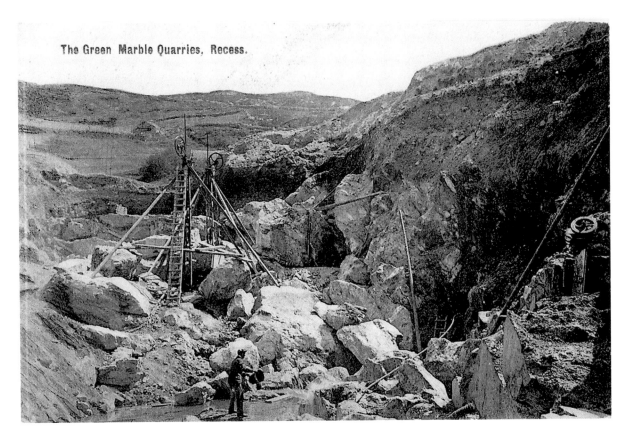

The Green Marble Quarries, Recess.

The Green Marble
Quarries, Recess

Clifden railway was closed. Most of the ancillary buildings associated with the railway have been demolished, leaving just the station building and a large shed.

Marble Quarries

By the end of the eighteenth century there were several mines at work throughout Connemara. Copper, lead and sulphur were the principal ores mined. The Martins of Ballinahinch invested heavily in prospecting ventures on their lands but without much success. During the 1820s 'Humanity' Dick Martin turned his attention towards developing the serpentine or green marble quarries on his estate. The nickname 'Humanity' had been given to Martin because of his work in promoting legislation which prohibited cruelty to animals. Martin and his son, Thomas, were the first to polish the marble, revealing its beauty. They made two tables for Ballinahinch Castle and a fire place for the King of England. While 'Humanity' Dick was attending to his parliamentary duties in London Thomas managed the quarry. The major problem faced by Thomas was that of transporting the large blocks of marble to market. The development of Nimmo's road to Toombeola eased the problem somewhat. However, transporting large blocks of marble by road was both slow and expensive making it difficult to sustain sales. After the Famine the Martin estate was sold in the Encumbered Estates Courts to the Law Life Assurance Company who put it back on the market in 1853. It was finally acquired by the Berridge family who leased the quarry to Messers Sibthorpe of Dublin.

In 1886 the Lissoughter quarry was selling green marble at sixteen shillings (about €1) per cubic foot and was exporting large blocks to Britain and the United States for use in some high profile locations such as Saint Pancras College, Cambridge and the University Club, New York.

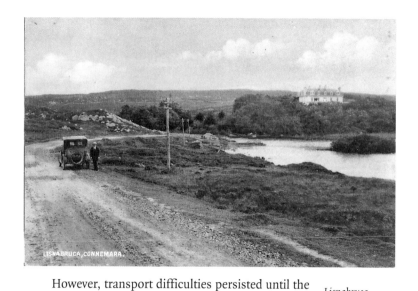

LISNABRUCA, CONNEMARA.

Lisnabruca, Connemara

and was finally black topped sometime in the 1930s. The registration number on the car is IM 1713.

Ballinahinch

Ballinahinch Castle was originally built as an inn by the Martin family in the early eighteenth century even though it was to all intents and purposes inaccessible to most of the very few travellers that would have ventured into the area at that time. It is quite likely that the house was built in connection with the smuggling trade which flourished in the Roundstone area over much of the eighteenth century. When Richard Martin inherited the Ballinahinch estate in 1794 it was encumbered with a debt of over £20,000. Richard's lavish lifestyle increased the indebtedness further. He abandoned Dangan, just outside Galway, and relocated at Ballinahinch. Its remoteness no doubt gave him some protection against creditors. Ballinahinch took its name from the O'Flaherty castle built on an island in what is now known as Ballinahinch Lake. Richard Martin used this castle as

However, transport difficulties persisted until the Galway–Clifden railway was opened. Prior to this it took five weeks to transport a large block of marble from the quarry to Galway docks. The blocks were moved on timber rollers by a team of men and horses. After the railway opened the same trip only took five hours. By then the quarries were leased to an American company who sent several shipments to the United States. In 1905 Lissoughter was managed by a Mr Raftery, who produced some particularly fine blocks of marble using a steam-powered stone saw. The quarry was featured in a postcard produced by Healy's of Dublin about this time. The card shows a workman just after he has thrown a bucket of water over an exposed face of marble. This was done to bring up the colours to impress a prospective customer. The quarries are still in production.

Lisnabruca

Lisnabruca House was built by the Berridges sometime after they acquired Ballinahinch. Members of the family lived there for some time. During the 1920s and 1930s it was regularly let as a fishing and shooting lodge. The roadway, as can be seen from the card, was subject to heavy traffic. It was steamrolled occasionally

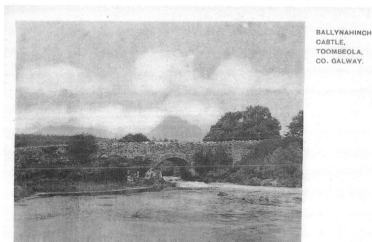

BALLYNAHINCH CASTLE, TOOMBEOLA, CO. GALWAY.

Ballynahinch Castle, Toombeola, Co. Galway

a prison for any of his tenants who were cruel to animals. He had been reared to believe that anyone who indulged in cruelty to animals could very easily be cruel to people. In 1822 as a member of parliament he was instrumental

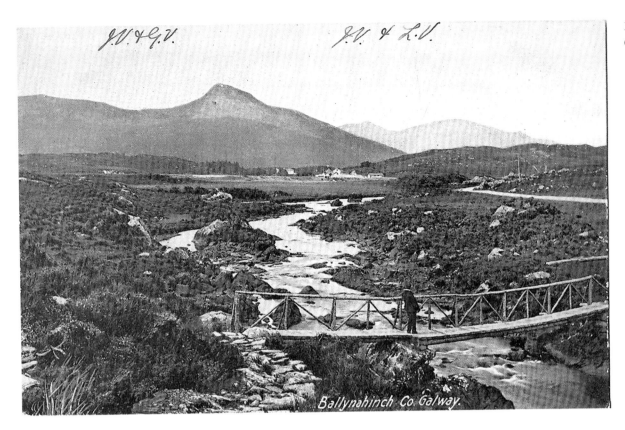

Ballynahinch Co. Galway.

in having the Cruelty to Animals Act passed by the Westminster Parliament. He acquired a new nick name 'Humanity' Dick. He was already known as 'Hair Trigger' Dick because of his skill as a duellist. Shortly after this he lost his seat in parliament and under pressure from creditors moved to France where he died in Boulogne in 1834. The estate was left with very heavy debts. His son Thomas died of fever during the Famine, leaving the property, which was heavily mortgaged, to his daughter Mary who emigrated to New York and died there shortly after her arrival. The estate was acquired by the Law Life Assurance Company of London. This company sold the estate to the Berridge family who renovated and enlarged the castle.

Maria Edgeworth described the house as she saw it in 1833 as 'a whitewashed dilapidated mansion with

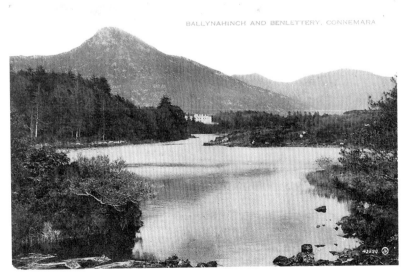

BALLYNAHINCH AND BENLETTERY, CONNEMARA

Ballynahinch and Benlettery, Connemara

nothing of a castle about it excepting four pepperbox-looking towers stuck on at each corner – very badly and whitewashed and all that battlemented front is mere whitewashed stone or brick or mud.' Clearly the diva from Edgeworthstown was not impressed.

The Berridges developed the fishery, installing a salmon hatchery to improve the level of fish stocks. The fishery benefitted considerably by the opening of the Clifden railway which encouraged angling tourism. It also meant that large quantities of salmon could be exported directly to the Dublin and London fish markets. Some 397 tons of fish were sent to market from Ballinahinch in 1900. As part of the development of angling tourism the Berridges installed a number of small fishing piers and had several timber access bridges constructed to facilitate access to good fishing stands. This style of accommodation bridge was commonplace over much of north Connemara in the early years of the last century. Whilst they were useful, care had to be taken crossing them in very wet weather. Maggie Conroy, a young girl from near Recess, had a narrow escape from drowning in August 1932 when she lost her footing in a torrential downpour and fell into the river. She was carried downstream by the flood but was rescued by her father.

A much more substantial accommodation bridge is located near the castle. It was constructed as part of Nimmo's road to facilitate the development of the Martin marble quarry. The roadway was to provide access from the quarry to Toombeola so that the large blocks of marble could be shipped out to prospective customers. In 1924 the Berridge family sold the estate to the Maharaja Jam Sahib of Nawanagar who was more commonly, and famously, known as Ranji Prince of Cricketers. He spent every summer at his new residence and was extremely generous to his estate staff and indeed the locals. After Ranji's death in 1932 his nephew sold the estate to the McCormack family who, in turn, sold it to the Irish Tourist Board who opened the fisheries to the general public, converting the house into a hotel. The estate passed to Noel Huggard who, in turn, disposed of it to an American, Edward Ball. Ball sold shares in the property and now it is run by a corporation. Given its scenic location it is hardly surprising that the castle has featured on many postcards both photographic and artistic.

Ballynahinch Lake

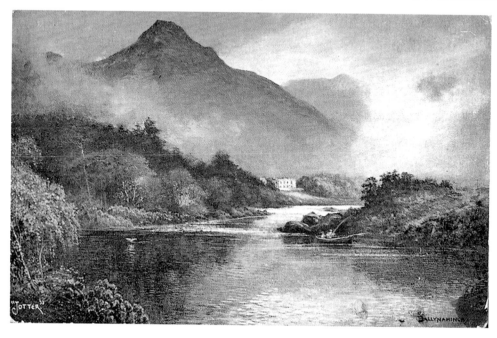

Chapter 6 **Clifden**

Clifden

Walter Coneys is said to have built the first house in John D'Arcy's new town of Clifden in 1809. In 1824 Hely Dutton described the new settlement as 'promising at no very distant period to arrive at great celebrity, it only wants a mercantile man with capital and enterprise to accomplish this'. Clifden, he claimed, possessed every advantage for those wishing to build at minimum cost. Stone, sand and lime were readily available and labour costs were low. Even though he doesn't refer to brick there was ample supplies of marl available in the floodplain of the river near Waterloo Bridge and in fact two brickfields were opened there at some stage. Access by sea for the importation of timber and other materials was another favourable point that Dutton noted. The roads had been improved considerably and ran for miles on level ground. He noted that D'Arcy's exertions in this regard were ably assisted by Thomas Martin. D'Arcy had also built a 'very commodious hotel and a very beautiful gothic church from the picturesque pencil of Mr Coneys'.

Greetings from Clifden 1915

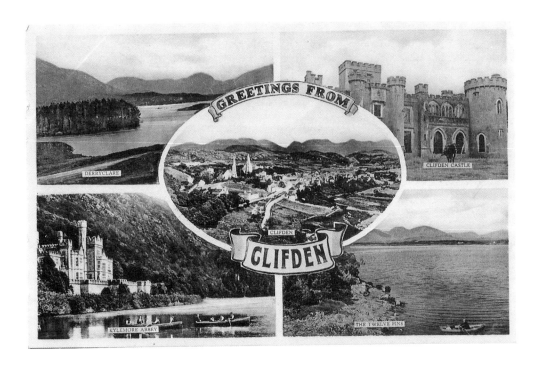

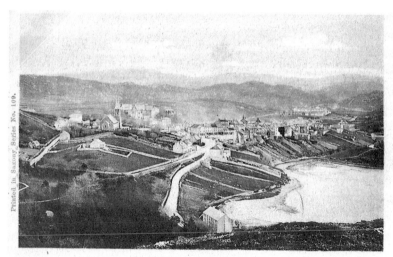

Clifden, Connemara.

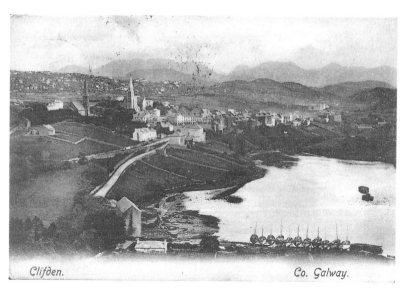

Clifden. Co. Galway.

A Catholic chapel and a market house were under construction and it was intended to construct salt stores for the fishery. From these early beginnings the town grew and developed. In 1841 the population was 1,509 and the town had 182 houses. Although the number of houses increased to 236 in 1851, the population decreased to 1,287. The Famine and its aftermath had taken

a severe toll on the town. Monument Hill has been a favourite vantage point for photographing the town for over a century. The earliest postcard views of Clifden were photographed from the hill and give a good view of the town's layout.

Harbour

In 1821 John D'Arcy sought and obtained a grant from the Fisheries Commissioners to construct a pier. The grant was for £495. No work was undertaken on the project and the Commissioners authorised Alexander Nimmo to take the project in hand. He created a sheltered landing place at Doughbeg and identified a suitable site for a quay wall. A further grant was applied for and D'Arcy agreed to contribute financially to the project. The pier was finally finished in 1831. In November 1847 the Marie Constance, a French schooner sailed from Lisbon for Ireland and put into Clifden Bay in distress. She was brought safely to anchor by the local coastguard. The ship was seized under an Admiralty warrant in favour of a bond holder. The coastguard lodged a claim for salvage before a local magistrate who awarded them £75 even though the Admiralty warrant had been issued. The award was appealed to the Admiralty Court who overturned it, and awarded the bond holder priority status. He was to be paid in full with his costs and the residue of money raised by the sale of ship and cargo was to go to the salvors. Over the nineteenth century the marine facilities proved inadequate for shipping needs. The Commissioners of Public Works made a loan of £428 9s. at five per cent interest to the Grand Jury to construct a new pier. During the 1890s Cannon Lynskey was pressurising the Congested Districts Board to have improvements to the harbour carried out. He had suggested a major extension of the quay, which Major Ruttledge Fair estimated would cost between £10,000 and £15,000. When this seemed like a lost cause he proposed that lock

gates be erected across the channel near the quay. This was not considered feasible. However, James Perry carried out a survey of Clifden Bay in connection with proposals for a new harbour for Clifden. His manuscript map, dated July 9th 1900, shows the seabed contours from a depth of half a fathom to five fathoms (three feet to thirty feet). The centre lines of walls for two alternative harbours that could be constructed on the same site are marked in. By 1904 the proposed improvements to the harbour had been reduced in scale and it was contemplated that a large pier on the site of the earlier harbour proposals would suffice. The site chosen was on the shore in front of Clifden Castle.

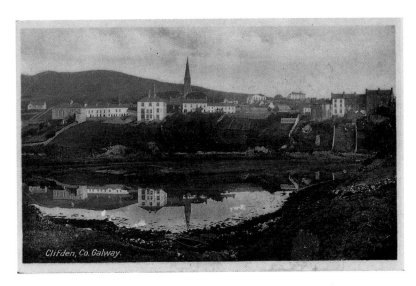

Clifden, Co. Galway.

Clifden Castle

John D'Arcy claimed the credit for the design of his castellated two-story house with its Gothic doorway and windows. The Castle was built sometime about 1818 in a well chosen site. It had a commanding view of Ardbear Bay, while the hills behind provided shelter. The Castle grounds, comprising about fifteen acres, were reclaimed and laid out as a lawn, with pathways marked by standing stones, a grotto, and a marine temple built with shells. It is thought that some of the standing stones may have been removed from their original pre-Christian sites and re-erected in the grounds, the remainder being made-to-order. The Castle had its own small pier for private use and also to cater for select visitors. In 1837 D'Arcy mortgaged his estates in Connemara and Kiltullagh, Athenry for £25,000 to Thomas and Charles Eyre to raise funds for further development of the area.

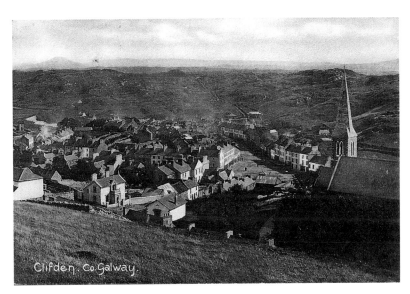

Clifden, Co. Galway.

When John D'Arcy died in 1839 his son Hyacinth inherited the estates and the debts. The Famine devastated his rental income and the interest on the outstanding loan mounted. In 1850 the estates were sold through the Encumbered Estates Court. The purchasers of Clifden Castle, the town of Clifden and a large portion of the Connemara estate were Thomas and Charles Eyre. The purchase price was £21,245. The Eyres made several alterations to the Castle and added the armorial crest to the façade. They also added a new grand entrance gate complete with their coat of arms, made for them by James Stephens at his foundry in Galway. Thomas Eyre bought out his brother Charles's interest in the D'Arcy

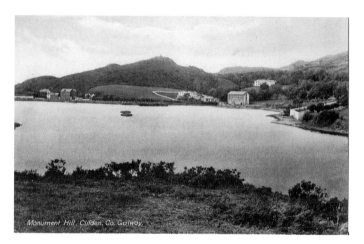
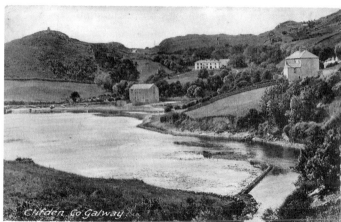

Monument Hill, Clifden

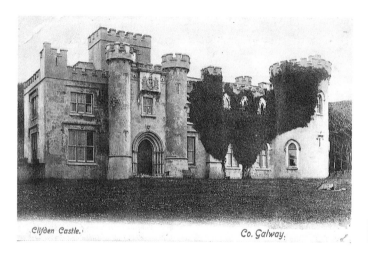
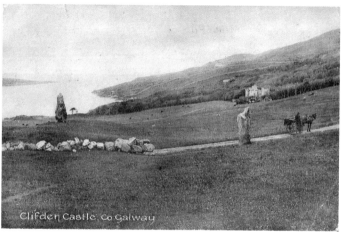

Clifden Castle

estate and when he died in 1864 he was succeeded by his nephew John Joseph who died in 1894. When John Joseph died he left his entire estate, including Clifden, as well as business interests in Britain, in trust to provide an income for his heirs. The Castle was abandoned and fell into ruin.

Waterloo Bridge

Although a comparatively new town, Clifden has had more changes to its main approach roads than most other Irish urban centres. The original route into the town was via Gowlan West, Killymongaun, and Ardbear. As John D'Arcy's new town of Clifden began to take shape and his castellated mansion neared completion, a new main road was constructed from Gowlan, crossing the Owenglin River via a new bridge to enter the town at Hulk Street leading into Market Street. The single elliptical arch spanning a narrow river gorge with its two towers was intended to create a grand entrance to the new settlement on the Galway approach. The castellated

towers were decorated with mock arrow loops similar to those used to ornament the Castle. An unusual feature of the bridge can be seen under the southern abutment where the rock has been cut and shaped to a smooth and sloped surface. This, no doubt, was to cater for the flash floods that occasionally occur in the Owenglin. In August 1932 two bullocks were swept away by floods and carried downriver from Bornanouran. Any large rock outcrop under the bridge would catch debris and hold them. In this way a dam could easily be built up raising the floods to a height where they could endanger the arch. The bridge design has been attributed to Alexander Nimmo but this has yet to be confirmed. The treatment of the riverbed to prevent flood damage does not match Nimmo's work. The new road was later extended into Sessions House Bridge, a new Board of Works bridge constructed to allow a link from Main Street to the Courthouse. At the Spring Assizes of 1842 James D'Arcy secured a presentment to construct 214 perches of road; the Board of Works were to contribute £42, which they had in hand for that purpose; Hyacinth D'Arcy was to contribute £56 7s. 6d. and £169 2s. 6d.; the balance of the cost was to be levied off the barony of Ballinahinch. The money was to be paid in three installments. All three installments came up for payment at the Summer Assizes of 1843. The new road started from a point to the east of the brickfields and ran due west to the Courthouse. D'Arcy had already secured presentments to construct ten perches of new road between the Court-house and the schoolhouse and to repair twenty-four perches of the road between the chapel of Clifden and the schoolhouse gate at the Spring Assizes of 1841. The former was represented at the Spring Assizes of 1843 and must have been completed because Martin Harte and Patrick Pye were paid one shilling to close the old road through the burial ground of Clifden chapel. During the early 1980s a new bridge and section of road was constructed bypassing the doglegged river crossing of

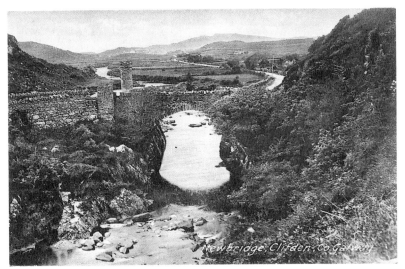

Newbridge, Clifden, Co. Galway

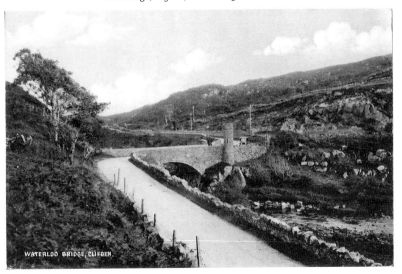

Waterloo Bridge, Clifden

Waterloo Bridge. The new bridge was constructed on dry ground and when it was completed the river course was altered to run under it. This is an old technique; its first recorded use in Ireland was in Ringsend in Dublin in the seventeenth century. Over the years Waterloo Bridge has suffered some damage. One of the towers has been lost due to impact damage from traffic. One can only wonder

what caused the damage to the parapets in 1849 when Redmond Joyce was paid £2 to carry out the necessary repairs.

Clifden Railway

The arrival of the motorway age in Galway introduced the concept of public consultation to a new generation, who, understandably, thought that this was a new and welcome development in transparency in proposed major public sector projects. A number of proposed routes had to be selected, mapped and put on display for public comment. In reality this was an updated version of the process that railway companies had to follow from the 1870s onwards when they were proposing new lines. Detailed maps showing the proposed route and the location of every property that was to be affected had to be drawn up and printed for the process. The company had to advertise their intended railway, describing the route to be taken and naming every townland that it was to pass through. The public had to be informed of the various locations where the plans were available for inspection. All properties likely

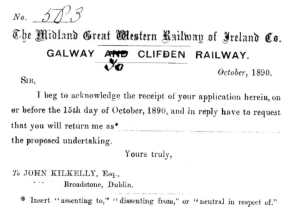

No. 5P3

The Midland Great Western Railway of Ireland Co.

GALWAY AND CLIFDEN RAILWAY.

Sir, *October,* 1890.

I beg to acknowledge the receipt of your application herein, on or before the 15th day of October, 1890, and in reply have to request that you will return me as* _____ the proposed undertaking.

Yours truly,

To JOHN KILKELLY, Esq.,
 Broadstone, Dublin.

* Insert "assenting to," "dissenting from," or "neutral in respect of."

to be affected by the proposed railway had to be identified in a book of reference which was correlated with the book of plans. All owners, leasers, and tenants of the properties in question had to be named in the book of reference and, also, had to be written to informing them where the plans were available for inspection. Included in this notice was a prepaid reply, usually a postcard on which they were to indicate whether they were in favour, against or neutral concerning the planned line. 1890 was a busy year for railway proposals in County Galway. No less than five different plans for a Galway–Clifden railway were prepared as well as plans for an extension of the Athenry and Tuam line to Claremorris. The manuscripts giving details of the voting replies to the Midland Great Western Railway's proposed Galway–Clifden railway have survived. The voting details are as follows:

	Number	Assent	Dissent	Neuter	No Answer	Spoilt
Owners	50	15	4	-------	31	-------
Leases	49	24	5	1	19	-------
Occupiers	347	172	41	6	105	9

Included in the 'Spoilt' column were those who sent in unsigned cards or those who failed to fill in their preference. Only 211 people out of the 446 contacted were in favour of the railway, whilst 155 people didn't bother to vote even though the proposed line was going to impact on their property – Voter apathy is by no means a new phenomenon.

Whilst the construction of the line brought much-needed employment, albeit short-term, to the area the long-term benefits were enormous. Tourism boomed, leading to the construction, enlargement or modernisation of hotels. This, in turn, led to an increase in demand for locally produced goods and services. The fishing industry and the livestock trade got a boost because of easier and cheaper access to markets. The existence of a direct main line railway from Clifden to Galway and onto Dublin was also a factor in influencing Marconi to establish his transatlantic radio station at Derrygimlagh, just outside Clifden. Above all the opening of the railway brought with it the hope for a better future. The closure of the line in 1935 was a body blow to Connemara and should be seen as the greatest loss sustained in the twentieth century, not just by Connemara but by all of County Galway.

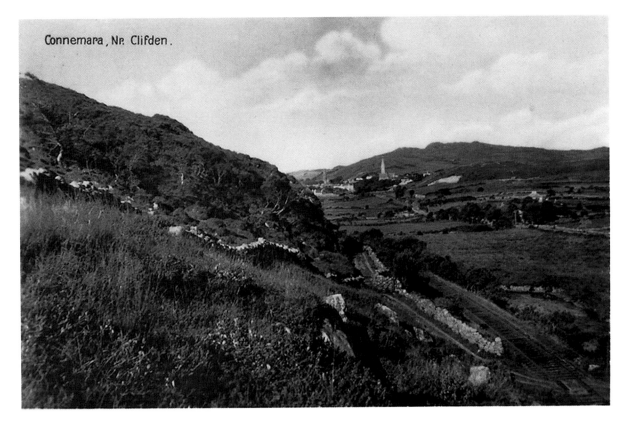

Connemara, Nr. Clifden.

Connemara, near Clifden

The railway approached Clifden on the south side of Waterloo Bridge and can be seen in an unusual view of the town taken from a point west of the bridge and published by the Milton Company in the early 1900s. At the bottom right hand corner an accommodation crossing for a local trackway can be seen. A small section of the river with a marl bank is also visible. This was the location of one of the two brickfields that Clifden had in the early years of the nineteenth century. The absence of kilns marking the brickfields on the Ordinance Survey map indicates that the bricks were formed into an arch or tunnel and fired by burning turf within the arch. Four to five thousand bricks could be fired or baked at a time. The fires had to be continuously stoked and kept alight until the bricks were baked. Long iron rods curved at one end were used for stoking the fires. Considerable amounts of turf were needed for this process.

Main Street

Prior to the construction of the Courthouse and Sessions House Bridge the principal street in Clifden was Market Street. Main Street had been constructed but was not the main thoroughfare into the town until the Sessions House Bridge was finished. The streetscape underwent dramatic change in its building façades and skyline in the period following the opening of the Clifden railway as can be seen from the selection of cards, mainly from the period 1895 to 1910. By contrast there was very little alteration to the streetscape between 1910 and 1950 as is obvious from the 1950 postcard. The earliest card shows a somewhat rundown street. The transformation can be seen in the next few cards which also feature some items of interest. The most obvious of these are the Midland Great Western Railway buses registration numbers IM 181 and IM 179. The first bus has

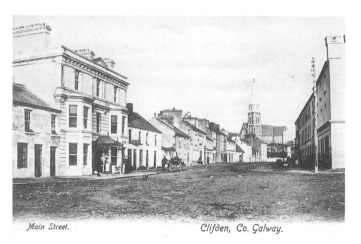

Main Street. Clifden, Co. Galway.

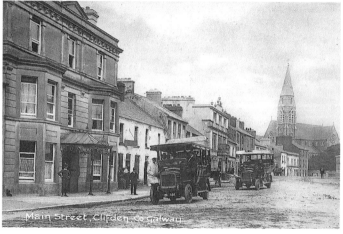

Main Street, Clifden, Co Galway

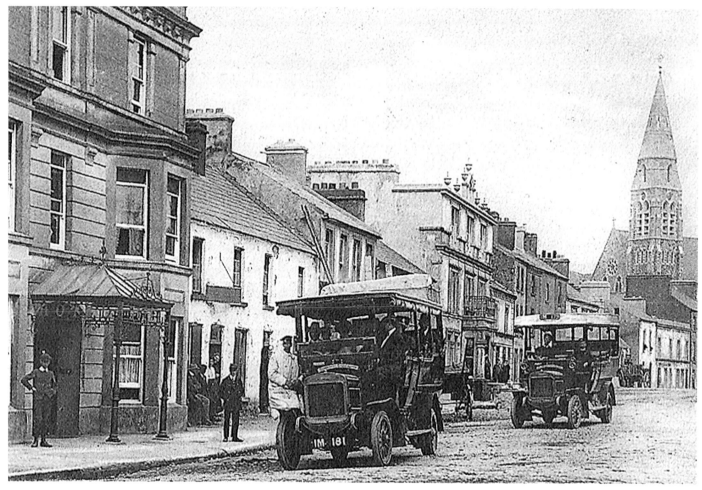

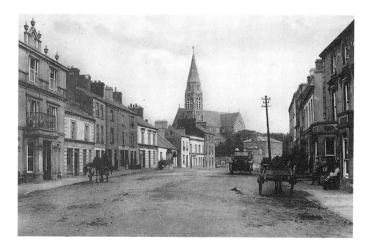

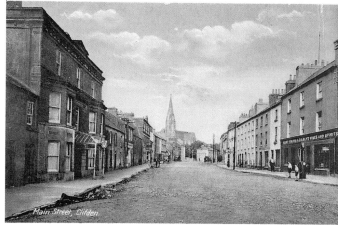

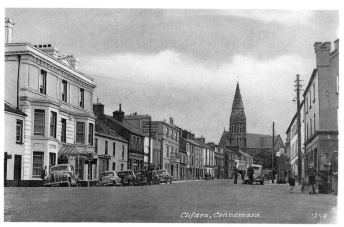

A selection of postcards featuring Main Street, Clifden

picked up passengers at the hotel and is about to set out for Westport. The driver is nicely posed to the left. The Railway Hotel did not belong to the Railway but had a contractual relationship with the company concerning accommodation for passengers. From the beginning in 1895 the Midland Great Western Railway through its agency agreement with the British Midland Railway offered Euston (London)–Dublin–Clifden–Westport–Dublin–Euston round trip fares. Accommodation could be arranged if required, hence the contract with the hotel. Another view features drainage pipes on the left hand side of the road with a restored trench running alongside the footpath. This is a pointer to a problem faced by the residents on an occasional basis – flooding. John Corbett was contracted to build a 'gullet twelve perches long between John Lee's house and Kings and from thence across the main street to the main sewer at Paul Carr's with two iron gratings'. The contract price was £40, which was a large sum, therefore the gullet must have been a large one and must have been intended to carry away a sizable quantity of rainwater and mitigate street flooding.

The Berridge sisters are featured driving into town in their open top. Their hats are secured by tying the ribbons under their chins. The Berridges were enthusiastic motorists and held speed trials at Ballinahinch in

1908. Speed limits were not a problem in those days so the young ladies did not have to worry about a possible appearance in the courthouse, which features at the end of the street. During construction works on the building a young man, a carpenter from Athenry, fell from the roof and died from his injuries. He was buried in the graveyard opposite. Also featured on the right hand side of a card is the first petrol pump erected in the town.

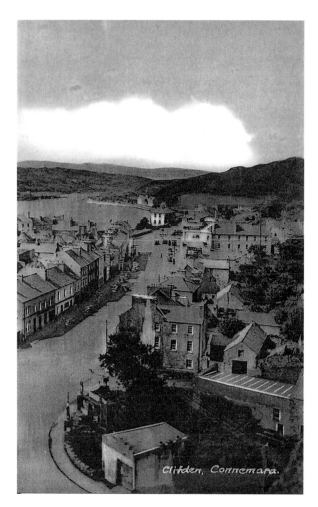

Clifden, Connemara.

complete the church and tenders were sought for the works in May 1896 and again in June 1898. Monsignor McAlpine succeeded Canon Lynskey as parish priest and under his stewardship the work was completed. A clock and church bell were installed in 1899, followed by an organ in 1900. A new pulpit and confessionals were installed in 1904. Further improvements and the decoration of the nave and transepts were carried out by James Clarke and Sons, Dublin.

Monument Hill

The card features a man bringing sheep to the fair with Monument Hill in the background. The monument was erected to commemorate John D'Arcy, the founder of Clifden. The funds were raised by public subscription but proved insufficient for the task. Further work was carried out in 1870 but it was not until 1992 that the monument was finally completed. The work was a

*Roman Catholic
Church, Clifden*

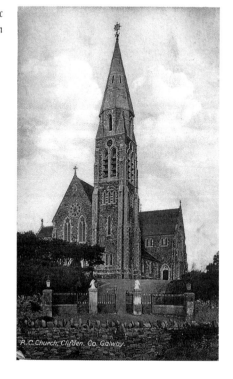

R.C. Church, Clifden. Co. Galway.

Church

With the construction of the new roads by James D'Arcy in 1843 a prime site for a church or other public building was created uphill behind the Courthouse. The Famine and its aftermath, however, put paid to any thoughts of a major building project. It wasn't until 1871 that tenders were sought for the construction of a new Catholic church on the site to the design of John Joseph O'Callaghan. The foundation stone was laid on August 28th 1872 by Archbishop McHale of Tuam. The contractor was P. Morris. Cannon Lynskey, the parish priest promoted the construction of a tower and spire to

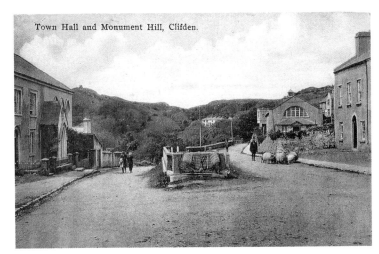

Town Hall and Monument Hill, Clifden.

*Town Hall &
Monument Hill,
Clifden*

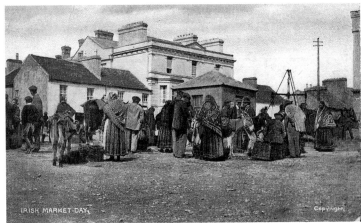

IRISH MARKET-DAY.　　　　　　Copyright.

*Irish Market
Day*

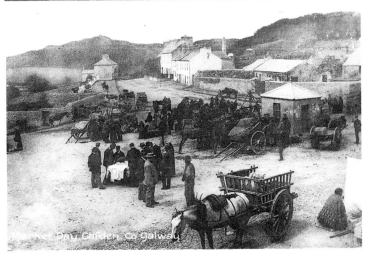

Market Day Clifden Co Galway

*Market Day,
Clifden,*

voluntary effort by the Clifden Heritage Group. To the right is the town hall which was constructed about 1900. It was used for occasional cinema screenings in the 1950s. The building was renovated and restored in 2009. The road junction now carries a monumental high cross memorial to Thomas Whelan who was from the Sky Road. Thomas was arrested and charged with the murder of Captain Bagally on Bloody Sunday 1920. He was convicted and executed on March 14th 1921. He proclaimed his innocence to the last. The building on the left is the former Methodist chapel which contained a schoolroom and the minister's house. The lower road leads down to the quay.

Markets

Slater's Directory for 1846 lists the fair days as June 26th, September 1st, October 15th, and December 17th. Market day was a Saturday. By 1892 there were eight fair days in the town. With the doubling of the number of fair days the old pound was converted into a fair green with a small area fenced off to cater for its original purpose. Significant quantities of livestock were shipped by train from Clifden after the fairs held in the town and elsewhere in north Connemara. The Clifden station master would have to lay on a supply of twenty-five wagons to facilitate buyers at fairs in Leenane, with the station in Westport having to supply a similar amount. The Clifden Fairs do not seem to have appeared on early postcards but the local markets feature regularly. The market square had a

weigh house and scales for weighing the produce brought in for sale. Buyers for Dublin and other fish markets would have their purchases weighed at the weigh house. The usual commodities were on offer: potatoes and other vegetables, eggs, poultry and butter. Small amounts of fish and shellfish were sold for local consumption. Sometimes large tree trunks would be brought to market as can be seen in one of the views. One view, produced by Bardleben of New York and Germany would seem to have been produced for the Irish immigrant market in America. Tin Pan Alley songwriters with their *Mother Machree* songs were not the only people to cash in on the immigrants' nostalgic memories of home. The card shows a sizable crowd waiting to have their goods weighed. Church Street looks unusual with the neat mounds of what appears to be rubble stacked up against the walls. Some calves seem to be penned along the street also.

Ardbear Old Bridge

Built in the early 1800s, this bridge was on the original main road into Clifden. It has been known by many different names over the past two centuries. Ardbear, the Bridge of Clifden, and Creighton's Bridge are some of the names used at different periods. The bridge originally had four arches but the feeder arch to the

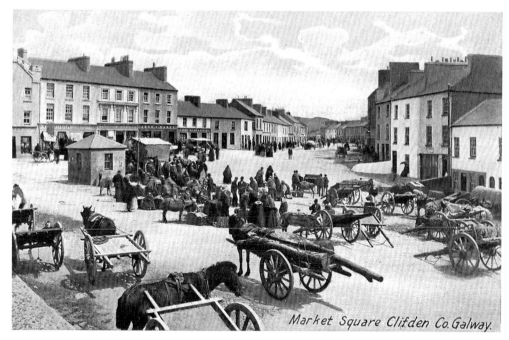
Market Square, Clifden

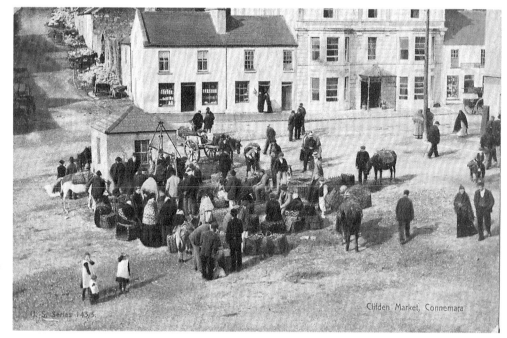
Clifden Market

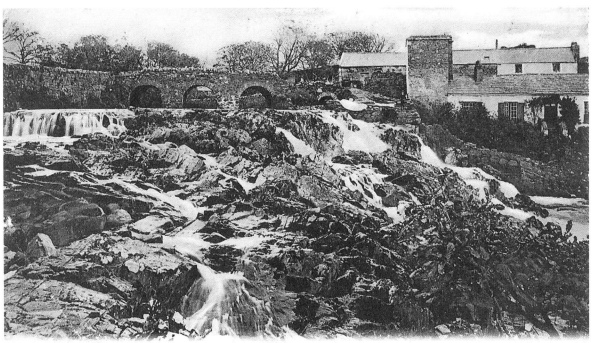

Clifden.

The Wrench Series, No. 20414

The Falls.

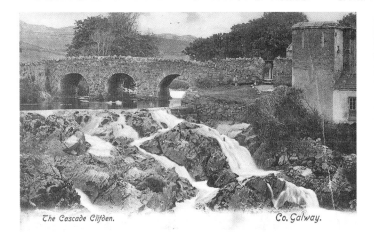

The Cascade Clifden. Co. Galway.

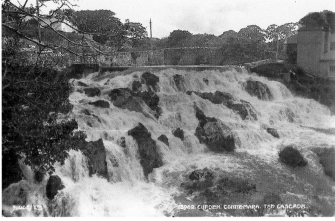

old brewery was blocked off on the downstream side in the 1890s. The bridge in its original state features in a postcard produced in the Wrench Series of cards that clearly shows the mill arch which is of a later construction date than the bridge. In the background is Wilson's Coach Factory with the shafts of an upended trap and cart clearly visible. The bridge in its altered state is shown in a card issued by Lawrence of Dublin. Both cards were issued in the period 1898 to 1900. The Lawrence card shows the site of the feeder arch filled in and the area levelled up and grassed over. The arch is blocked off on the downstream only. It is possible to enter under

the arch on the upstream side when the river level is low. The bridge parapet has been repaired also. The photograph was taken about 1895. The photograph for the Wench Series card dates from pre-1890. After the construction of Alexander Nimmo's Ardbear New Bridge the older bridge became known as Ardbear Old Bridge and is so named on the Ordinance Survey maps. However, in the 1840s it was more commonly known as Creighton's Bridge.

On July 1st 1840 Abraham John Creighton obtained a decree against Edward Birch Smith, Joshua and Elizabeth Smith and others and as a result several plots were put up for sale on December 19th of that year. The plots were listed as follows: Number One, Waterfall Plot; Number Two, Soap Boilers Plot; Number Three, the Mill Holding with one rood of ground attached as formerly leased to James D'Arcy; Number Four, thirty acres of bog on the east side of the road from Clifden to Streamstown located about a mile from Clifden; Number Five, James O'Dowd's Plot; Number Six, Doctor Gray's holding; Number Seven, James Faherty's field. Together with the distillery, malt house, brew house, offices and mill with all fixtures, fittings and utensils, and the mill with its races and watercourses, the entire area came to forty acres, three roods and seventeen perches plantation measure. All the property was held on a lease for three lives renewable forever from John D'Arcy of Clifden Castle which was granted on August 19th 1825 at an annual rent of £8 10s. The James D'Arcy of the mill was the contractor for the road from Waterloo Bridge to the Courthouse constructed in 1842/3.

Birch Smith had tried to dispose of his interests in the property in 1830. In January of that year he advertised the letting of the property together with twelve acres of arable land and a King's Warehouse or bonded store. The advertisement claimed that corn could be bought locally at a cheaper rate than that prevailing at any other location in Ireland and also that higher prices prevailed locally for the products produced than could be obtained elsewhere. As a sweetener for an early close of letting he could provide the purchaser of his interests with 100 barrels of grain. He again advertised the disposal of the property on June 17th 1830. This time he stated that 'a person understanding the business with a moderate capital would be taken as a partner'. He also offered the option of a yearly letting. By August 2nd he was advertising the property under the title of the Clifden Concerns either for sale or annual letting. A purchaser could be accommodated by allowing part of the purchase money to be left as a lien on the premises. Obviously the business was not living up to its early promise. Nimmo had noted that the concerns had paid some £300 a year in excise duties and taxes. The brewery is indicated as a ruin on the first edition Ordinance Survey map c.1841 and there is no mention of the distillery.

A. J. Creighton was in possession of the mills in 1849. He was awarded two presentments at the Spring Assizes that year. One was for keeping in repair for seven years twenty-two perches of road between the police barracks in Main Street and Mr Creighton's house at 1s. per perch. The second was for 'repairing the defending walls of the Bridge of Clifden called Creighton's Bridge and Creighton's Mills'. He received £4 10s. for this work.

Some further information on the mills is to be found in the valuation books covering the period 1897–1931. The directors of the National Bank were listed as occupiers of the corn, tuck and sawmills presumably as a result of a default on a loan. The premises were on lease from John J. Eyre. In 1901 Matthew Roberts was in occupation but the premises again reverted to the Bank. In 1903 Cecilia M. Joyce was in occupation jointly with the Bank. This arrangement apparently continued until 1927 when E. J. King took over the lease and converted the mills into an electricity generating station. The ratable valuation was increased from £15 to £30. In 1927 King appealed the valuation and

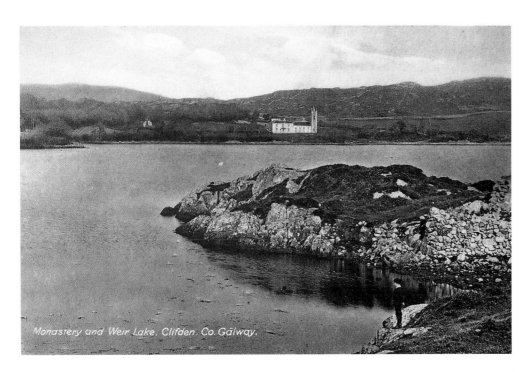

Monastery and Weir Lake, Clifden. Co. Galway.

it was reduced to £25. This was confirmed in 1930 but was subsequently reduced to £22 following a further appeal in 1930.

The headrace inlet for the mills was on the opposite bank to the brewery and water was channelled into it by means of a low weir, a portion of which is visible adjoining the brewery bank in the Lawrence card. The waterfall on the left of the Wrench Series card indicates the line of the weir also. King built up this weir and added an overflow sluice at the roadside defending wall to allow water to be discharged down the river when the plant was not in operation as can be seen in the Judges of Hastings card issued about 1930. The floods of 1932 swept away a large portion of the weir. The station supplied direct-current electricity. It closed when Clifden was connected to the national grid in the 1950s. In 1952 the Clifden Electric Light and Power Station supplied 150 customers with some 40,000 units of electricity. The company charged 1s. per unit for lighting

Monastery and Weir Lake, Clifden

and 6d. per unit for heating and cooking. The generating plant was driven by a combination of water power and oil burners, which were necessary when the flow of water in the river was low. In the 1932 floods the clear waterway provided by the three open arches of the bridge was insufficient to cater for the large volume of water in the river, which backed up and overflowed the banks, flooding several houses.

Franciscan Brothers

The Franciscans came to Connemara at the request of Archbishop McHale to counteract the proselytising activities of Protestant missionaries in the region. Their first foundation was in Roundstone and in 1837 they came to Clifden where they opened a school in the Quay House which they rented as their residence whilst their monastery was under construction at Ardbear. After Archbishop McHale died in 1881 his successor D. MacEvilly had a new national school opened in Clifden.

The brothers were not involved. They did, however, open a classical school at Ardbear where French, Latin and bookkeeping were taught amongst other subjects. In September 1947 the brothers opened a secondary school and in 1953 they moved into Ardbear House. After the introduction of free education in 1967 the numbers attending the school grew substantially. In 1973 a community school was opened on the site which resulted from an amalgamation of the Franciscan school with

The Lake & Cemetery, Franciscan Monastery, Clifden, Co. Galway

that of the Mercy Sisters and incorporated a vocational education element into the curriculum.

Salt Lake

Salt Lake is, in reality, a small inlet of the sea which has been virtually landlocked by the construction of a causeway with two widely spaced arches. Prior to this it had been used as a harbour with a small pier. The small island has a stone beacon that was used as a navigation aid. It is possible that this little harbour facility predates the founding of Clifden. As can be seen from the card, the Franciscans had their burial ground here.

Marconi Radio Station

In 1905, the year he got married, Guglielmo Marconi came to Ireland in search of a suitable site for a transatlantic radio station. He found the ideal site at Derrygimlagh. Indeed one could say the site picked itself. The site was close to a reasonably sized English-speaking town that was served by both a main line railway and the telegraph system. Clifden had a ready supply of skilled, semi-skilled and unskilled labour available as a result of the construction of the railway and the mini building boom involved in the supply or enhancement of tourist accommodation. The town also had a port. The site itself had a plentiful supply of turf, which was needed for the boilers of the steam generators. There was a good supply of clean, soft water available; this meant that encrustation, or limescaling, of the boilers would not be a problem. The physical layout of the site dictated the layout of the station and lent itself to the construction of the massive boiler and electrical generation hall, the condenser house, a laboratory, forge, staff quarters and canteen. Both the generation hall and condenser needed substantial foundations, which were obtained by utilising the areas of extensive rock outcrop that occurred on the western side of the site. These areas were levelled up with broken stone and finished off to final floor level with a heavy layer of concrete so that these two buildings could be erected. The eight large transmission masts, each 310 feet tall, were located behind the condenser house in an area where the underlying granite rock had only a shallow covering of peat. Finally, there were only two access points to the site so unauthorised visitors could be kept out. Marconi was, rightly, afraid of industrial espionage so visitors were not allowed on-site without written authorisation from company headquarters. Photographers were not permitted entry, except one from the company; and no reporters were admitted,

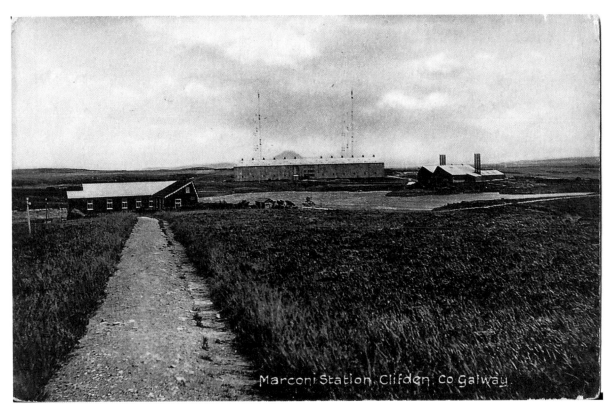

Marconi Station,
Clifden

most especially not those working for technical journals. Construction work began in 1905 and was completed within two years. A narrow gauge railway was constructed to transport heavy equipment and materials around the site. When the station was operative the railway was used to bring in workmen and supplies and also for hauling turf to the boiler house. During the building works considerable problems were caused for the road contractor Martin Pye, who could not maintain his contract sections of road because of the damage caused by construction traffic. In his quarterly report dated February 13th 1906 the county surveyor James Perry informed the county councillors that their only alternative to nilling Pye's contract was to prosecute him and his sureties for non-compliance with his agreement. Perry recommended against prosecution and suggested that he be given the balance of the contract money to make the road safe for traffic until the next renewal date for contracts, March 31st 1906. Pye had the contract renewed but was in difficulties within a matter of weeks. He made a complaint to the County Council about the damage caused by transporting heavy spars on rollers to the site. These were for the transmission antennae. The ends of the spars were, obviously, ploughing the gravel surface at humps or hollows in the roadway. The councillors decided that Mr Pye should seek compensation from the Marconi Company to cover his extra costs in maintenance. The problem of construction traffic damaging public roads was not new; several road contractors had to have their contracts nulled because of the damage caused by heavy traffic associated with the construction of the Galway–Clifden railway. Perry thought it would be unfair to prosecute the unfortunate contractors concerned and the only alternative he had was to have the contracts nulled. Whether the railway company paid for repairing the damaged sections of roadway or not is unclear. In more recent times motorists have bitter memories of the potholes created in the roads of east Galway by the contractors involved in the construction of the M6 motorway.

Through the Twelve Pins of Connemara.

Chapter 7 The Tourist Trail

Inagh Valley, Kylemore, Letterfrack, Renvyle, Salruck, Killary, Leenane, Lough Nafooey.

Motoring in Connemara

The Gordon Bennett International Car Rally of 1903 gave an enormous boost to the promotion of motoring holidays in Ireland and a series of postcards was produced to commemorate the event. The rally also led to an increase in pressure to have steamrolling carried out on the roads to improve the driving surface. By 1906 James Perry, the county surveyor was advocating that the County Council acquire a steamroller of its own and commence a programme of rolling the main roads. The County Council had already in 1903 used a hired machine to roll the road from Galway city to the racecourse to facilitate racing fans. Whilst Perry recognised that at that particular time cars were 'the playthings of the rich' he anticipated that motor traffic would increase. He was convinced that motor wagons and buses were here to stay and wanted to have the main road network in appropriate order for the new type of traffic. In 1908 the Berridges of Ballinahinch held motoring speed trials in Connemara, which promoted the idea that the area was an adventurous place for motoring holidays. Postcards like the one shown did much to promote the motoring charms of the area particularly in the 1920s. However, it should be remembered that later motorists did not have the benefit of solid tyres. The Midland Great Western Railway buses were a frequent site on north Connemara roads. The company had three buses in operation plying between their hotels at Recess and Mulranny in Mayo. They were also used to complete the link between Clifden and Westport.

Clifden to Recess Connemara.

Lough Inagh

Nestled between the Maamturks and the Twelve Bens, the Inagh Valley was a tourist attraction long before the opening of the Clifden railway in 1895. There was a hotel in operation near Recess that catered to anglers as early as 1852. Sometime about 1894 the Berridges constructed Finniskin Lodge as a hotel in the Inagh Valley as part of their plans to develop their Ballinahinch fisheries. When the railway company were seeking a site for a hotel at Recess the Berridges offered to sell them the Finniskin Lodge. The company declined the offer, purchasing instead the Recess Hotel. The opening of the railway generated a significant increase in business for both hotels. Both became increasingly popular not alone for anglers, but also for photographers, nature lovers, hillwalkers and cycling enthusiasts. As a result of the growth in tourist numbers a large

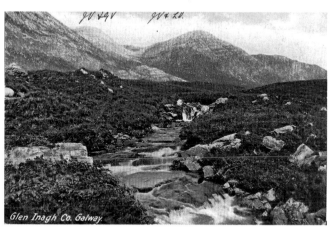

Glen Inagh Co. Galway.

number of postcards were produced showing the attractions of the valley. Oftentimes the finished product was quite different to the reality. The practice of doctoring photographs to enhance the view or to remove unwanted items from the scene is almost as old as the

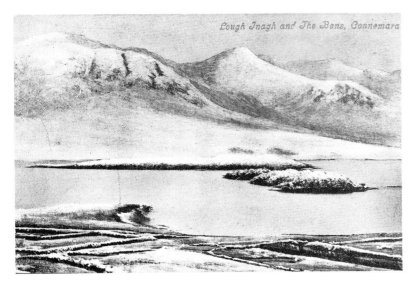

'Winter Wonderland'
Lough Inagh and the Bens

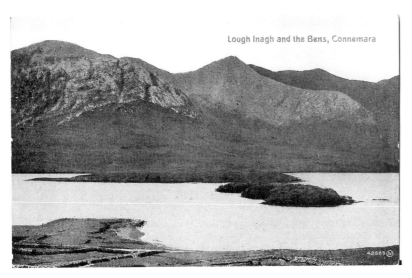

Lough Inagh and
the Bens,
Connemara

was posted in Belfast on December 21st 1903 to wish the recipient a happy Christmas and is produced from the same negative as the postcard below it. There was very little snow in the west of Ireland in 1903 despite a major storm on February 26th of that year. However, 1892 was a particularly bad year for snow, with falls being recorded on twenty days. January was the worst month of the year and the mountain streams that feed the lake became torrents after severe rainfall.

Kylemore

The Kylemore Pass was a favourite beauty spot for early nineteenth-century tourists judging by the published accounts of their travels. Enthusiastic anglers were also aware of the salmon fishery that existed on the Dawros River. Very shortly after purchasing Kylemore Lodge in 1862 Mitchell Henry set up a salmon hatchery to restock the Dawros River. The foundations for Kylemore Castle on the site of the Lodge were not laid down until 1867.

The Castle was designed by Samuel Ussher Roberts, a Waterford-born engineer who had come to Galway to take charge of the Corrib Drainage and Navigation works in 1848. Roberts had pioneered the use of water turbines in Ireland on the Glyde Drainage Scheme before coming to Galway. He designed the Galway Waterworks and supply system. The pumps were powered by two water-wheels, which were only replaced in 1903. He was involved in designing two separate railway schemes to link Galway and Clifden in the 1860s. Kylemore Castle took four years to complete and cost £29,000. Dalkey granite and Ballinasloe limestone were used in its construction. Turkish baths were erected on the east side of the building. The Castle was initially lit by gas lamps. The gas was produced in the estate's own gasworks. This was later changed to electric lighting in 1893 when a high-pressure turbine was installed. Henry's wife, Margaret, died in 1874 and his daughter, Geraldine, was killed in an accident in 1892. Following Geraldine's death he put the

art of photography itself. Valentine's were past masters at doctoring their cards. Sometime about 1903 the company 'enhanced' a number of their stock images to produce what might be called 'winter wonderland' scenes. It would seem that they were intended for the Christmas trade. The 'winter wonderland' card shown

Kylemore estate up for sale. However, he was still living there in 1900 but was in financial difficulties. After Edward VII visited the Castle briefly in 1903 it was rumoured that he was going to purchase it as an Irish royal residence. In the event it was bought by the Duke of Manchester in September 1903 for £63,000. The Duchess made several alterations to the house.

When Mitchell Henry died in 1910 he was cremated and his ashes were brought to Kylemore for internment beside his wife. The Duke of Manchester was on his way to bankruptcy by then and in 1914 the Castle and estate fell to John Falke, a London business-man and owner of the Thames Side Hotel. Falke had bought up the mortgage on the property some years previously. He tried to establish a large modern hotel and hydro establishment in the Castle but without success. He then auctioned off all the contents.

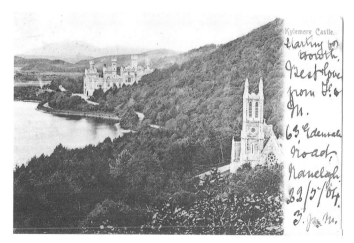

Kylemore Castle

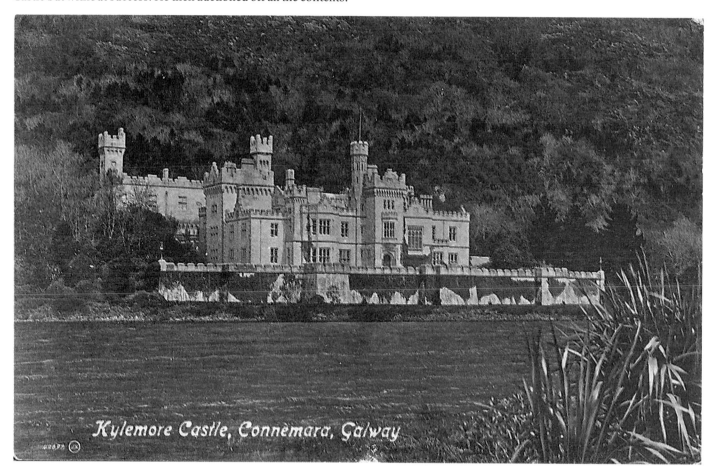

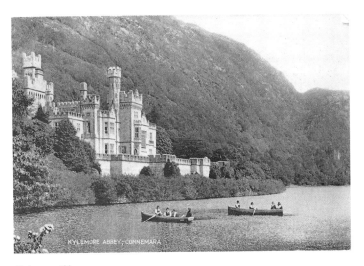

Kylemore Abbey

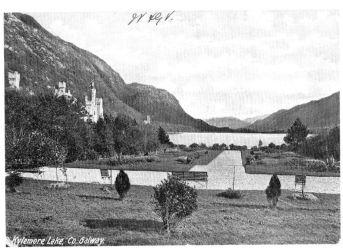

Italian Gardens

In 1920 the Benedictine Sisters from Ypres acquired the Castle and in September 1923 opened a school for both boarders and day pupils. Some of the postcards from the late 1920s feature pupils boating on the lake. On the night of January 25th 1959 a fire caused extensive damage to the interior of the Castle. The repairs and alterations to the building took three years to complete.

Italian Gardens

The Castle had two gardens in its early years: the large walled gardens with twenty-one glasshouses that had underfloor heating ducts; and a smaller Italian Garden on the lake shore with a view of the Castle. It was laid out with classical simplicity so that visitors could enjoy the views of both the landscape and the buildings of the Castle complex. The admission building to the Castle now occupies the site.

Gothic Church

Mitchell Henry was devastated by the death of his wife, Margaret, while the family was on holidays in Egypt in December 1874. Her body was embalmed and was interred in a specially constructed mausoleum that was located near the main avenue. In 1877 work began on the construction of a Gothic Church as her memorial chapel. The Church was designed by James Franklin Fuller, who had designed Sir Benjamin Guinness's extensions to

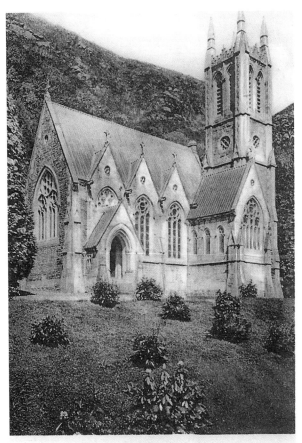

Kylemore Abbey - Gothic Church.

Ashford. The Church interior was modelled on the Chapel of Saint Stephen at Westminster. All the marble used in its construction was Irish; Connemara green, Cork red and Kilkenny black marbles being used for the pillars. The church was completed in 1881. Over the passage of time the building slowly fell into disrepair. In 1991 the Benedictine Community at Kylemore began a major project of conservation and restoration on the building. This was completed in 1995 at a cost of £500,000 and the church was blessed by Archbishop Michael Neary of Tuam and formally opened by Mary Robinson, President of Ireland on April 28th of that year.

The Flag of Ramillies

Tradition has it that this, along with other flags, was captured by the Irish Brigade from the British Army at the Battle of Ramillies in 1706 and later presented to the Benedictine Sisters to hang in their church in Ypres. When the nuns had to abandon their convent during the First World War they took the last surviving flag with them. When they found a permanent home at Kylemore it was hung in their new Abbey. It survived the fire that occurred in 1959. The card was issued sometime after the nuns took up residence at Kylemore in 1920.

Postman

Postal services began at Kylemore in 1869 with the opening of a post office. This was located within the demesne grounds initially but early in the twentieth century it was relocated to a new site. The card features a photograph taken by Mitchell Henry's son Lorenzo in the 1890s. His father made representations to the postal authorities to have the postal service for the Aran Islands improved in 1882. Prior to that, mail was delivered to Inishmore twice a week, weather permitting, by sail boat. Mitchell Henry wanted the delivery to be by steamer, which would practically guarantee year-round deliveries. After some pressure he got his way. However, he was unsuccessful in 1884 when he sought to

Erin Postcard

The Mail at Kylemore Abbey Connemara.

with the Commissioners of Public Works. Henry paid for the cost of the diversion, which was not the normal practice of County Galway landlords, many of whom felt that the public purse should facilitate them in rerouting roads to avoid their parkland. The road was constructed across the lake on a causeway. Local tradition has it that the fill material for the causeway was spread on wool. This was to eliminate, as far as possible, disturbance to the silt on the lakebed which could have caused serious damage to Henry's salmon fishery. Within months of acquiring the site and before serious building work on the Castle had started Henry had set up a fish hatchery to stock the local river system. The road between the lake and Tullywee Bridge was constructed through very soft ground so bundles of brushwood were tied very tightly in rolls and cross laid on the bog as the foundation for the road. The old main road can be seen to the left of the bridge with a gate across it.

Kylemore Pass

Kylemore Pass. Co. GALWAY.

Lawrence, Publisher, Dublin.

have a post office opened on Inishmean. A sub post office was, finally, opened on the island on January 1st 1901.

Kylemore Pass with Tullwee Bridge

The old public road ran along the site where Kylemore was built. Samuel Ussher Roberts, who had designed the mansion, constructed a new road running across Pollacapple Lake and to the south of the Castle in 1871. Roberts was county surveyor at that time but was to retire shortly afterward to take up an appointment

Clifden (Co. Connemara).

Kylemore Pass from Letterfrack Bay.

The Wrench Series, No. 20421

Letterfrack

James and Mary Ellis, two English members of the Society of Friends, or Quakers, settled in Letterfrack in 1849 on land they leased from Robert Graham of Ballynakill. They set about reclaiming the land, and began to develop the area as a Quaker settlement. New houses were constructed, as was a meeting house, a school, a dispensary and a doctors house. Upwards of eighty men were employed in draining and improving the land, tree planting and the building of walls and fences. Mary was engaged in providing clothing and other relief to the famine-stricken families of the locality.

When Henry Coulter visited the area in 1852 he described Letterfrack as one of the gems of Connemara; he thought that the village resembled a modest English one. When John Ellis's health broke down in 1857 the family returned to England after selling their leasehold interest to John Hall. Hall was a supporter of the Irish Church Mission Society and was noted for his anti-Catholic views. Under his influence proselytising was attempted. In 1882 Hall put the property up for sale. It was acquired on behalf of the Archbishop of Tuam who invited the Christian Brothers to Letterfrack. At his prompting the Brothers applied to the authorities for permission to convert the Ellis house into an industrial school for Catholic boys. Permission

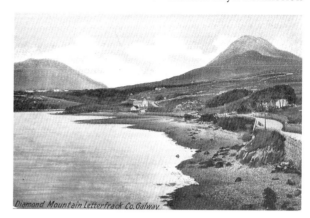

Diamond Mountain Letterfrack Co. Galway.

Diamond Mountain, Letterfrack

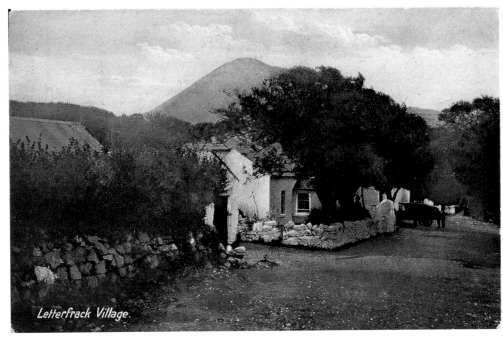

Letterfrack Village

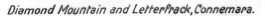

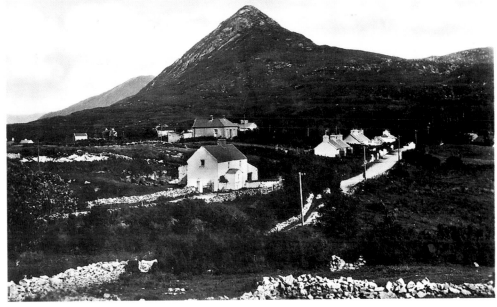

Diamond Mountain and Letterfrack, Connemara

was granted in 1886 for a school to accommodate seventy-five boys; the number was later increased to one hundred and fifty. Living conditions in 1892 would appear to have been little better than at subsistence level to judge by the Congested Districts Board reports. The pier was described as of little use for fishery purposes but capable of improvement. Against this background the arrival of the Brothers and the construction work created in the erection of the industrial school created some welcome economic activity in the locality. The Ellis house was converted into the monastery and a large institutional building was erected. This contained three large dormitories, classrooms, a kitchen, refectory, washrooms and laundry. The buildings dominated the skyline when viewed from the coast road as can be seen in one of the cards.

Renvyle

The lands around Renvyle were occupied by the O'Flaherty clan from the fourteenth century onwards. Their castle was finally destroyed by the Cromwellian Major Myles Symes. The Blakes acquired the property in 1680 and leased it to the O'Flahertys for a period. The first Blakes to live here were Henry and Margaret Blake who took up residence in the former tenants large thatched house. They enlarged it, adding a second story and roofing it with slates that had been

quarried locally. Henry was a progressive and fair landlord by all accounts; he supplied his tenants with Indian meal during the Famine and gave rent abatements; and as a result he faced financial ruin and had to dispose of a large portion of his estate.

When Henry died in 1856 he was succeeded by his son Edgar who died in 1872. Edgar's widow, Caroline, took over running the estate but ran into trouble with the Land League some years later over rents charged to tenants. This might well have been as a result of the Blakes imposing a headage charge on their tenants for permission to graze their livestock on the mountainsides. The Blakes did not allow free commonage. To recoup some of her losses Caroline converted the house into a hotel. The business prospered for a number of years. Famous artists, writers, and shooting and fishing enthusiasts stayed there. However, the First World War caused serious disruption to the business and the house was sold to Oliver St John Gogarty, the Dublin surgeon and author, who closed the hotel and used the house as a summer home. After the Free State was established Gogarty was appointed to the new Senate, which made him a marked man for the anti-treaty people. In 1923 they burned the house, destroying all its contents. Gogarty rebuilt it but as a hotel. After initial success the hotel went into a slow decline and was sold in 1950. Renvyle House still trades successfully as a hotel.

Tully Lough

Tully Lough was used as the background setting by W. H. Bartlett in his painting *The Lady of the Lake* which was executed about 1887. It featured Ellen Marguerite Blake, who was about eleven years of age at the time. Bartlett was staying at Renvyle House. The painting was sent to the Royal Academy but was not exhibited. The picture was later sold to an American buyer. Despite Bartlett's fame Ellen recalled, later on, that she was bored having to pose for such a long time.

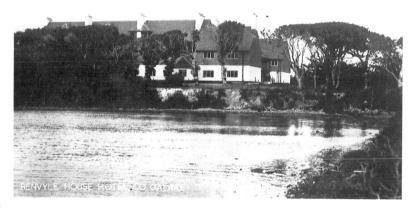

Renvyle House

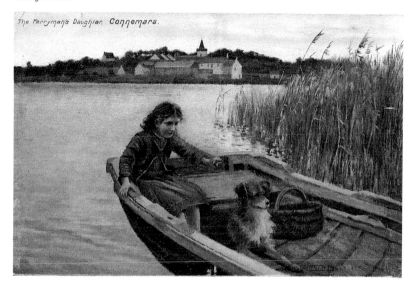

The Ferryman's Daughter

The picture was set at the landing stage on Freilaun or Heather Island and the buildings in the background are supposed to represent the old coastguard station. Ethelstane Blake had built a house on the island with stones, it is said, from a crannog or lake dwelling that lay close to Half Moon Island. A postcard was issued

featuring the painting about 1900. The title had been changed to *The Ferryman's Daughter, Connemara*. There was no ferry on Tully Lough, however, there were several on Lough Corrib and one across the entrance to Killary Harbour.

Salruck

General Alexander Thomson built Salruck House in 1836 on lands he acquired through marriage to Anne, the widow of Charles C. Miller. There was a lengthy legal battle over his acquisition of the property, which was contested by other members of the Miller family. In 1825 the matter was resolved and Thomson accepted some five thousand Irish acres (about eight thousand statute acres) as his settlement. The Famine hit the area severely and Thomson built a provision store to assist his tenants. He introduced assisted emigration on a large scale and redistributed the resultant available land to his tenants to increase the size of their holdings and make them more viable. He was also a major supporter of the Irish

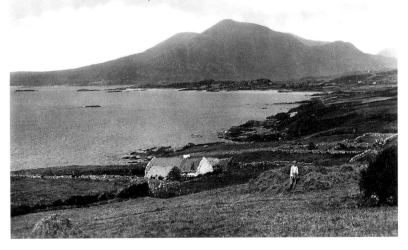

Salruck and Mwelrea, Leenane, Connemara.

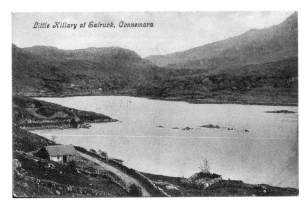

Little Killary at Salruck, Connemara

Salruck and Mwelrea, Leenane, Connemara

Little Killary at Salruck, Connemara

Church Mission Society and promoted their proselytising activities. He died in 1856.

The generosity and kindness Thompson had shown to his tenants continued into later generations and did not go unnoticed: in 1920 his daughter-in-law, Marie Louise, was visited late at night by the local IRA unit commander who told her that she need have no fear for her house, that it would not be burnt as both she and her late husband had been good to the local people. The Salruck area featured prominently in nineteenth-century travellers' accounts of Connemara and, accordingly, features in quite a few postcards.

Lough Fee

Given its location in a deep valley it is easy to see why Lough Fee was so popular with visitors. Sir William Wilde had a fishing lodge here that he called 'Illaunroe' and had decorated with murals painted by Frank Miles. The lodge can be seen on the far shore of the lake beyond the small island. Two of the murals depicted Sir William's sons, Oscar and Willie, as fishing putti. Shortly after qualifying in medicine William Wilde assisted Charles Lever in dealing with a cholera epidemic in Connemara. He went on to become one of the leading ear, nose and throat surgeons of his day and published the first clinical text book on the subject. He was knighted for his work as a medical statistician. He was a noted antiquarian and archaeologist and published extensively in these fields. He is best remembered in the

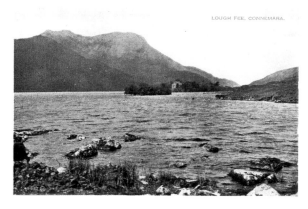

Lough Fee, Connemara

west of Ireland for his classic book *Lough Corrib, Its Shores and Islands*, first published in 1867 and reprinted several times. Like his famous son, Oscar, Sir William became embroiled in an unseemly court case. The case involved a former patient with whom William had had an affair.

Artist's View

By 1900 collecting postcards had become very popular. Ornate albums were produced for sale to collectors and catered to their specific tastes in collecting – scenery, streetscapes, famous people, ships and so on.

Lough Fee, Connemara

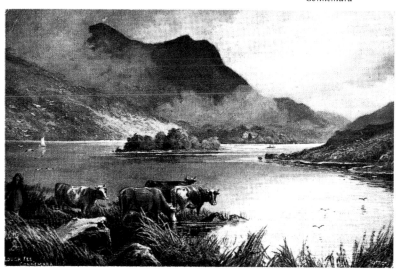

Art cards were very popular. To cater to this demand Raphael Tuck and Sons issued a large number of artistic renditions of famous beauty spots in their Oillette Series. These were of scenes from the west of Ireland and the Scottish Highlands in the main. They gave a highly romanticised view of the area depicted. Many of the scenes were painted by Walter Hayward Young (1868–1920) under the pseudonym 'Jotter'. Young became internationally famous for his postcard designs and produced some eight hundred cards in his lifetime. He painted from large sized photographs and added in some extra embellishments, such as the colleen with the

Loch Fee & Loch Muck

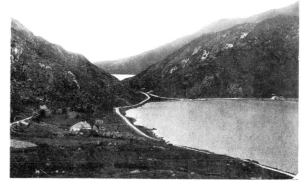

cattle, the yacht, and the angler in his boat seen in the presented example of his work. He also took some artistic licence with the landscape. The tourist description is printed on the back of the card and reads as follows:

> Lough Fee lies midway between Killary Harbour on the north and German Mountain (1,973 ft.) on the south. It is a charming stretch of water, long and narrow in shape, about two miles in length. Benchoon Mountain, the crags of which are shown in the picture, rises to a height of 1,919 ft. at the western end of the lough.

German Mountain is Garraun and Benchoon is Benchoona according to the Discovery Series of maps.

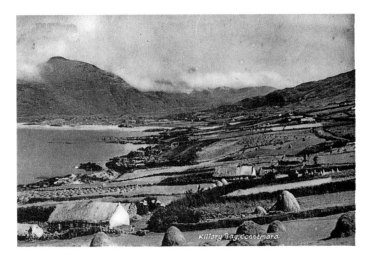

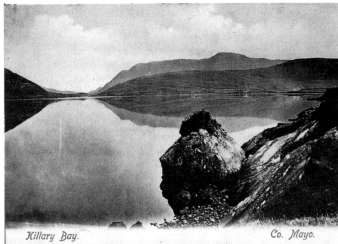

The outlet river from Lough Fee flows through a narrow pass into Lough Muck and this provided a favourite view for many early postcard producers.

Killary

Killary is Ireland's only fjord and is a much frequented tourist attraction. It seems to have first come under official notice in a report by William Bald in 1814 on the bogs of south-west Mayo. In this report he suggested that it should be one of the first places in the region to be improved because of its herring fishery and also for the large acreage of land suitable for growing oak, pine, birch, and mountain ash which could, in time, be harvested for British naval use. The timber would be exported through Killary. The proposals have an echo of the Tudor exploitation of Irish woodlands as a supply of raw material for shipbuilding purposes.

During the late nineteenth century Killary seems to have been given some serious consideration as a naval base. One of the proposed railways to Clifden, which had a full set of Parliamentary Plans prepared after a detailed survey, was the Galway and Clifden (via Oughterard) Light Railway, Recess and Killary Branch. The proposed

Killary Bay

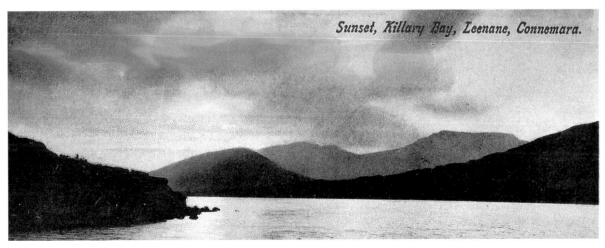

Sunset, Killary Bay, Leenane

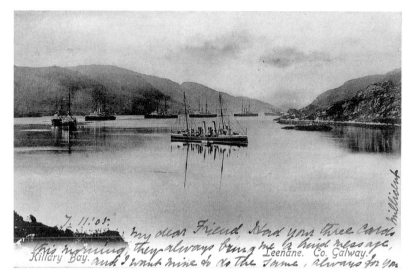

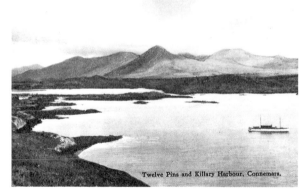

Killary Bay

Twelve Pins and
Killary Harbour

railway was designed to link Galway Docks to Clifden Quay with a branch line running from Recess to the deep water at Killary. There was to be a connection into Galway Railway Station so that the three harbours could be linked to Dublin. As the expense involved in preparing the proposal was considerable the promoters obviously thought that a naval base in Killary was a very strong possibility. The leading engineer involved in the project was Edward Townsend who was also involved in preparing the Midland Great Western Railway sub-mission which, in the end, was the line chosen. As the

question of conflict of interest wasn't raised it seems likely that the Killary line was, in reality, a kite-flying exercise on behalf of the Midland company. The Killary proposal had a major bearing on choosing the site for Recess Station.

It wasn't the first time that possible British military requirements were considered when infrastructural projects were being promoted for County Galway. The abortive Dublin–Galway–Bertroughboy railway proposal of 1834 had its Connemara terminus chosen because the harbour was considered safe from a land-based assault. The fear of another French invasion of the western seaboard was still alive apparently. Certainly this fear in official circles was played on, unsuccessfully as it turned out, in several attempts to obtain funding for the construction of major road bridge across Lough Corrib at Kilbeg–Knockferry where the lake is at its narrowest. The British North Atlantic Squadron steamed into Killary during the summer of 1892 whist on manoeuvres off the west coast. Mitchell Henry of Kylemore responded with a letter to the *Times* newspaper extolling the advantages of Killary as a naval base. A return visit was made in October 1899 and the fleet was photographed for Lawrence and the photograph duly appeared as one of his postcards. By a strange coincidence the photograph was taken from Michael and Thomas O'Neill's field in Derrynacleigh, that was the proposed site for the Killary terminus of the Recess and Killary branch line which would have been ideally located to service a naval harbour. A far less peaceful visit by the British navy took place on June 29th 1921 when troops were disembarked on the south Mayo coast in an attempt to round up members of the IRA. Between these visits the marine research vessels *Helga I* and its successor *Helga II* made several exploratory visits. *Helga II* was refitted as a gun ship during the First World War and steamed up the Liffey during Easter Week 1916 to shell central Dublin.

Killary harbour began life as a single pier built by Alexander Nimmo and according to him it made an excellent boat quay and was of considerable benefit to fishermen. The pier was ideally sited near the major road junction of Leenane and serviced the trading needs of a wide area with boats plying to and from both Galway and Westport. An additional pier was constructed in 1846/7 which converted the site into a small harbour. The work was carried out as a famine relief scheme. William Edward Forster visited the area on the 17th to the 19th of January 1847 and recorded a brief account of his visit thus:

> the small village of Leenane where we found a large body of men engaged in making a pier under the Labour-rate Act. The village appeared to me, comparatively speaking, well off, having had in it public work for some weeks, and the wages at pier-making being rather better than those earned on the roads. Still even here the men were weak, evidently wasting away for want of sufficient food.

Despite their appalling condition, the workforce constructed an excellent pier which has stood the test of time.

Road, lined with broken stone, Killary

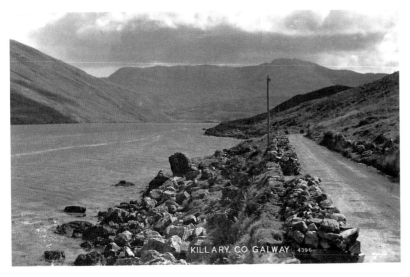

KILLARY, CO GALWAY 4396

Occasionally postcards illustrate something that appears unusual to people today. Mason's of Dublin captured one such scene on the road to Leenane in the 1920s; their postcard shows a former method of obtaining material for road maintenance. A stone breaker was employed by road contractors on an occasional basis and his job was to prepare a large amount of broken stone for either the construction of a new road or the repair of an existing one. He was armed with a lump hammer and a four inch diameter brass ring. A cost effective way of obtaining a plentiful supply of stone for breaking was to have farmers clear surface stones from their fields and place them on the side of the road for the stone breaker. Hely Dutton, writing in 1824, complained that the road from Dangan to Rahoon was scarcely passable because of all the stones placed on the roadside. In 1903 a clear passage had to be created through the stones lining the road near Maam. The stones were usually built into neat piles with convenient gaps left between them. The breaker would sit in a gap and break down the stone to the required size. When steam-powered stone breakers came into widespread use in the first and second decades of the last century large quantities of stone were crushed for use on the roads. If the roadworks were a direct labour scheme the farmers charged for the stone; accordingly, the size of the pile became standardised for easy measurement of its volume. As can be seen the stones are laid out in a neat, orderly fashion awaiting the arrival of the stone crushing plant. Mason's were actively photographing Galway scenes around 1925 to 1930. The scene must have intrigued the photographer as he had to climb onto the roadside boundary wall to capture it.

Leenane

Alexander Nimmo had a bridge constructed here but it was washed away in a flash flood, as were both of its successors. The first edition of the Ordinance Survey

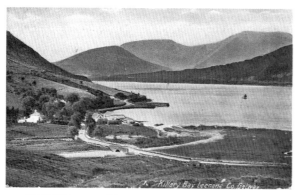

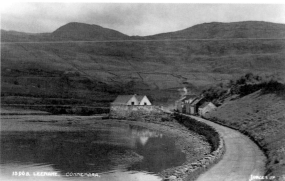

Leenane,
Connemara

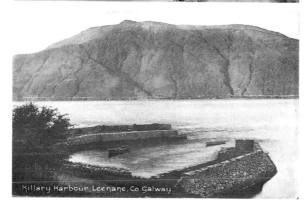

over 1.75 kilometers) and drains a valley that has steep mountainsides. It is, probably because of its history, one of the very few rivers to have been mapped by the Ordinance Survey with spot levels taken all along its course down the mountain side. To be fair to him, Nimmo did not have the benefit of this information in the 1820s when he built his bridge. However, as a Scotsman he should have provided more arches to cater for the floods and should have known that flash floods

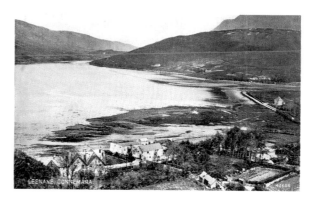

can exert enormous pressure on causeways, which if not relieved by flood arches can lead to their collapse. The fourth bridge, according to local information, was washed away in the 1870s and was replaced by a structure with three widely spaced arches linked by short causeways. The bridge at Leenane was washed away again within recent years. Its replacement has been designed to cater for major flash floods.

Killary Harbour,
Leenane,

map of the area indicates that the bridge that existed in 1840 was a single-arch structure at the centre of a long causeway which effectively dammed the floodplain outlet. The single arch would have been sufficient to cater for normal flows in the river which is not a gentle one after heavy rain. It falls through some two hundred and thirty feet over a distance of a mile (seventy meters

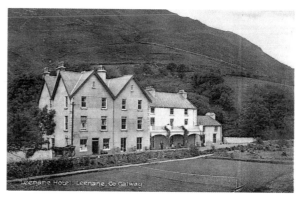

Leenane Hotel

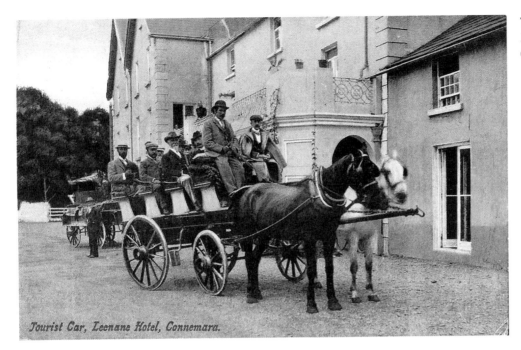

Tourist Car, Leenane Hotel, Connemara.

Leenane Hotel

McKeon's Leenane Hotel has a long history stretching back into the eighteenth century. The business started as a small inn and belonged to Jack Joyce. It was acquired by Anthony O'Reilly in 1842. O'Reilly had formerly been in the coastguard service. During the 1850s Robert McKeown acquired the property and set about enlarging and improving the premises. In 1865 he announced that he had added six bedrooms, water

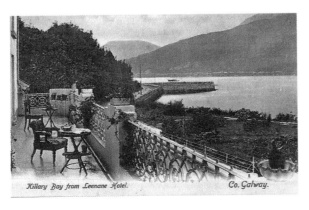

Killary Bay from Leenane Hotel. *Co. Galway.*

closets and a bathroom for the comfort of guests. He also provided a car to collect intending guests at either Westport or Clifden by prior postal arrangement. A one or two horse car was available depending on the size of the incoming group. The collection fare was 3s.6d. from either collection point. McKeown soon realised that his collection from, and subsequent return of passengers to Clifden or Westport could be expanded to provide an all-in service. He advertised the fact that tourists taking the Clifden to Westport car faced a two-day journey and that their overnight stay at his hotel was not covered in the price; however, were they to book a seat on his car accommodation was guaranteed and included in the fare. He developed a tourist car trade centred on the hotel. Customers were brought to the most scenic places in north Connemara and south Mayo. The success of this venture is indicated by the large number of postcards produced of the area before the First World War. He acquired extensive fishing and shooting rights, which were available to guests at no extra charge. He also

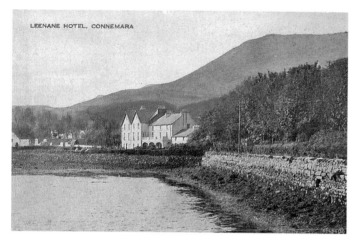

LEENANE HOTEL, CONNEMARA

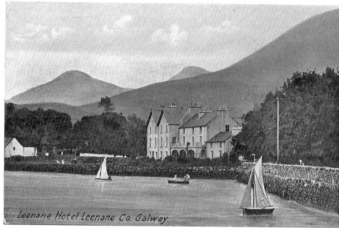

Leenane Hotel Leenane Co. Galway.

placed some small boats on the Bay for sea anglers. The business grew slowly but steadily until the railway to Clifden was opened. Thereafter, business was brisk and got a major boost when King Edward VII paid the hotel a visit on his tour around north Connemara in 1903. Indeed this royal visit really set Connemara on the map for the English tourist. The hotel had salt-water baths for the ladies, a tennis court, and a pleasure garden. By 1900 the McKeown family had also acquired a fishing lodge at Bundorragh on the Mayo shoe of Killary with fishing rights on the river there. Anglers who wished to stay at the hotel could avail of the services of a boat and boatman to ferry them across the fjord.

Some of the cards that featured the hotel showed enhanced views where the backdrop was altered to make it look more dramatic. The most obvious additions to the card are the three boats in the foreground; less obvious is the addition of two extra mountain peaks in the background. The message on the back reads: 'Boys motored to the open sea yesterday afternoon and found lovely sands and Marconi station.' Unfortunately, the postmark on this card is damaged and so cannot be read in full. As the stamp is a portrait of Edward VII and the Marconi station was completed in 1907 the card must have been posted between 1907 and 1910. The reference to

Leenane Hotel

McKeown's Home Industry, Leenane c.1900

driving means that people were taking motoring holidays in Connemara before 1910.

McKeown's Homespun Industries

After the Congested Districts Board opened an instruction centre in Leenane to teach weaving skills to people Robert McKeown installed six looms in an extension to the hotel and set up his Homespun Industries. The work done by the Board in improving the breed of sheep in the area led to a major improvement in

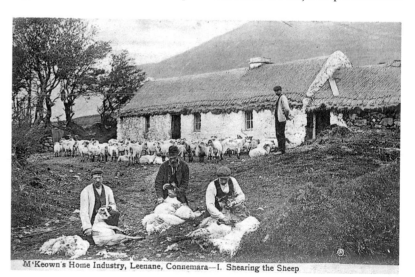

M'Keown's Home Industry, Leenane, Connemara—I. Shearing the Sheep

the quality of wool produced. McKeown built his business to entail the entirety of the production process from shearing the sheep right through to marketing the finished tweed. The Valentine Company produced a series of postcards illustrating various aspects of the production process. After shearing, the wool was scoured to remove dirt and the natural greases that would interfere with the dying process. The scouring was carried out by the men using walk mills. The wool was placed in tubs containing stale urine and trampled by the barefooted men. This technique is known to have been practiced in Roman times. The stale urine cut the grease. The large industrial mills used a naturally occurring mineral known as fuller's earth, so-called because it was used in fulling or thickening woollen cloth and degreasing it. Fuller's earth was expensive so the smaller country 'tuck' or fulling mills used stale human urine.

Wool Washing, Connemara

After it was scoured and washed the wool was distributed to various households where it was carded, spun into yarn and dyed if required. Carding was carried out to untangle the raw wool and bring the fibres reasonably parallel to each other. In spinning the carded wool, fibres are drawn out and twisted around each other

nnemara Homespun Industry. Distributing the wool

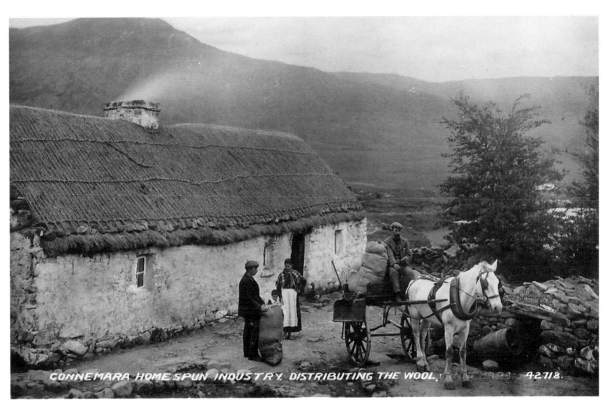

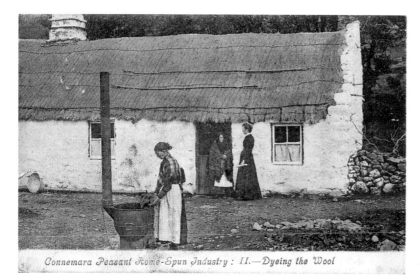

Connemara Peasant Home-Spun Industry : II.—Dyeing the Wool

to form a continuous long fibre called yarn. Undyed wool was used for báinín and blanket production. If the yarn was required for tweeds, rugs or shawls then it was dyed. Dying hanks of yarn was a skillful procedure. If areas were missed during the operation the hank could finish as a piebald one. Dying the raw wool, or stock dying, could also be carried out before the carding and spinning stages of the process. Dying, as well as being a skilled process, was expensive. Dyes had to be purchased, as had dying equipment like the outdoor boiler that can be seen in the postcard. The boiler consisted of a large two-handled pot that sat into a fire grate. The wool was placed in a pot of dye which was simmered gently and stirred regularly to make sure that all of the wool had absorbed the dye.

The household production process was regularly checked by a supervisor who was captured by the photographer posing with the lady of the house who is wearing her Sunday shawl. The photograph was obviously contrived unlike many of the others in this series of cards which were, in reality, published as promotional material. When orders were received McKeowns would send out the acknowledgement

Dyeing the wool. Connemara Peasant Homespun Industry

written on one of the cards. The windows shown in the cottages featured on the cards are considerably larger than what was the usual size. This was because spinning required good light which was not available in cottages with the standard sized windows. For most households spinning for domestic use was done outdoors. Given the vagaries of Irish weather the time available for spinning was therefore rather limited and prone to interruption. McKeown realised that this would slow down the delivery of yarn to the weavers so he subsidised the installation of large sized windows in the houses where spinning was carried on. This meant that there were far fewer interruptions in the delivery of thread to the weavers' shed. When the royal visitors purchased a length of Connemara tweed in 1903 the demand for the product soared. Several families took up weaving and built galvanised iron weaving sheds. They supplied McKeowns who acted as their retail agent. The Connemara tweed became so popular that German manufacturers imitated the product.

Lough Nafooey

Leenane is by no means the only location in Connemara that has lost a bridge as a result of flash

Lough Na Fooney, Near Leenane, Connemara

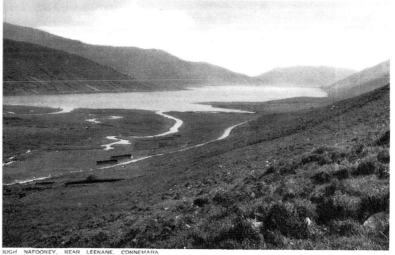

DUGH NAFOONEY. NEAR LEENANE. CONNEMARA

flooding. James Perry designed the bridge at Lough Nafooey to survive the torrential spate of water carried by the Fooey River on its short run down the side of Devilsmother. The 'Bicycle Bridge', or 'Wheel Bridge' as it was later called was built about 1884 to replace an earlier timber bridge. Aside from flash floods Perry had other design problems to contend with. The ground was low-lying bog and would not bear the weight of a substantial masonry bridge, therefore any structure that was to be built had to be as light as possible. Perry considered a replacement bridge in timber but rejected the idea. The design he settled on allowed for the maximum discharge of water through the arch thereby avoiding the danger of flood waters washing away the embankments and bridge. As a further precaution the embankments were constructed without using any mortar. This left open joints through which flood waters could be dissipated with minimum effect on the structure. The pipes for the wheels were to be seven inches in diameter on the inside and have walls one inch thick and, according to Perry's specification, were to be perfect castings. The weight of the bridge was carried by the abutments but when traffic was passing over it the extra weight was transferred to the wheels which transferred it evenly over the soft riverbed. Each wheel was cross-braced and cross-linked to the other and connected to the bridge deck in five places to ensure maximum stability. Perry exercised strict quality control on the project which is why the bridge lasted almost one hundred years. It gave way under a fully loaded articulated lorry in September 1981 and was eventually replaced with a reinforced concrete structure.

DROICEAD AN FONNSA LOĊ NA FUAṪA, CONNEMARA.

Copyright :
Monaghan, Oughterard.

For Galway Fair, Connemara

Chapter 8 South Connemara Coast

Barna, Spiddal, Gorumna, Carna, Roundstone, Aillebrack.

Barna

Barna or Bearna in Irish literally means a gap and it was in that gap in the coastline that the Lynch family, the local landlords, decided to construct a harbour to rival that of Galway. Because no harbour dues were imposed the area became known as Freeport, a name that survives as a local name in the village. The Lynch harbour was constructed with a pier 470 feet long with a lighthouse at its head. Inside the pier was lined with quay walls. This venture into the maritime business was short-lived as a major storm demolished the pier. By 1822 the entire harbour was a ruin and the area was poverty stricken and in the throes of famine. Using a mix of Government and charitable society funds Nimmo had a new pier constructed.

However, the money ran out and the pier was left unfinished as it had been decided that a local contribution should be made to the cost of finishing the works. As this contribution was not forthcoming the works were tidied up and left. The hurricane of November 20th 1830 destroyed the unfinished pier. The current pier dates from the late 1840s or early 1850s. During construction works a narrow gauge trackway, or railway, was utilised to transport the large blocks of stone used in building the pier. This was Barna's first and only railway. Proposals were brought forward to extend the Galway and Salthill Tramway to the village but nothing materialised. In 1912 an ambitious scheme to create a major deep-water port for Galway were brought forward. These included a railway connection to Galway station via the Shantalla Quarry branch line. The harbour was to be located between Rusheen Bay and Barna. Because of the huge costs involved a protracted public debate took place on the merits of the proposal. The First World War, the War for Independence and the Civil War put an end to the debate for some years. However, the plan was brought forward again in the late 1920s but the high construction costs involved put paid to the proposal for good.

Barna, Connemara

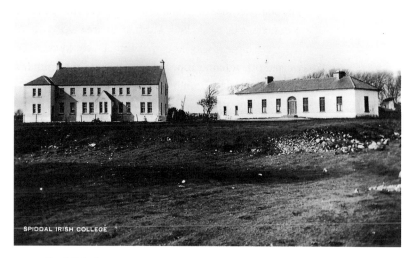
SPIDDAL IRISH COLLEGE

Spiddal

The official attitude of Galway County Council in the early 1900s to the promotion of the Irish language would appear to have been in agreement with the Gaelic League. At their meeting held on April 18th 1902 the councillors passed a resolution condemning the Intermediate Education Board's appointment of a foreigner as examiner in Irish, labelling the move as 'uncalled for, and an insult to our native Irish scholars'. They conveyed their displeasure to the Board. In February 1907 when the councillors were considering the appointment of a new county surveyor in the place of James Perry who had died they officially adopted a policy of the Gaelic League and stipulated that a knowledge of the Irish language was required from Perry's replacement. At their meeting of February 19th they stipulated that the successful candidate must pass an examination in Irish within one year of the appointment being made. This attitude to the promotion of the language may well have had some bearing on the decision to relocate Coláiste Chonnacht from Tourmakeady, County Mayo to Spiddal in 1910.

When the national school system was instituted in 1831 the English language was the established medium

Spiddal Irish College

of education. It was only in the 1890s that Irish was allowed to be taught as a stand-alone subject. By then the language was in serious decline. In an attempt to redress this situation the Gaelic League established Coláiste Chonnacht in Tourmakeady, County Mayo in 1906. The purpose of the school was to train teachers in the teaching of Irish. The school was relocated to Spiddal in 1910. Gaelic League branches from all over the country sent people here on scholarships to learn the language. Two of the most famous of these were Eamonn DeValera and Patrick Pearse. One of the more prominent teachers at the Coláiste was M. J. O'Mullane (1889–1956). O'Mullane published a series of pamphlets on early Irish history and heroic verse.

Ceanntar na nOileann
Bartlett

William Henry Bartlett (1858–1932) studied art at the Ecole des Beaux Arts in Paris and became a member of the Royal Society of British Artists in 1879. Between 1880 and 1918 he exhibited regularly at the Royal Academy. His paintings were of the western highlands of Ireland, i.e. Connemara, Mayo and Donegal. He was a frequent visitor to Renvyle House in the 1880s and 1890s where the majority of his Connemara paintings were executed. Many of these were reproduced as postcards. In 1894, he expressed the hope that the Galway–Clifden railway, then in the course of construction, would open the area to visitors. This was achieved far beyond his wildest dreams. While many of his Connemara pictures are highly artistic, romanticised renditions of the region they, often, have a basis in fact. A case in point is his pair of pictures relating to islanders going to or returning from fairs. The only connection the smaller inshore islands had with the mainland was by boat. The post was delivered to Gorumna Island by postal canoe or currach as late as 1892. The construction of the series of causeways linking

the islands of Furnish, Letter Mullen, Gorumna, and Letter More, which was begun in 1886, was only completed in 1897. All of these island communities had to depend on boats to bring in supplies and send turf, eggs or livestock to market. The Erin go Breagh series of cards issued two Bartlett scenes entitled 'Going to Galway Fair' and 'Coming Home from the Fair'. The former was also issued with the title 'Going to the Fair, Connemara' (see page 158). Small fairs were held four times a year in Kilkieran, although most farmers sent their cattle to Clifden. The few large farmers in the region sent their cattle to fairs in Galway. The boats featured are wide-bellied shallow draught inshore boats. They appear to be similar to the currach adhmaid which had evolved from the canvas currach and were highly suited to the rocky south Connemara coastline. 'Coming Home from the fair' shows the tricky operation of offloading a cow.

The boat, because of its shallow draught could be keeled over on its side in shallow water in an area where there were no large rocks and the animal would then be walked off. A halter rope was tied around the animal's neck to prevent it from lunging and upsetting the boat. The card shows a woman holding the rope, whilst the men in the stern and the bow are getting ready to keel the boat onto its side so that the cow can be walked off. The man in the centre will hold the cow by the head to keep her steady during the operation. Calves were sent to the mainland to be sold as there was often insufficient good grazing to rear and fatten them on the islands.

Gorumna

The system of causeways and bridges linking Gorumna and the neighbouring islands to the mainland was designed by James Perry, county surveyor for the

Back from the Fair, Connemara

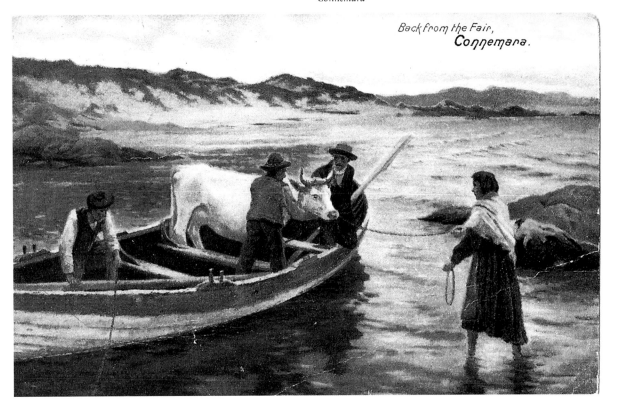

Back from the Fair, Connemara.

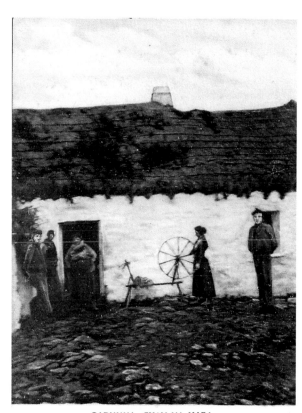

GARUMNA, CUAN NA MARA.
Bothán, taobh an bhothair: bean an tighe ag an doras; cailín ag
sníomhachán; fir móna.

of the island denuded of top soil. The island was described as being 'utterly desolate' in 1891 with very little soil cover and no trees or shrubbery. The population that year was 1706 people. The island had 289 houses, 279 being occupied by families. Some of the houses were described as 'cabins'. Some were only twelve feet long by ten feet wide, others eighteen feet long by twelve feet wide. The roof timbers were either driftwood or bog deal and the thatch was laid on turf and held down by sugans or straw ropes. The 'chimney' was built around a hole in the roof. The fireplace was a hearth made with some loose stones against either the gable or an internal wall, without any chimney breast. Geese and hens were kept on an extensive basis and eggs were sold to middlemen traders for onward sale into Galway. Sheep were also kept but only sheared as the wool might be required. The women did the shearing. In common with most other areas, young boys wore skirts for a number of years. On Gorumna the skirts were worn up until about the age of fourteen as a result of the belief that wearing trousers would stunt the boy's growth. In other parts of Ireland boys changed to wearing trousers around the age of seven. The tradition most commonly associated with this practice was that the fairies would come and take away a boy child but ignore a girl so the boys wore skirts to confuse the fairies. No doubt a higher incidence of mortality amongst infant boys as opposed to young girls lent some credibility to the custom. The practice, in all probability, had a very practical origin: young boys can be difficult to toilet train.

The card shows a bothán, with the woman of the house chatting to two turf cutters whilst the third man, near the girl, is standing close to the base stone for a rotary quern. The young lady is at a large-sized spinning wheel – the type promoted by the Congested Districts Board. All the script on the card is in Irish including the information 'Clo-bhuailte san nGearmain' – printed in Germany.

Western Division, who also supervised the work. Prior to this the islands were quite isolated. The completion of the causeways put an end to Gorumna's poitín trade. The island had been noted for the quality of its poitín, which was neither adulterated nor distilled from treacle; the islanders, instead, used one part oats to three parts malted barley. They used querns to grind the malt. The island had some peatland and exported turf to Letter Mullen, Aran and north Clare. Poitín was concealed in the cargo on occasion. Indeed so much poitín and smuggled goods, such as brandy and tobacco, were carried across Galway Bay from the Connemara shore that the Coastguard was strengthened and several coastguard stations were constructed to help stamp out the illicit trade. The regular harvesting of peat left parts

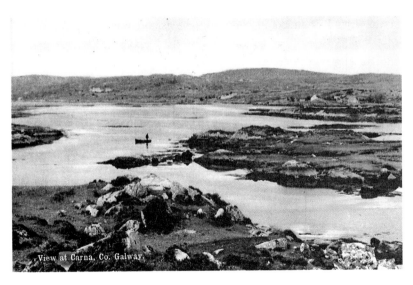

View at Carna, Co. Galway.

Carna

Virtually all of the population of the Carna district reside near the coast and, consequently, earned their livelihood from the sea. The area has a long rocky coastline which was, and still is, ideal for harvesting seaweed. In 1892 some 360 families, or over one-third of the population of the area, were engaged in the production of kelp. Some 1800 tons were produced and brought to market. In 1892 there were three companies purchasing the product as opposed to only one in 1890

View at Carna, Co. Galway

A Wrack Harvest, Connemara

and as a result the price per ton had increased significantly. The Congested Districts Board estimated that kelp sales that year would have earned some £8,000 for the people of the area. Seaweed was used as fertiliser also. Considerable quantities of seaweed that were not suitable for kelp making were harvested for local use and for sale outside the area. During the 1870s large cargos were taken to Galway and shipped by rail to Ballyglunin and Tuam for local landlords. Cargos were also shipped to places such as Kinvara and Clarinbridge where they had a ready market. The arrival of cheap mass-produced chemical fertilisers on the market, particularly during the early 1880s, killed off trade. Under the promptings of Father Flannery a committee was set up to promote industrial development and the Carna Industries Fund was created. They tried to develop the Connemara Industries, a limited liability company that was to promote the production of knitted goods. After the death of Father Flannery the company quickly went into decline. Joseph Kelly, a national school teacher endeavoured to set up a manual instruction course in carpentry for twelve boys at his school in Cashel. This, along with other proposals to improve the earning capacity of the people, was not successful.

Major Forbes, a Scottish Presbyterian, got a licence to create and maintain oyster beds in the area in

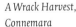

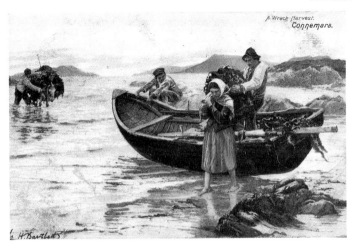

A Wrack Harvest. Connemara.

A Connemara Strand.

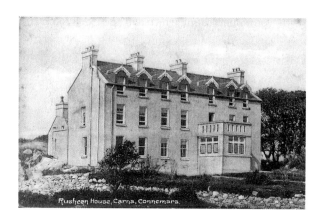

Rusheen House, Carna, Connemara

the late 1860s. During his absence from Rusheen due to illness his beds were raided by the local people and nearly wiped out. Despite this setback, he stayed on in the area. He had been educated in London by Jesuit priests so he invited them to come to Carna to set up a school for boys. When the Jesuits saw the area they baulked at the idea and told Forbes that both teachers and pupils would starve there. Nothing daunted Major Forbes, who next invited the Mercy Convent in Clifden to send some sisters to establish a school. The nuns duly arrived on October 7th 1874 and established their first convent in a thatched house given to them by Major Forbes. A building in the farmyard attached to Rusheen House was converted into a national school, the first in the Carna region. The children were educated through Irish, their only language, which was contrary to the National Board of Education rules. The sisters also began a Sunday school in the parish church to give religious instruction to the older children who had, prior to this, received no education whatsoever. The nuns set up a cottage industry for girls which produced lace and knitted goods. In 1879 the sisters inherited Rusheen House and lands from the Major. They also got a generous legacy with which they built a convent and chapel. This was in accordance with Major Forbes's will, which stipulated that both buildings were to be for the 'promotion of the Roman Catholic religion and the training of the children of the neighbourhood in such religion'. Forbes was, no doubt, disgusted at the activities of the soupers and proselytisers. As the years passed the school gained a huge reputation for the quality of the education received. During the early years of the last century some of the pupils began to get County Council scholarships. In 1955 the nuns extended the classes available so that pupils could be educated to Intermediate Certificate level. The classes were co-educational. In 1959 a new secondary school was built which catered to pupils up to Leaving Certificate level. Boarding facilities were provided for girls, while boys from outside the area were able to get accommodation in local households. The boarding facilities closed in 1973, the same year that the school merged with the

Carna, Convent Grounds

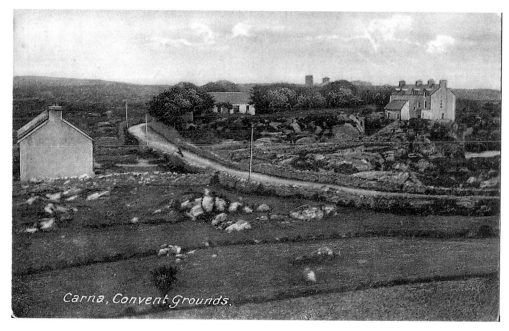

Roundstone, Co. Galway

nearby vocational school, which had opened in 1965. The amalgamated schools became a community school, the first to be created in the country as a result of this new policy. A new school building was erected on the site of the original convent school in 1988 and in 2000 the last Sisters of Mercy left Carna.

Roundstone

The present day village of Roundstone owes its creation to the Scottish engineer Alexander Nimmo who built a pier here from 1822–5. There had been some small settlement here prior to this. Built into the wall of an old storehouse is a stone bearing the date 1731. The building may well have been erected as a wool store in connection with the smuggling trade that flourished in the locality during the eighteenth century. The secluded nature of the site and the depth of water in the bay, which allowed safe anchorage for large sailing vessels, made the area ideal for smuggling. Nimmo's pier is on the south side of the harbour. The northern pier was constructed between 1848 and 1856 by the Board of Works, who extended it to cover some dangerous rocks in 1906. During the construction of Nimmo's pier a local tenant complained that the blasting operations damaged his property. He sought compensation from Nimmo, who bought out his lease from the Martin estate. When Nimmo died in 1832 his interest passed to his brothers, John and George. Samuel Jones, a former assistant to Alexander, took an action against them in the Court of Chancery for the recovery of a debt. George Nimmo was drowned along with his two crew members when their boat hit a rock, split in two and sank in 1856.

When one studies the cards showing the harbour at low tide one gets a good idea of the amount of rock that had to be removed by blasting during the construction of the south pier. Nimmo, in his report on the fishery stations on the Connaught shoreline, mentioned the depth of water available in the bay. This

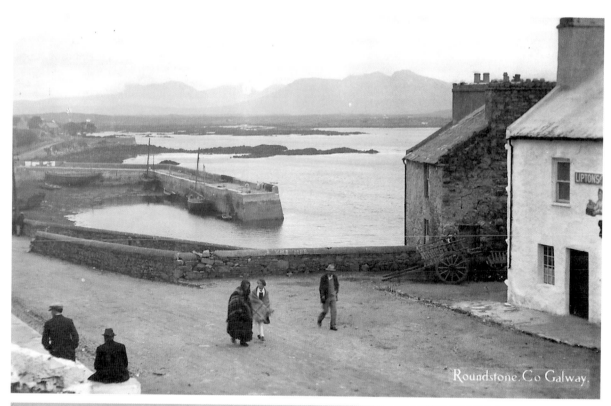

Above: Roundstone Village

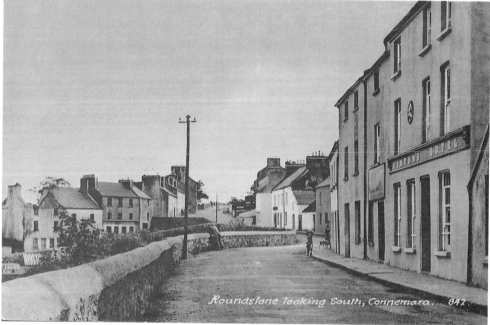

Left: Roundstone looking south

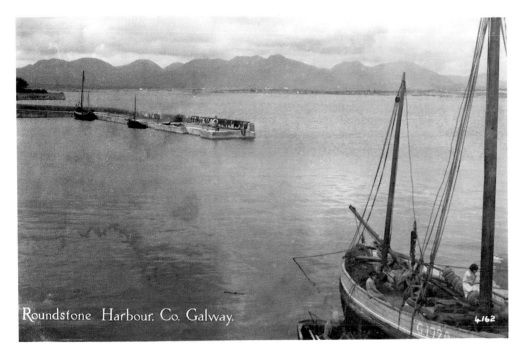

Roundstone Harbour

Roundstone Harbour. Co. Galway.

Below: The Beaches, Roundstone

information became relevant in a murder case ten years after Nimmo's death when a man named McDonagh was convicted of murder by the Admiralty Court but appealed his conviction on the grounds that his trial was heard in the wrong court. McDonagh's counsel had argued that his client should have been tried at the Assizes, despite the fact that the crime had been committed on a boat. The conviction was upheld because the report stated that the water was from two to five fathoms (twelve to thirty feet) deep in the area where the murder took place and, accordingly, it was within the jurisdiction of the Admiralty Court. Nimmo was long dead and so could not be questioned as to the veracity or otherwise of his measurements.

Gurteen Beach
Dogs Bay

The beaches in this area have always been very popular among visitors. As well as being of outstanding beauty, the area is of some archaeological significance. In January 1991 severe storms shifted the sand dunes and revealed the site of an early human settlement. Storms in the 1830s had led to the discovery of the foundations of nine oval-shaped houses. From the various finds made in this area it would appear that there has been human occupation of the area for almost six thousand years. A small find of five Charles II halfpennies was made at the beach in 1948. As the coins were badly corroded it wasn't possible to date them and they were discarded as being of no value. It is probable that the coins were lost by a local resident.

THE BEACHES, ROUNDSTONE CO GALWAY 4208

Aillebrack

There was great excitement in Clifden on the morning of Monday October 24th 1932 when Oliver Eric Armstrong flew over the town on his way to Aillebrack to collect Lord de Ramsey, who was spending the weekend at Ballyconneely, and fly him back to Dublin. Armstrong had flown to Dublin on the previous Saturday with airmail post for Germany. He took off from Oranmore in heavy fog. His only runway light was a man with an acetylene bicycle lamp stationed twenty yards from a hedge at the take off end of the field. He landed safely at Baldonnel and transferred the mail to a KLM aircraft, returning to Oranmore the next day. Armstrong's was not the first airmail flight from Oranmore, however; this had taken place on August 26th 1929 when J. 'Mutt' Summers, accompanied by Colonel Charles Russell, flew to Croydon Aerodrome via Baldonnel Aerodrome, arriving at 2.10 p.m., then returned to Oranmore, arriving at 7.10 p.m. Armstrong was inspired to join the RAF by the Alcock and Brown flight in 1919. He left the RAF in 1931 and joined Iona National Airways. He subsequently was pilot on the inaugural Aer Lingus flight from Baldonnel to Bristol on May 27th 1936. On his Iona Airways flight with the Berlin airmail he took copies of the *Connacht Tribune*. The *Tribune* were so pleased with the publicity that they ran a competition after the event and promised free flights of five minutes duration to fifty lucky winners.

Aillebrack had been marked out for Armstrong's arrival, which had been arranged for Sunday October 23rd 1932. However, the timetable was altered and he landed on the Monday morning instead. Fortunately, an unknown photographer was present to photograph the scene and produce some real-photo postcards of the event.

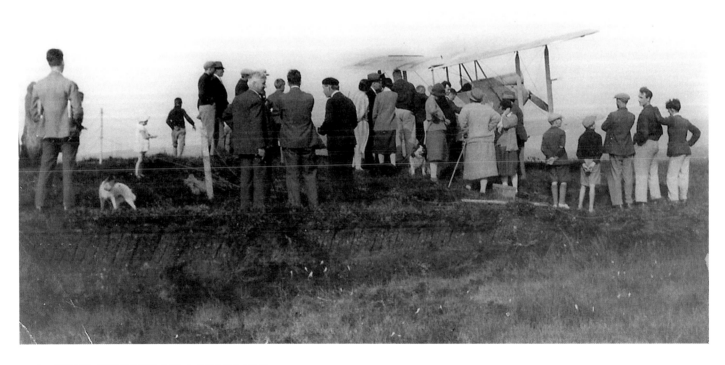

Chapter 9 Aran Islands

Inishmore, Inishmaan, Inisheer.

The Grand Jury ignored the roads of Aran for virtually the entire nineteenth century. In 1843 no money was voted for road maintenance on the islands. However, the islands were required to pay the sum of £10 1s. 7d. as their contribution to County Galway's share of the costs associated with the Shannon Drainage and Navigation Works. According to the presentment book for the Spring Assizes 1873, John A. O'Flaherty had in 1870 been awarded the contract to maintain 'all the roads in the Islands of Aran' for seven years at 6d. per annum. This might appear to be a misprint that should have read 'at 6d. per perch, per annum', but it is, in fact, correct. The princely sum of 3d. was all that was put forward for payment in spring 1873. This was the half-yearly contract payment. The same year the islands were required to contribute to the county's subsidy for the Midland Great Western Railway. Finally, in 1898, it would appear that some attempt was made to maintain at least one road on the islands; in that year Roger Derrane was contracted to maintain the road from Kilronan pier to the junction at Kilmurvey for five years at £33 per year. The Grand Jury system was abolished and replaced by the County Council system in 1899 and roads on all three islands began to be improved, admittedly at a slow pace. The postcard illustrated features an Andalusian type Connemara pony. These hardy ponies

Islanders on horse, Inishmore

ISLANDERS ON HORSE, ARAN.

169

were used extensively in hauling the sand and seaweed from the foreshore that was used to make the small island fields.

Inishmore
Market Day, Kilronan

Inishmore was fortunate in having some harbour facilities in the early part of the nineteenth century. A small pier had been constructed at Killeany in 1822, which led to an improvement in the fishing economy of the island; there was a fleet of thirty-nine fishing vessels based there during the 1830s. When the problem of providing a safe harbour was addressed around 1850 the island was examined for suitable sites and Kilronan was chosen as the best option. Thomas Ganly was appointed to oversee the works when the Office of Public Works commenced the construction of the new pier in 1853. Ganly settled on the island, marrying a local woman. The

Market Day, Kilronan

new pier was able to accommodate steamer traffic and, as a result, Kilronan grew in importance at Killeany's expense and became the chief port of the islands. The pier facilitated greatly the work of the Congested Districts Board in improving the fishing industry on the islands, starting in 1891 when the Board subsidised a regular steamer service to Aran. One of the benefits of this service was that livestock, particularly pigs, could be

exported much easier than heretofore. Accordingly, the pig jobbers came to buy for the bacon factories, thus leading to an improvement in prices.

Onaght Church, Kilronan

Onaght Church

This church was built as a community effort. The site was donated free of charge by Mr Timothy Gill, Oghnacht, Father T. Varley, the parish priest, worked out the design layout and the parishioners cleared and levelled the ground. This work was carried out by groups of twelve men working two-day shifts. Other groups of men quarried the stone for the construction work. Sea sand that had been washed to eliminate salt and other impurities was used in the mortar and for plastering. The church of Saint Patrick and Saint Enda was blessed and opened for worship in 1959. The photograph that the card is based on would appear to have been taken on the day of its dedication. The new church was modelled on the ancient church of Oghaill in the centre of Inishmore.

Dun Aengus

As can be seen from the postcard, this fort, described by many as being one of the most magnificent and dramatic stone forts in western Europe, sits on top of a 300 foot high cliff. The surviving remains consist of three ramparts with some traces of a possible fourth, which is believed to have been located some

ÁRA MHÓR, CUAN NA GAILLIMHE.
Dún Aongusa ar bhruach aille 300 troigh ós cionn na mara móire: ó'n gcreg; ceathramhadh chaiseal, chevaux de frise, triomhadh caiseal, dara caiseal, priomh-chaiseal.

(76)

Ara Mhor, Cuan Na Gaillimhe

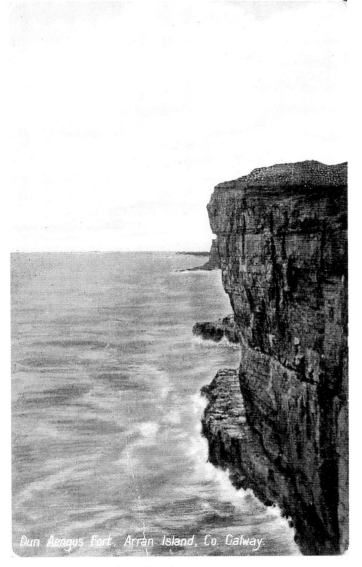

Dun Aengus Fort, Aran

from collapse. There is much conjecture as to the purpose Dun Aengus served. It has been argued that it was constructed as a venue for ceremonial purposes.

Dun Caher

Dun Caher or the Black Fort is different from the other Duns or forts on Aran. It is built across a headland and consists of a strong wall two hundred and twenty feet in length, twenty feet high, varying in width from sixteen to eighteen feet. It has three terraces and seven flights of steps. It contains the remains of two

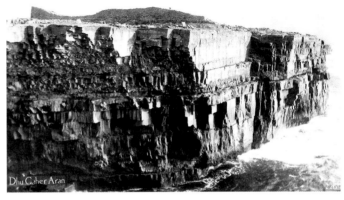

Dhu Caher, Aran

considerable distance outside the cheval de frise. The inner rampart or wall was constructed in three sections to create terraces which are interconnected by terraces and contains several inbuilt chambers. Major restoration works were carried out on the ramparts by the Commissioners of Public Works in the 1890s when the large buttresses were added to support the outer wall

rows of stone houses. The outside defences were further strengthened by the erection of a cheval de frise, or a series of stone stakes set upright in the ground. The part of the wall with the entrance gateway collapsed into the sea sometime before 1839.

Dun Eoghill

It seems that this fort was named for a grove of oak trees that grew nearby. Some stunted oaks and scrub hazel trees were still to be seen growing in the vicinity of the fort in the eighteenth century. The fort consists of two walls. The inner wall is sixteen feet high and about 11 feet wide. The outer enclosing wall, which is not concentric, is twelve feet high and almost six feet wide. The fort rests on the highest point of the islands and has been restored.

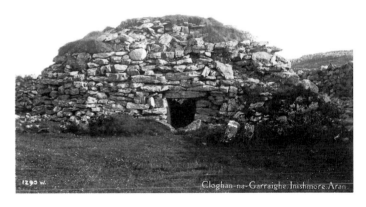

Cloghan-na Garraighe, Inishmore

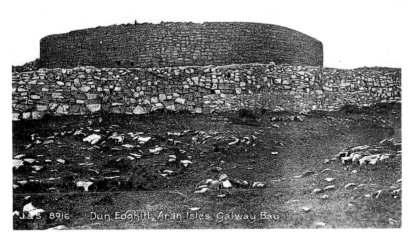

Dun Eoghill, Aran Isles

Cloghan na Garraighe

This is the largest and best preserved of the beehive huts on Aran. It is rectangular at ground level but the corners get progressively rounded off creating an oval chamber inside; both ends, and the side walls converge inwards. The stone courses in each wall overhang, on the inside, the courses below so that the building narrows as it rises. The stones are set with a slight outward slant to throw off rainwater. The top or ridge level is finished off with a row of flagstones. The doorways are set opposite each other and are only about three feet high. At one end or gable is a small opening which might have served as a window but most likely was a smoke hole in lieu of a chimney.

Temple Benan

Saint Benen's Church is named for Saint Patrick's favourite disciple, Benen or Benan, who founded a church at Kilbannon near Tuam. In former times islanders frequently went on pilgrimage to Craogh Patrick where Benen is comererated at the first station. Temple Benen dates from the late sixth or early seventh century. It is unusual in that it is built on a north–south axis rather than the normal east–west axis. It is Ireland's smallest oratory and was constructed with very large, and irregular, blocks of stone or cyclopean masonry. The card features two local youths who, quite probably, were guiding the photographer around the island. In the background a leacht can be seen. This type of monument was erected in many locations around the island for the purpose of commemorating those lost at sea. This custom was not confined to Aran but was practiced

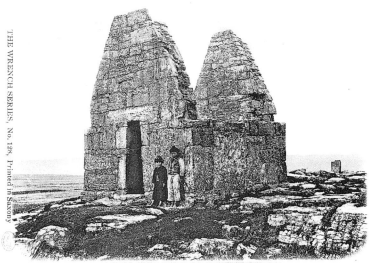

An ancient church, Aran Islands

elsewhere in Connemara; one was sited at the lower end of Bridge Street in Clifden, near Ardbear Bridge, and at least five were known to have existed along high ground on the south of Killary.

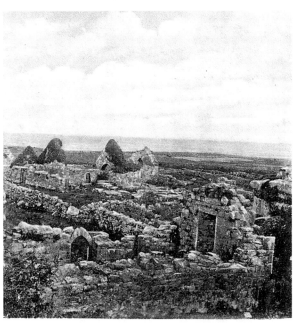

ARA MHOR, CUAN NA GAILLIMHE.
Na Seacht dTeampaill: Teampall an Phoil, Teampall Breacáin 7 eaglais eile; "leaba", tobar beannuighthe 7 leacacha.

An Ancient Church, Aran Islands

Ara Mhor, Cuan Na Gaillimhe

Manister Kieran, Aran

Seven Churches

Despite its name, this site does not contain seven churches. It has two, Teampall Bhreacáin and Teampall an Phoill. Other monastic sites in Ireland contain a larger amount of churches; Clonmacnoise and Glendalough have nine each. Teampall Bhreacáin dates from the eight century but was much altered over the centuries, an extension to the church was built in the tenth century and further alterations were carried out in medieval times. In the little graveyard attached to the church is a slab inscribed with the words 'VII Romani' and a cross. This is understood to refer to the seven martyred sons of Symphorosa. Teampall an Phoill dates from the fifteenth century. The rest of the remaining structures are the ruins of monastery houses or domestic buildings.

Manister Kieran

An earlier church, Manister Connachtach, on this site was rebuilt and renamed Manister Kieran in honour of Saint Kieran who spent seven years on the island as a disciple of Saint Enda. According to legend, Enda set Kieran to work one day threshing corn for the community. Kieran threshed so thoroughly that he threshed all the corn into grain. This legend is used to explain the scarcity of thatched houses on all three islands – as there was no straw available. Thatching survived on the islands long after Kieran left. The church has striking architectural features; the west doorway, from the eight or

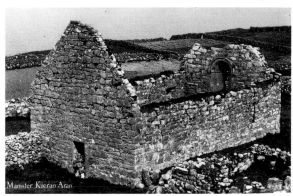

Manister Kieran Aran

ninth century in particular displays fine architecure, while the east window, from the twelfth or thirteenth century, is Romanesque.

Inishmaan
Dun Connor

Dun Connor is located near the highest point of Inishmaan and has commanding views over the whole island. And is considered by some to be of better construction than Dun Aengus. The rampart wall is eighteen feet seven inches thick at the base and rises in three tiers to a maximum height of seventeen feet. The fort contains the ruins of several cloughans, or beehive huts, built with unmortared stone. Tradition has it that William O'Malley of Roundstone hid out in the fort in 1872 when he was being sought by the police for the murder of his father. He was eventually smuggled off the island and made his way to America. An interesting feature of the Mason postcard is the appearance of some slated roofs. Inishmaan did not have a piped water supply until the community organised Group Water Scheme was installed in 1983. The water supply scheme was set up under the auspices of the Island Cooperative Society and all the pipe laying was done by local labour. Outside expertise was required for the construction of the reservoirs and the installation of the pumping equipment. Prior to the water scheme, the island depended on a number of wells for supply. These small sources could be augmented by the erection of slated roofs which made it easy to catch the rainfall runoff after a shower and divert it to a rainwater tank. The lack of water did more to reduce the number of thatched roofs on Inishmaan than anything else, despite the Saint Kieran legend.

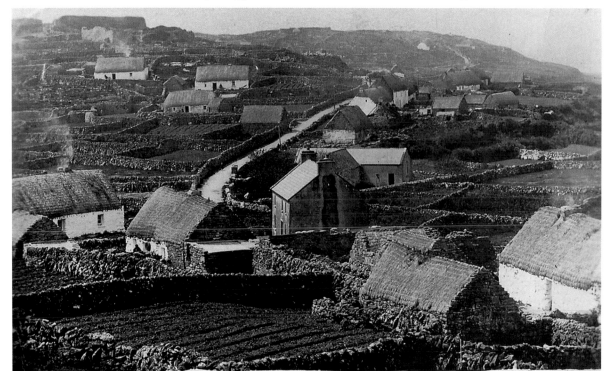

Dun Conor, Inishmaan, Aran

DUN CONOR . INISHMAAN . ARAN .

*Children on Beach,
Aran*

Children on Beach

The caption on the back of this real-photo postcard identifies the scene as the beach on Inishmaan and gives the date as August 1929. The card may be the work of Father Eric Finn, a noted Irish scholar who was responsible for the Sean McGuire card issued by Garbally College in 1928 (p. 45). Father Eric visited the islands on several occasions. The children are wearing the traditional attire appropriate to their age. The older boys are wearing long trousers, sleeveless jackets and caps, with the younger lads in their skirts. Whilst there is a certain amount of playfulness amongst the younger children the older boys are almost all looking out to sea. No doubt they were watching the tricky process of unloading cargo from the steamer which is still at sea in the knowledge that within a few short years they, too, would be undertaking that hazardous task.

Steamer Day Inishmaan

The first steamer to work out of Galway docks was the *O'Connell* belonging to James Stephens, who owned a foundry in Galway city. This vessel seems to have had a short stay at Galway. The *Citie of the Tribes* was constructed for the Galway Bay Steamboat Company and was first registered in Galway in 1872. She was used primarily as an excursion boat making trips to Ballyvaughan, the Cliffs of Moher and the Aran Islands. In 1882 the *Citie* was contracted to carry mail to the islands on a twice weekly basis. In 1891 the Congested Districts Board subsidised a regular steamer service to the islands, using the *Citie*, in the hope of promoting their fishing industry. The *Citie of the Tribes* was sold in 1903 and was replaced by the SS *Duras*, which had been specially built for the Aran trade. She had a low freeboard that facilitated the transfer of cargo to the currachs at Inishmaan and Inisheer. She was, in

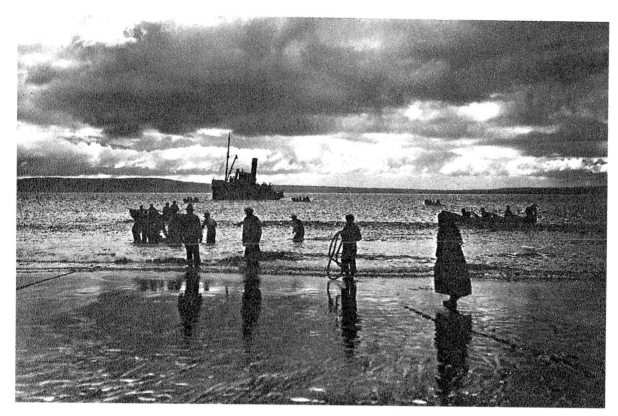

turn, replaced by the *Dun Aengus*, which remained on the Aran run for forty-six years. She, in turn, was replaced by the *Naomh Eanna*, which had a sickbay to allow for the transfer of patients from the islands to the mainland for medical attention. As can be seen there is a large crowd of spectators on the beach watching the proceedings. The arrival of the steamer always created a bit of excitement, particularly if its cargo had to be loaded or offloaded at sea. The card was one of a large series of postcards issued by the Cultural Relations Committee of Ireland and was distributed through Irish Free State legations abroad to journalists, authors and other interested parties. Other cards featured some of the treasures from the National Museum or sites of antiquarian interest. They were issued, in part, to counteract the 'Oirish' caricatures and other anti-Irish propaganda that had circulated for many years prior to the creation of the Irish Free State, and in part to promote the country and develop its tourism industry.

Inisheer

Inisheer's skyline is dominated by the ruins of O'Brien's castle, which is a small tower house set into the centre of an ancient ring fort. This would have improved the defences of the castle considerably in the fourteenth and fifteenth centuries. The development of artillery siege pieces would have made this extra defence layer redundant unless one was an infantry man sent in to storm the walls after an inaccurate cannonade.

Inisheer was in the same position as Inishmaan when it came to steamer services, with goods and passengers having to be transferred to currachs at sea

and brought ashore. The export of livestock was a tricky operation. The animals had to be fitted with a rope harness, which was tied around their middle, and a halter. They were then driven into the sea behind a currach to be led by the halter to the steamer and when they reached it they were winched aboard by ropes that were attached to the harness. The steamer, which is not visible in the card, provided the platform for the photographer. The cargo for the island appears to have been discharged and some currachs are beached on the shore and are being unloaded. The other currachs that are visible heading back to the island have delivered their cargo, human or otherwise, to the steamer. Cargo for the island would be offloaded or discharged before cargo from the island would be taken onboard.

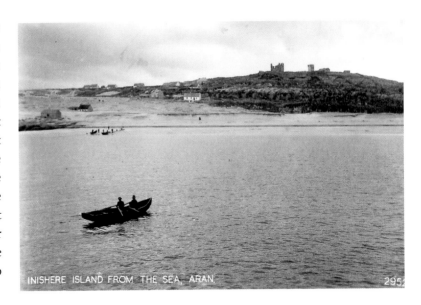

INISHERE ISLAND FROM THE SEA, ARAN.

Select Bibliography

Books

Anon., *The Aran Islands and Galway City* (Dublin).

Boland, John, *A Short History of Ballinasloe Mercy Sisters 1853–2003* (Ballinasloe, 2003).

Breatnach, Caoilte, *Kinvara, A Seaport Town* (Kinvara, 1997).

Burke, Oliver J., *The Abbey of Ross* (2nd edn, Dublin, 1869).

Claffey, John A., ed., *Glimpses of Tuam since the Famine* (Tuam, 1997).

Cronin, Denis A., *A Galway Gentleman in the Age of Improvement* (Dublin, 1995).

Crossman, Virginia, *Local Government in Nineteenth Century Ireland* (Belfast, 1994).

Curwen, J. C., *Observations on the State of Ireland*, 2 vols (London, 1818).

Egan, Patrick K., *The Parish of Ballinasloe* (Galway, 1994; facs. edn).

Egan, Patrick K., *St Brendan's Cathedral, Loughrea* (Dublin, 1986).

Fahey, Jerome A., *The History and Antiquities of the Diocese of Kilmacduagh* (Galway, 1986; facs. edn).

Fahy, Mary de Lourdes, *Near Quiet Waters* (Ballinasloe, 2007).

Fryer, C. E. J., *The Waterford and Limerick Railway* (Poole, 2000).

Furey, Brenda, *The History of Oranmore Maree* (Oranmore, 1991).

Harbison, Peter, *Guide to the National Monuments of Ireland* (Dublin, 1970).

Harbison, Peter, *A Thousand Years of Church Heritage in East Galway* (Dublin, 2005).

Healy, Ann, *Athenry: A Brief History and Guide* (Athenry, 1988).

Herity, Michael, ed., *Ordnance Survey Letters Galway* (Dublin, 2009).

Lally, Des, *History of Ballinahinch Castle* (Ballinahinch).

Lynam, Shevawn, *Humanity Dick Martin: 'King of Connemara' 1754–1834* (Dublin, 1989).

May, Tom, *Churches of Galway, Kilmacduagh and Kilfenora* (Galway, 2000).

McHugh, J. B., *The Friary of Ross* (Headford, 1987).

MacMahon, Michael, *Portumna Castle And Its Lords* (Portumna, 1983).

MacMahon, Michael, *Portumna Priory* (2nd edn, 1985).

McNamara, Marie & Maura Madden, eds, *Beagh, A History and Heritage* (Beagh).

McNeill, D. B., *Coastal Passenger Steamers and Inland Navigations in the South of Ireland* (Belfast, 1965).

Molloy, Christy, *Milltown Sketches* (Milltown, 1995).

Monahan, Phelim, *The Old Abbey, Loughrea, 1300–1650* (Loughrea).

Monahan, Phelim, *History of the Carmelite Abbey, Loughrea* (Loughrea).

Morrissey, James, ed., *On the Verge of Want* (Dublin, 2001).

Muirhead, Findlay, ed., *Ireland* (London, 1932).

Murray, James P., *Galway: A Medico-Social History* (Galway).

O'Donoghue, Brendan, *The Irish County Surveyors 1834–1944* (Dublin, 2007).

O'Keeffe, Peter & Tom Simington, *Irish Stone Bridges, History and Heritage* (Dublin,1991).

P. G., *Claregalway Abbey* (Claregalway).

Packenham, Valerie, *The Big House in Ireland* (London, 2000).

Parsons, Aisling et al., *St Mary's Cathedral Tuam* (Tuam).

Robinson Tim, *Stones of Aran: Labyrinth* (Dublin, 1995).

Robinson, Tim, ed., *Connemara after the Famine: Journal of a Survey of the Martin Estate, 1853* (Dublin, 1995).

Robinson, Tim, *Connemara Part 1: Introduction and Gazetteer* (2nd edn, Roundstone, 2005).

Semple, Maurice, *Reflections on Lough Corrib* (Galway, 1974).

Shepherd, Ernie, *The Midland Great Western Railway of Ireland: An Illustrated History* (Earl Shilton, 1994).

Shepherd, Ernie, *Waterford, Limerick and Western Railway* (Hersham, 2006).

Spellissy, Sean, *The History of Galway: City and County* (Limerick, 1999).

Stratten & Stratten, *Dublin, Cork, and the South of Ireland* (London, 1892).

Tully Cross I.C.A., *Portrait of a Parish, Ballynakill, Connemara* (Renvyle, 1985).

Qualter, Aggie, *Athenry* (Athenry, 1989).

Thomas, Avril, *The Walled Towns of Ireland*, 2 vols (Dublin, 1992).

Villiers-Tuthill, Kathleen, *History of Clifden* (Clifden, 1981).

Villiers-Tuthill, Kathleen, *Beyond The Twelve Bens* (Clifden, 1986).

Villiers-Tuthill, Kathleen, *History of Kylemore Castle and Abbey* (Kylemore, 2002).

Villiers-Tuthill, Kathleen, *Alexander Nimmo and The Western District* (Clifden, 2006).

Waldron, Kieran, *Out of the Shadows* (Tuam, 2002).

Wilkins, Noel P., *Parks, Ponds and Passes, Aquaculture in Victorian Ireland* (Dublin, 1989).

Wilkins, Noel P., *Squires, Spalpeens and Spats* (Galway, 2001).

Wilkins Noel P., *Alexander Nimmo Master Engineer 1783–1832* (Dublin, 2009).

Wilde, William, *Lough Corrib, its Shores and Islands* (facs. edn, Headford, 2002).

Williams, Guy St John, *A Sea Grey House: The History of Renvyle House* (Renvyle, 1985).

Articles

Anon., 'The Story of Athenry', *The Galway Reader*, 2, 161–8; 3, 77–81.

Anon., 'A Ballinasloe Pot-Pourri', *The Galway Reader*, 3, 183–8.

Bigger, Francis Joseph, 'Killconnell Abbey', *Journal of the Galway Archaeological Society*, 1 (1900–1), 144–67.

Bigger, Francis Joseph, 'The Franciscan friary of Killconnell', *Journal of the Galway Archaeological Society*, 2 (1902), 3–20; 3 (1903–04), 11–15.

De Courcy, Sean, 'Alexander Nimmo: Engineer Extraordinary', *Connemara*, 2 (1995), 47–56.

Dixon, F. E., 'Pioneer Publishers of Dublin Picture Postcards', *Dublin Historical Record*, 32/4 (1979), 146–7.

Duffy, Paul, 'Note on documents relating to Ballinasloe Show in Trumbull Papers', *A Catalogue*, Kennys, Galway, 1983, pp. 120–1.

Duffy, Paul, 'Aspects of the Engineering History of the West Region', *The Engineers Journal*, 40/8 (1986).

Duffy, Paul, 'A Transport Trinity at Clonfert', *Inland Waterways News*, 17/4 (1990), 5.

Duffy, Paul, 'Random Notes on the Corrib: Mask Canal', *Inland Waterways News*, 19/2 (1992).

Duffy, Paul, 'Random Notes on Lough Corrib Ferries', *Inland Waterways News*, 19/3 (1992).

Duffy, Paul, 'Ballinasloe and Inland Navigation', *Inland Waterways News*, 20 (1993).

Duffy, Paul, 'A Proposed Steamer for Lough Corrib', *Inland Waterways News*, 20/3 (1993).

Duffy, Paul, 'Galway's Gaols Dli', *The Western Law Gazette*, 8 (Winter 1993), 28–31.

Duffy, Paul, 'Notes on Portumna's Bridges', *Inland Waterways News*, 21/4 (1994).

Duffy, Paul, 'A Bridge for Knockferry', *Inland Waterways News*, 22/3 (1995).

Duffy, Paul, 'The Suck and Poolboy Mill', *Inland Waterways News*, 22/4 (1995).

Duffy, Paul, 'A Dublin–Galway Ship Canal', *Inland Waterways News*, 23/4 (1996).

Duffy, Paul, 'Clonmacnoise', *Inland Waterways News*, 25/2 (1998), 15.

Duffy, Paul, 'On Engineering' in Tadgh Foley, ed., *From Queens College to National University* (Dublin, 1999).

Duffy, Paul, 'Abstracting the Extractive History of County Galway' in Matthew Parkes, ed., *Galway's Mining Heritage: Extracting Galway* (Galway, 2006).

Duffy, Paul, 'A Numismatic Pot-Pourri from Galway', *Galway's Heritage*, 2 (Winter 2006), 3–17.

Duffy, Paul, 'Notes on the Engineering Heritage of Connemara' prepared for The Heritage Council's Galway Meeting (2008).

Duffy, Paul, 'The Stephens Foundry' in Evelyn Mullally, ed., *Clonbern Graveyard, Its Monuments and People* (Belfast, 2011).

Duffy, Paul, 'The Engineering Heritage of Killimor Parish' in Angela Geoghegan & Nuala McGann, *Killimor: Our Parish and Our People* (Killimor, 2013).

Egan, Rev. Patrick K., 'Ballinasloe Town and Parish, 1585–1855', *The Galway Reader*, 4/1, 89–101.

Jocelyn, Robert, 'Marconi Express', *Connemara*, 1 (1993), 12–15.

Lucas, A. T., 'Notes on the History of Turf as Fuel in Ireland to 1700 AD', *Ulster Folklife*, 15/16 (1970), 172–202.

Maguire, S. J., 'The Flogging Parson of Ballinasloe', *The Galway Reader*, 3, 97–8.

Maguire, S. J., 'Cardinal Wiseman in Ballinasloe', *The Galway Reader*, 3, 110–14.

Mitchell, James, 'An Account of the Franciscan Friary and of the Parish Churches at Claregalway during the last two hundred and fifty years', *Journal of the Galway Archaeological Society*, 37 (1978–80), 5–34.

Mitchell, James, 'The parish church of St Mary, Oughterard', *Journal of the Galway Archaeological Society*, 54 (2002) 35–54.

O'Connell, Jarlath, 'Some Notes on Tuam in Olden Days', *The Galway Reader*, 1, 23–9 & 46–51; 2, 50–60 & 171–9; 3, 82–9 & 92–8; 4/1, 82–5; 4/2 & 4/3, 140–3.

Manuscript Sources

The Midland Great Western Railway of Ireland, Galway–Clifden Railway:
List of Owners
List of Lessees
List of Occupiers

The Athenry and Tuam Extension to Claremorris Light Railway Company:
Report of James Perry to the Grand Jury of the County of Galway, 14th March 1890

Plans

Midland Great Western Railway of Ireland, Galway to Clifden Railway 1890.

Galway, Oughterard and Clifden Light Railways, 1890.

Galway, Via Oughterard and Clifden Railway: Recess and Killary Branch, 1890.

Athenry and Tuam Railway Extension to Claremorris, Spring 1890.

Athenry and Tuam Railway Extension to Claremorris Summer, 1890.

Proposed Harbour at Clifden County Galway, Plan of Coast and Bay, 1900.

Proposed Pier at Clifden, County Galway, 1904.

Reports

Bald, William, Report on the Bogs of South Western Mayo. Third Report of the Commissioners appointed to enquire into the Bogs of Ireland (London, 1814).

Dept. of Finance, Turf Production: Report of Conference with County Surveyors held on 12th June 1941.

The Grand Jury for the County of Galway:
Gregory, W. H., Report of the Committee of the Grand Jury assembled at Spring Assizes, 1849, upon the Accounts and General Circumstances of the Goal, Bridewells, and Courthouses of the County of Galway, in Presentment Book, Spring Assizes, 1849.

Presentment Books of Summer Assizes 1843, and Spring Assizes 1849, 1873, 1891, 1892.

Schedule of Applications for Presentments made at the Extraordinary County Presentment Sessions held at Galway on the 4th day of May, 1846.

Abstract of New Presentments after Spring Assizes, 1899.

Galway County Council:
Quarterly Statements of Proposals for Works, various dates from December 1901 to November 1911.

County of Galway Technical Instruction Committee Annual Reports 1902–10 (1st–10th Annual Reports)

Newspapers, Periodicals and Directories

Clare Champion

Connacht Journal

Connacht Tribune

Galway Express

Galway Vindicator

Tuam Herald

Western News and Western Examiner

Western Star and Ballinasloe Advertiser

The Edinburgh Magazine

The Gentleman's Magazine and London Gazette

Walker's Hibernian Magazine